HOW TO DRAW
ANIME & GAME CHARACTERS

Vol. 2
Expressing Emotions

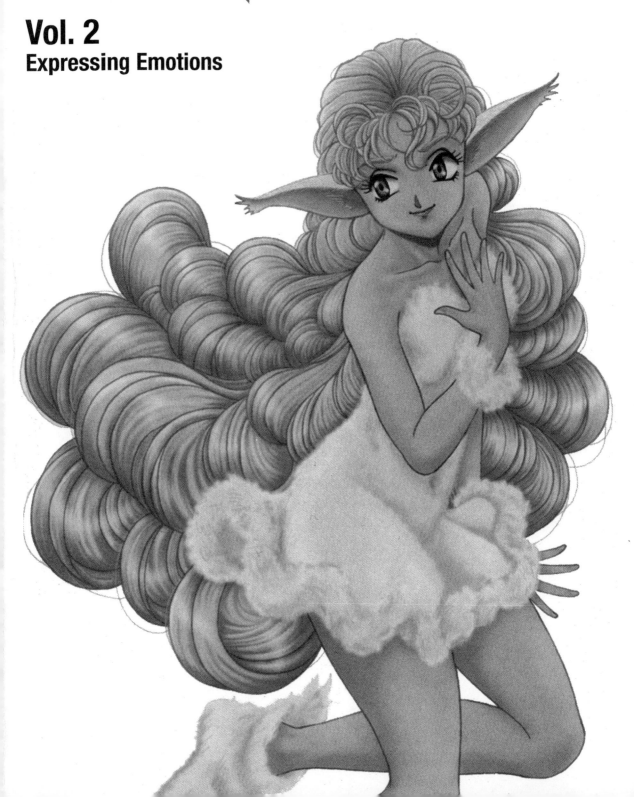

Introduction

In the last volume, I explained how to draw characters and get a hold of the representative characters. But before you start drawing, I have a question to ask. Why do you want to draw? This is in fact the most important point. The overwhelming majority of people respond "Because I like to draw" but drawing without a clear intention makes things difficult to understand for the viewer.

What you want to express should be intimately tied to the character you want to draw. The first step for communicating this is the expression of emotion. This is not limited to only the face but the entire body is used in drawing. The basis of animation is understood as the moving image but the root of word itself means "to give life." Movement carries the will and meaning of the character. To create characters in this way is to breathe life into them and to expand their world.

The following is a list of special terms and abbreviations used in this book.

Bishoujo:	Young, pretty girl
Bishounen:	Young, attarctive boy
CG:	Computer Graphics
Gakuen Genre:	School Life Genre
OVA:	Original Video Anime
RPG:	Role-playing Game
SD:	Simple Deformed (Exaggerated)
Shoujo:	Young girl
Shoujo manga:	Girl's comics
Takarazuka:	An all-women theatrical company in Japan

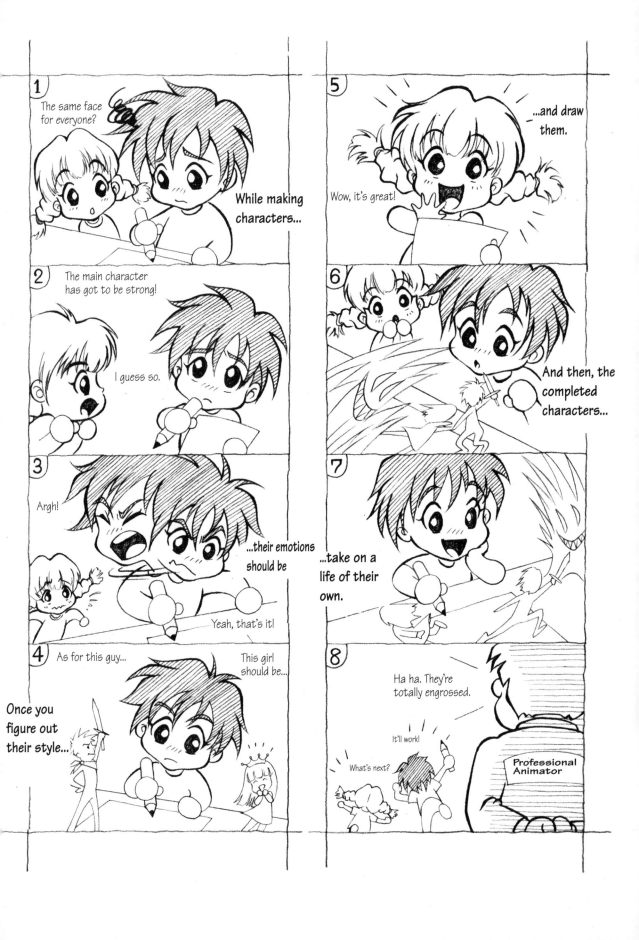

Table of Contents

HOW TO DRAW ANIME & GAME CHARACTERS Vol.2
Expressing Emotions
by Tadashi Ozawa

Copyright © 1999 Tadashi Ozawa
Copyright © 1999 Graphic-sha Publishing Co., Ltd.

First designed and published in 1999 by Graphic-sha Publishing Co., Ltd.
This English edition was published in 2001 by
Graphic-sha Publishing Co., Ltd.
1-14-17 Kudan-kita, Chiyoda-ku, Tokyo 102-0073, Japan

Original design: Motoi Zige
Cover drawing: Koh Kawarajima
English edition layout: Shinichi Ishioka
English translation: Língua fránca, Inc. (an3y-skmt@asahi-net.or.jp)
Japanese edition editor: Sahoko Hyakutake (Graphic-sha Publishing Co., Ltd.)
Foreign language edition project coordinator: Kumiko Sakamoto (Graphic-sha Publishing Co., Ltd.)

First printing: March 2001
Second printing: August 2001
Third printing: November 2001
Fourth printing: March 2002
Fifth printing: November 2002
Sixth printing: February 2003
Seventh printing: June 2003
Eighth printing: January 2004
Ninth printing: July 2004

ISBN: 4-7661-1174-5
Printed and bound in China by Everbest Printing Co., Ltd.

Chapter 1
Let's Start with the Basics

Chapter 1

The Fundamentals of Expressing Emotions Begin with Symbols

The Basic Patterns

Even simply said, humans have a host of expressions. Ranging from a leaping joy to a rage so fierce that you can't help but to cry out. Let's assume for a moment that you read "Expression of Enduring Anguish". What kind of expression comes to mind? Various images, faint or otherwise, spring to mind, right? Even people who don't draw can read emotions from a picture. This capacity has been cultivated since ancient times across the world and is what we call the symbolization of expressions, a language unto itself. This visual expression is basic to Japanese Comic Books and Animation and is rather straightforward and has become quite sophisticated.

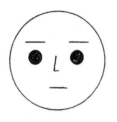

Expressionless

Take a look at the basic drawing on the left. It is overly simplified but you can quickly recognize it as a human face. In fact, this is the very process of symbolization in drawing. Using this as a base and replacing the mouth and the eyebrows, we get the following four small drawings.

— — — — — — — **Next, let's draw four new patterns for the mouth and eyebrows.** — — — — — —

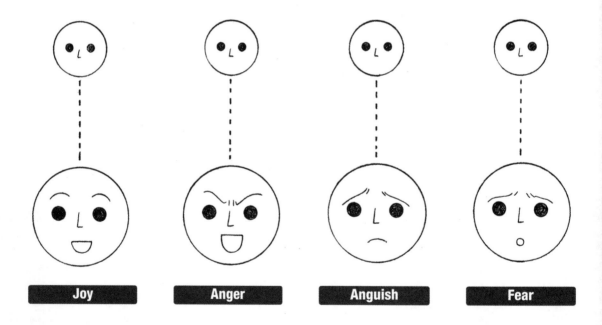

Joy **Anger** **Anguish** **Fear**

With changes to just the mouth and eyebrows you can express these emotions. Before we continue, firmly plant in your mind that drawing characters starts with symbolizing the expression of emotions.

Symbols of Expression

Let's work with the combination of the mouth and eyebrows on the basic pattern. With expressions of "joy" and "anger," can you tell that the extent to which the mouth is open demonstrates the degree of emotion? Before we get involved with drawing tears, sweat or eyes, let's practice with the basic pattern only.

Degree of Emotion Low

Eyebrows / Mouth	Joy	Anger	Anguish	Fear
⌣	Contentment Haughty Pride	Hot-Headed Mildly Angry Irritated	Regret Grief	Dullness Vexation Dissatisfaction
⌣	Pleasant Pride Agreement	Contempt Fret Sneer	Loneliness Painful Request Sorrow + Grief	Doubt Unease + Worry Hesitation
⬭	Surprise Deeply Moved	Criticize Rebuke	Exhaustion Pain Depression	Terror Unease + Consideration Flustered
⬭	Cheerful Hopeful Glad	Disgust Disgruntled Revulsion	Agony Humiliation Disappointment	Shock Confusion
⬭	Ecstasy Laughter Delight	Provocation Defiance Rage	Despair Sharp pain Agony	Frenzied Madness

Degree of Emotion High

Basic Patterns of Expression

A vividly drawn character is alive. Its distinctiveness is immediately recognizable. Here, drawing expressions becomes detailed handiwork. The drawings below are the basic patterns of expression.

These go one step beyond the symbolized drawings. Let's practice drawing the actual frontal-view of characters.

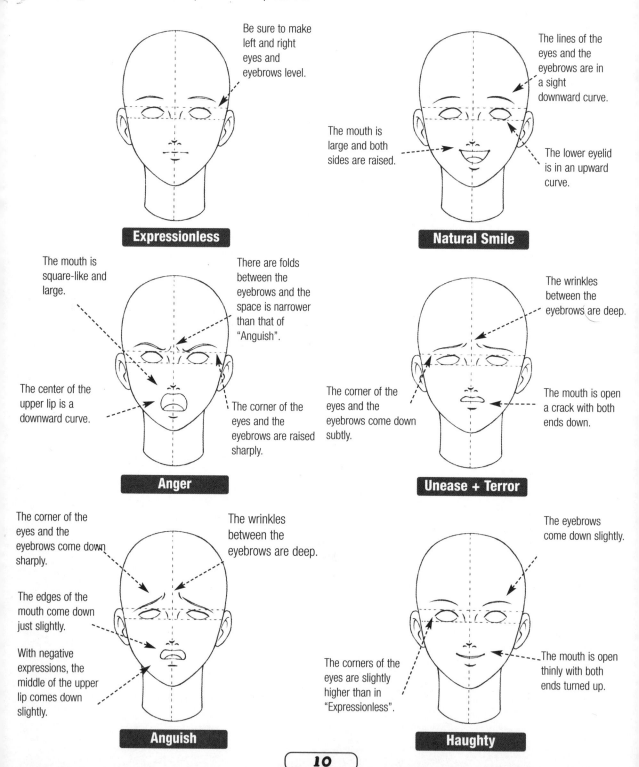

Be sure to make left and right eyes and eyebrows level.

Expressionless

The lines of the eyes and the eyebrows are in a sight downward curve.

The mouth is large and both sides are raised.

The lower eyelid is in an upward curve.

Natural Smile

The mouth is square-like and large.

There are folds between the eyebrows and the space is narrower than that of "Anguish".

The center of the upper lip is a downward curve.

The corner of the eyes and the eyebrows are raised sharply.

Anger

The wrinkles between the eyebrows are deep.

The corner of the eyes and the eyebrows come down subtly.

The mouth is open a crack with both ends down.

Unease + Terror

The corner of the eyes and the eyebrows come down sharply.

The edges of the mouth come down just slightly.

With negative expressions, the middle of the upper lip comes down slightly.

The wrinkles between the eyebrows are deep.

Anguish

The eyebrows come down slightly.

The corners of the eyes are slightly higher than in "Expressionless".

The mouth is open thinly with both ends turned up.

Haughty

Variations of Expressions

After the fundamentals, let's further challenge ourselves with the expressions that have been emphasized so far. By using various angles, we can evoke the atmosphere of the scene the character is in and bring to life different effects. For those who think they cannot draw characters well, use the drawings below as a sample to imagine what kind of expression you would have yourself. This is, in fact, a secret trick for professionals too.

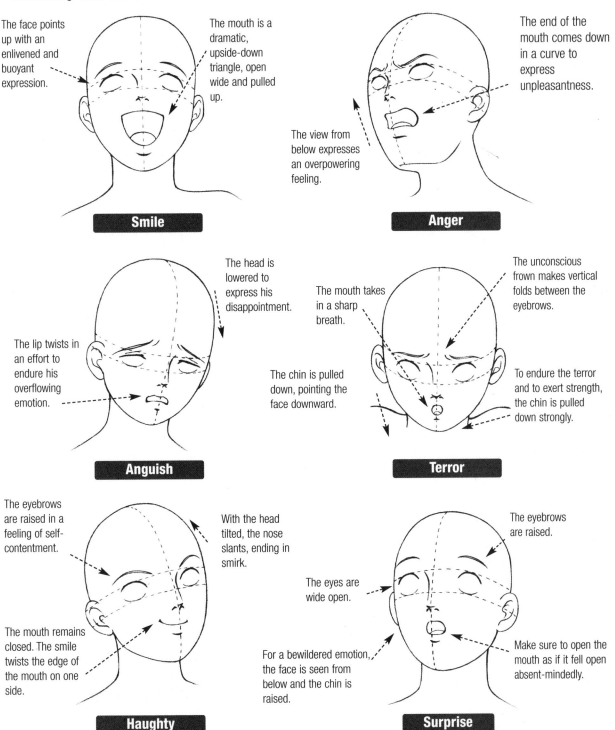

The face points up with an enlivened and buoyant expression.

The mouth is a dramatic, upside-down triangle, open wide and pulled up.

Smile

The end of the mouth comes down in a curve to express unpleasantness.

The view from below expresses an overpowering feeling.

Anger

The head is lowered to express his disappointment.

The lip twists in an effort to endure his overflowing emotion.

Anguish

The mouth takes in a sharp breath.

The chin is pulled down, pointing the face downward.

The unconscious frown makes vertical folds between the eyebrows.

To endure the terror and to exert strength, the chin is pulled down strongly.

Terror

The eyebrows are raised in a feeling of self-contentment.

With the head tilted, the nose slants, ending in smirk.

The mouth remains closed. The smile twists the edge of the mouth on one side.

Haughty

The eyes are wide open.

The eyebrows are raised.

For a bewildered emotion, the face is seen from below and the chin is raised.

Make sure to open the mouth as if it fell open absent-mindedly.

Surprise

Game Character (Girl)

Girls have slightly thick and straight eyebrows, expressing a clear personality and a single-mindedness borne of a hatred of losing.

The eyes and eyebrows are not joined, leaving area for the eyelids.

When viewed head-on, the bridge of the nose is given this touch.

The pupils are standard Japanese: solid black. The eyelashes of this character are not drawn when the eyes are open.

Emotions can be expressed with the movement of the line of the eyelids.

The ends of the mouth go down when "Expressionless".

The chin comes to a point slightly, like a young girl.

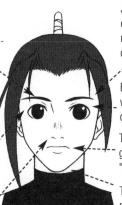

Expressionless

The ends of the eyebrows and the eyes are drawn in a downward curve.

The curve of the eyes has narrowed to the point where the eyes seem shut. The eyelashes are thick at the base of the eyes and become progressively thinner toward the ends of the eyes.

The mouth extends horizontally with both ends raised slightly.

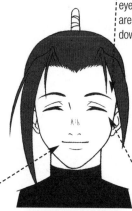

Joy

The eyebrows draw close to the center making vertical folds.

The ends of the eyes are brought up slightly.

The ends of the mouth come down sharply. The line of the lower lip is not drawn boldly, giving the impression of clenched teeth.

The line of the eyelid becomes vertical, expressing anger.

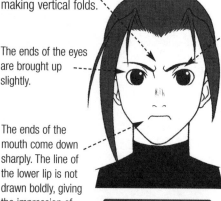

Anger

In order to give a sense of the volume of the eyelashes of her downcast eyes, the eyelashes are drawn thicker than that of "Joy".

The width of the mouth is less than half of what it is in "Expressionless". Lost in thought, the mouth is slightly open.

The eyebrows curve as they point downward.

Compare this to "Joy". Here, the curve of the downcast eyes (its downward curve) makes the eyes look shut so the curve is inverted.

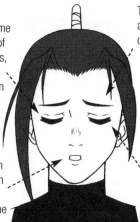

Unease + Worry

Be careful not to lower the end of the eyebrow too much otherwise the expression will be one of sadness.

The mouth is the same as of "Anger" but its size is halved. The lower lips sticks out in a childish manner.

This is the same pattern as that of "Unease + Worry," the eyebrows are drawn close to the center and there are folds between the eyebrows.

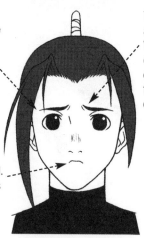

Dissatisfaction

The eyebrows peak and then curve. They are drawn short to show blithe.

The mouth is open in a bow-shape and slightly widened.

compared to the shape of the eyes in "Expressionless", they are rounder. The eyes seem to have just popped open.

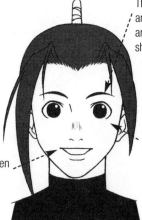

Cheerful

Visualize the Nature of this Character

Though this is the setup for a female Ninja, this character must attend school in the modern world, as a high school student. Except for being a Ninja she is still just an ordinary girl.

A character with some caprice, when treated as a child she becomes enraged. But when flattered she quickly warms up. Though not self-righteous, she feels strongly about protecting what she feels is important. She has pride and confidence in her stealth skills, which she does in fact possess. When treated like a child she makes a disappointed face. This type of character is often introduced as one who grows up feeling a world of elements in her heart.

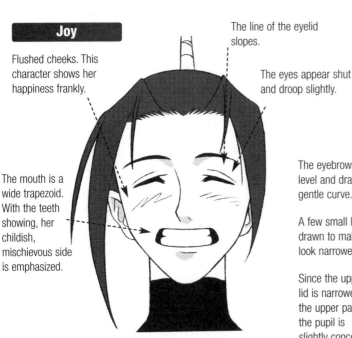

Joy

Flushed cheeks. This character shows her happiness frankly.

The line of the eyelid slopes.

The eyes appear shut and droop slightly.

The mouth is a wide trapezoid. With the teeth showing, her childish, mischievous side is emphasized.

For girls, the gums are not drawn in too much between the teeth, which would otherwise make her look rough. Also, the lines between the teeth are too real and are not drawn.

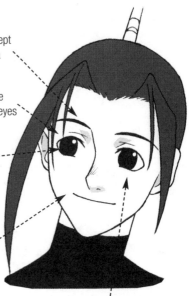

Smile

The eyebrows are kept level and drawn in a gentle curve.

A few small lines are drawn to make the eyes look narrowed.

Since the upper lid is narrowed, the upper part of the pupil is slightly concealed.

The ends of the mouth are slightly raised.

Because the cheeks are raised when smiling, the eyelid is purposely drawn in a curve.

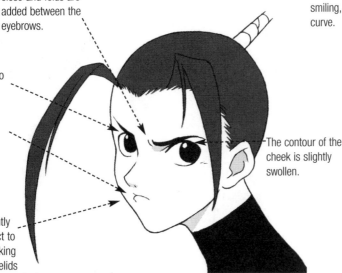

The eyebrows draw close and folds are added between the eyebrows.

To show the eyes looking upward, the highlight connects to the eyelids.

With the lower lip sticking out, the sharpened mouth expresses her childishness.

The eyes are slightly raised and connect to the eyebrows, making the area of the eyelids disappear.

The contour of the cheek is slightly swollen.

Bad Tempered

Be careful with details.

! Key

The sharpened mouth, swollen cheek, and a frown with up-turned eyes are standard for expressing childishness.

The lines of the eyelids are drawn clearly to show this is an intentional expression.

The eyebrows are raised slightly in a curve.

The upper eyelids are lowered slightly, concealing the upper part of the pupil.

With the addition of this line, there is a small element of a bully added.

Be careful with details.

The caricatured line of the teeth is added.

The face is seen from below, emphasizing that she is looking down upon someone.

Smug

The eyebrows are bent and lowered. The eyebrows thin toward their ends.

The pupils are slightly cast upward.

To show she is exerting strength at the corners of her eyes, wrinkles are added.

The area of the eyelids is reduced to a minimum (but do not connect them to the eyes).

The mouth is slightly raised and both edges point downwards. The line of the lower lip is not drawn to show her clenching her teeth.

When drawing tears, the line of eyelids is distanced.

Be careful with details.

Anguish

The eyes are opened wide and as she looks straight at the other person, the pupils are locked.

The eyebrows are the same as that of "Bad Tempered".

The embellishments here show that she is flushed with anger. This character is always serious when angered. The chin is slender like a girl.

The essential features of this character type:
1. As a Ninja, a Japanese character, the hair is straight and black. To give her an old-world atmosphere, the bangs are separated from the middle and the hair is pulled back in a taught tail. The left and right bangs are intentionally made unbalanced. It makes demonstrating their movement easier.
2. The pupils are solid black as well, making her look more like a young girl.

! **Key**
To show the slender form of a girl, the lower teeth are not drawn.

The chin is slender like a girl.

Anger

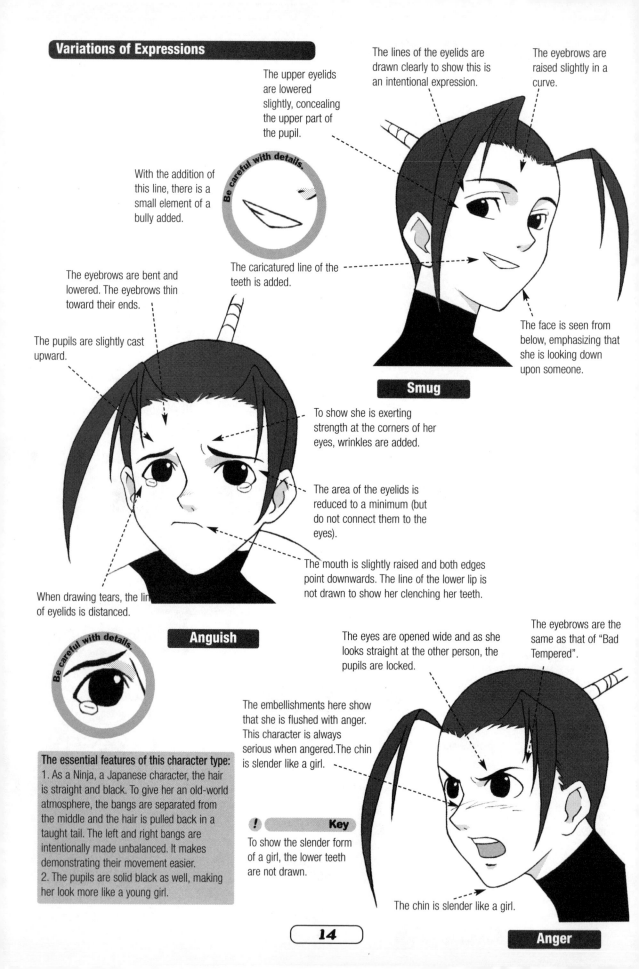

Rarely Seen Expressions

Characters that are either only cool, cute, or charming are flat. It is impossible to include the full range of expressions with just variations on the basic patterns. In this section, we show some expressions and situations that are seldom seen. The facial features and movements of the character are out of the ordinary, simplified or are deformed (caricatured) to add a comical element to the expressions. The emotions of a character caught off-guard are easily understood with these expressions. The most important thing is to make sure the expressions stay within the nature of the character. The reader must be easily effected by these expressions as they bring the character to life.

This face emphasizes the "little devil" quality of this character. She is drawn as though she is scheming something. (But that she is not planning some big trouble underscores her innocence.)

He! He! He!

The eyebrows are straight lines and arched severely, overlapping with the lines of the upper eyelids.

As two small spots that touch the upper eyelids, the pupils are deformed to an extreme. This emphasizes the whites of the eyes.

The face is seen from above so the forehead looks large and the features of the face are all lowered.

The mouth is arched and raised. The upper lip is a straight line and the lower lip is a stretched-out 'V'.

The lower eyelids are inverted half-moons. The whites of the eyes are bared.

One eyebrow curves slightly when she smiles shyly.

The other eyebrow is bent to express her slightly troubled emotion. Wrinkles are added to the corner of the eye.

The eyes are downcast as though she is frustrated. The lines of the eyelids are clear.

! Key

Overall the lines are made straight rather than curved. This deformation emphasizes the distinctive essence of this expression so it is effective to add a slightly comical and ironic element (making it a caricature).

The cheeks are blushed.

The mouth smiles gently.

The full body is on page 74.

I feel so embarrassed!

Game Character (Boy)

The ends of the eyebrows are disheveled, demonstrating the character's strong brute quality.

His youthful resolution and single-mindedness are expressed by the large black pupils.

The shut mouth is a large, straight line, giving him a strong will.

The eyebrows are raised slightly more than in "Expressionless".

By showing the whites around the pupils, the eyes look wide open. It helps express his anticipation and curiosity typical in a youthful character.

The mouth is closed but the edges curl up slightly.

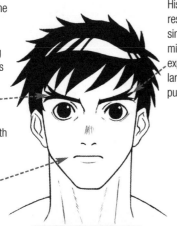

Expressionless

Cheerful

The eyebrows are completely joined with the upper eyelids, consciously exerting force at the corners of his eyes.

The eyes become ellipses with the ends raised slightly.

The mouth is open in a hexagonal shape. The upper and lower teeth are shown to bring out his manliness.

This lines of the eyelids show his eyes shut tight.

The folds are directed toward the forehead and brought together. Compared to "Anger" these are deeper.

The mouth is straight with sharp corners. T two lines at both edg of the mouth express clenched teeth.

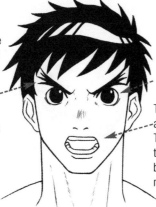

Anger

Pain

The upper eyelids come down, expressing downcast eyes. The area of the eyelids is widened.

The ends of the eyebrows come down significantly.

The edges of the mouth come down more than in "Expressionless". He lets out a sigh of exasperation.

The mouth is extended horizontally and is opened a little. Only one of the edges is raised.

Compared to "Pain", the space between the eyebrows is wider, and the wrinkles are more shallow.

The eyebrows are raised about the same as "Anger", with the area of eyelids gone.

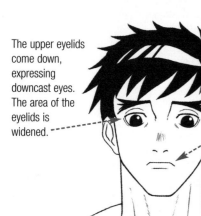

Disappointment

Smug

Visualize the Nature of this Character

He is a street-fighter that travels the world. He has been absorbed in karate and judo since he was young. Though his prowess is greatly valued, he still isn't satisfied with himself and he continues his earnest search for himself.

His character is basically pure and his emotions are tied into his actions. There isn't an underside to this character; all his emotions are directed outward. At times his overflowing hot-blooded nature betrays his young spirit.

His distance from the common, everyday world gives him a certain innocence, which also makes others perceive his good nature. However, he is more himself during a fight.

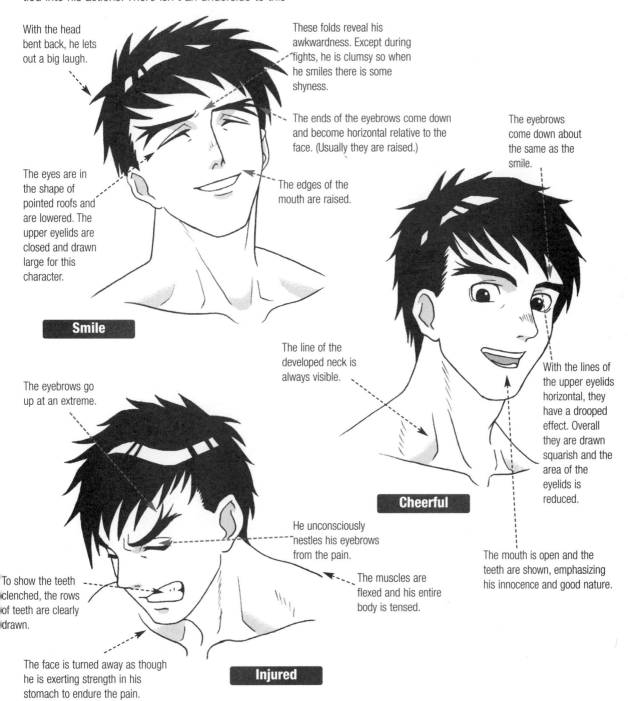

With the head bent back, he lets out a big laugh.

These folds reveal his awkwardness. Except during fights, he is clumsy so when he smiles there is some shyness.

The ends of the eyebrows come down and become horizontal relative to the face. (Usually they are raised.)

The eyebrows come down about the same as the smile.

The eyes are in the shape of pointed roofs and are lowered. The upper eyelids are closed and drawn large for this character.

The edges of the mouth are raised.

Smile

The line of the developed neck is always visible.

With the lines of the upper eyelids horizontal, they have a drooped effect. Overall they are drawn squarish and the area of the eyelids is reduced.

The eyebrows go up at an extreme.

Cheerful

He unconsciously nestles his eyebrows from the pain.

The muscles are flexed and his entire body is tensed.

The mouth is open and the teeth are shown, emphasizing his innocence and good nature.

To show the teeth clenched, the rows of teeth are clearly drawn.

The face is turned away as though he is exerting strength in his stomach to endure the pain.

Injured

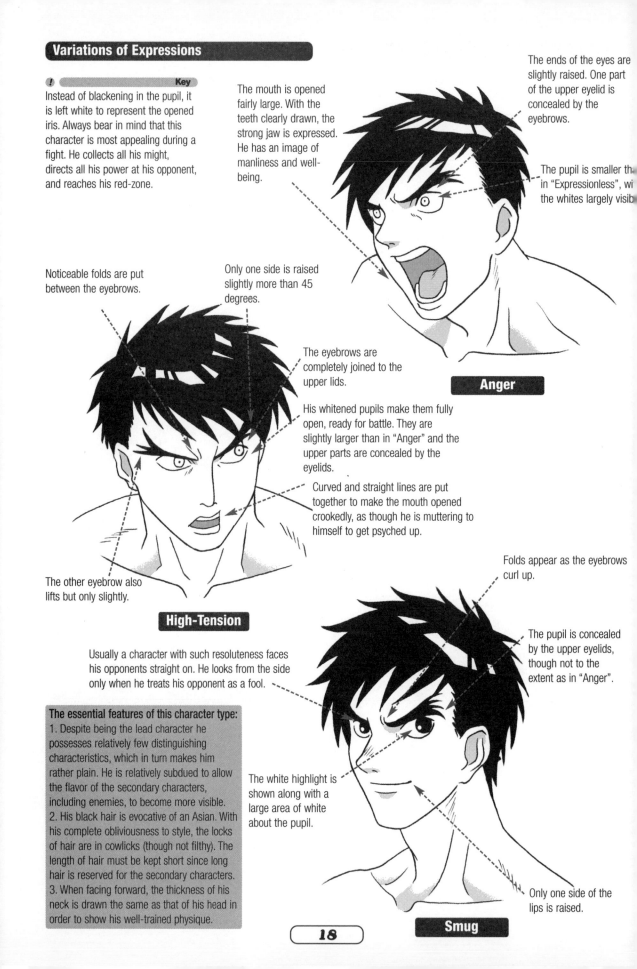

Variations of Expressions

Instead of blackening in the pupil, it is left white to represent the opened iris. Always bear in mind that this character is most appealing during a fight. He collects all his might, directs all his power at his opponent, and reaches his red-zone.

The mouth is opened fairly large. With the teeth clearly drawn, the strong jaw is expressed. He has an image of manliness and well-being.

The ends of the eyes are slightly raised. One part of the upper eyelid is concealed by the eyebrows.

The pupil is smaller than in "Expressionless", with the whites largely visible.

Anger

Noticeable folds are put between the eyebrows.

Only one side is raised slightly more than 45 degrees.

The eyebrows are completely joined to the upper lids.

His whitened pupils make them fully open, ready for battle. They are slightly larger than in "Anger" and the upper parts are concealed by the eyelids.

Curved and straight lines are put together to make the mouth opened crookedly, as though he is muttering to himself to get psyched up.

The other eyebrow also lifts but only slightly.

High-Tension

Usually a character with such resoluteness faces his opponents straight on. He looks from the side only when he treats his opponent as a fool.

The essential features of this character type:
1. Despite being the lead character he possesses relatively few distinguishing characteristics, which in turn makes him rather plain. He is relatively subdued to allow the flavor of the secondary characters, including enemies, to become more visible.
2. His black hair is evocative of an Asian. With his complete obliviousness to style, the locks of hair are in cowlicks (though not filthy). The length of hair must be kept short since long hair is reserved for the secondary characters.
3. When facing forward, the thickness of his neck is drawn the same as that of his head in order to show his well-trained physique.

Folds appear as the eyebrows curl up.

The pupil is concealed by the upper eyelids, though not to the extent as in "Anger".

The white highlight is shown along with a large area of white about the pupil.

Only one side of the lips is raised.

Smug

18

Rarely Seen Expressions

For this character, fighting is the focus so even with out-of-character expressions he still is an ordinary person. Try placing him in a relaxed atmosphere where neither training nor battle is involved.

The whole body is on page 78.

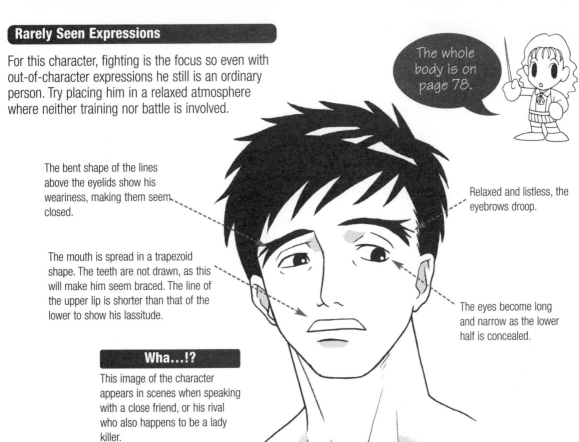

The bent shape of the lines above the eyelids show his weariness, making them seem closed.

Relaxed and listless, the eyebrows droop.

The mouth is spread in a trapezoid shape. The teeth are not drawn, as this will make him seem braced. The line of the upper lip is shorter than that of the lower to show his lassitude.

The eyes become long and narrow as the lower half is concealed.

Wha…!?

This image of the character appears in scenes when speaking with a close friend, or his rival who also happens to be a lady killer.

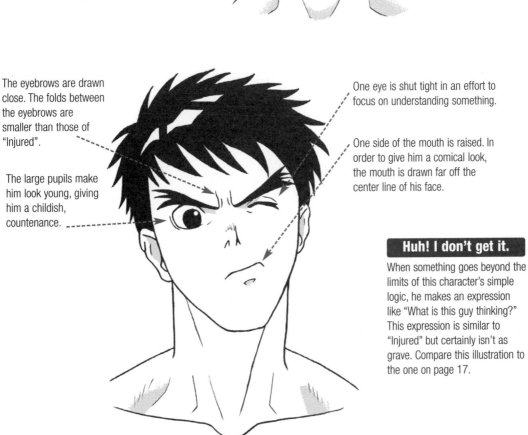

The eyebrows are drawn close. The folds between the eyebrows are smaller than those of "Injured".

The large pupils make him look young, giving him a childish, countenance.

One eye is shut tight in an effort to focus on understanding something.

One side of the mouth is raised. In order to give him a comical look, the mouth is drawn far off the center line of his face.

Huh! I don't get it.

When something goes beyond the limits of this character's simple logic, he makes an expression like "What is this guy thinking?" This expression is similar to "Injured" but certainly isn't as grave. Compare this illustration to the one on page 17.

Comic Child Character (Girl)

The bottom of the face is a rounded outline. With the mouth high up, her childishness is expressed.

The eyebrows and eyes gently curve downward.

Both edges go up and the mouth is spread open wide. When this character smiles, the teeth are not seen.

The lines of the lower eyelids are slight, upward curves.

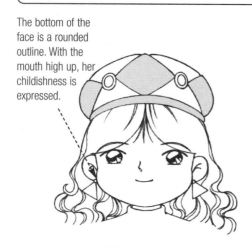

Expressionless

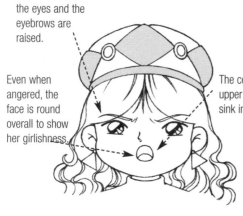

Smile

Both the ends of the eyes and the eyebrows are raised.

Even when angered, the face is round overall to show her girlishness.

The center of the upper lip does not sink in.

A tear drop builds up at the ends of the eyes. (The detail is on page 84.)

The upper eyelids and eyebrows are lowered.

The center of the upper lip has a slight downward curve. The size of this curve is a key point for expressing the extent of her grief.

The lower eyelids are starting to bend out of shape as they curve upward slightly.

Anger

Anguish

Shallow wrinkles are put between the eyebrows.

The upper eyelids hang over the eyes.

The mouth is round and small when she is confused or gasping.

Larger than in "Expressionless", both edges of the mouth are raised.

To show her tension, the lower eyelid is bent upward.

Pay attention to the slight lift in the eyebrow and the end of the eye.

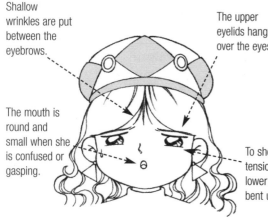

Unease

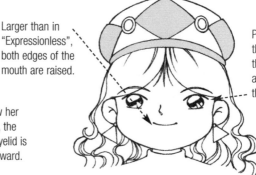

Smug

Visualize the Nature of this Character

There is a small comical element in this typical fantasy-adventure princess. Along the way, she is rescued many times by the male protagonist. Moreover, her relationship with him consist of continuing quarrels and make-ups. During this process, however, her understanding of the world gradually deepens. Though she is a little selfish, as well as a crybaby and obstinate, she is sweet at heart. At times, she even winds up leading the protagonist, so imagine her as a girl with some substance.

Be careful with details.

Her entire face lifts as she lights up.

The hands spread wide express the extent of her childish nature when happy.

She stares fixedly at the other person.

This detail expresses her anger.

Be careful when drawing the sleeve.

Smile

The jaw juts out.

Anger

Sweat forms from being agitated.

The mouth is shut tight to stop herself from crying out.

The shoulders are very tight.

Turning away her face the chin is raised.

Terror

21

Opposite from stronger emotions such as being troubled or happy, with this expression, one eyebrow is knitted and the other is as though she is smiling.

Be careful with details.

The neck is slightly tilted, as though she is putting on airs.

Be careful with details.

Shy Smile

With this touch, the cheeks blush

The borderline between the eyes and the tears do not cross (see above left).

With the head lowered and downcast eyes, her emotion sinks.

The eyebrows are raised to show her confidence.

Wiping away the tear adds girlishness to her expressions.

Anguish

Her head is off to one side and her line of sight is directed down.

Over enunciation makes her mouth like this. (Ex. "Now, you listen to me... ")

The essential features of this character type:
1. She has long and flowing curly hair.
2. The type of hat and earrings show her royal heritage.

The action of the hand reveals the resolution of her emotion and the strength of her character.

22

Smug

Rarely Seen Expressions

Generally these expressions are not seen but they are effective when this character is deeply moved or when she is out of character. The world in which this character lives has several comical elements and her age is very young so draw her cute and very caricatured.

The full body is on page 82.

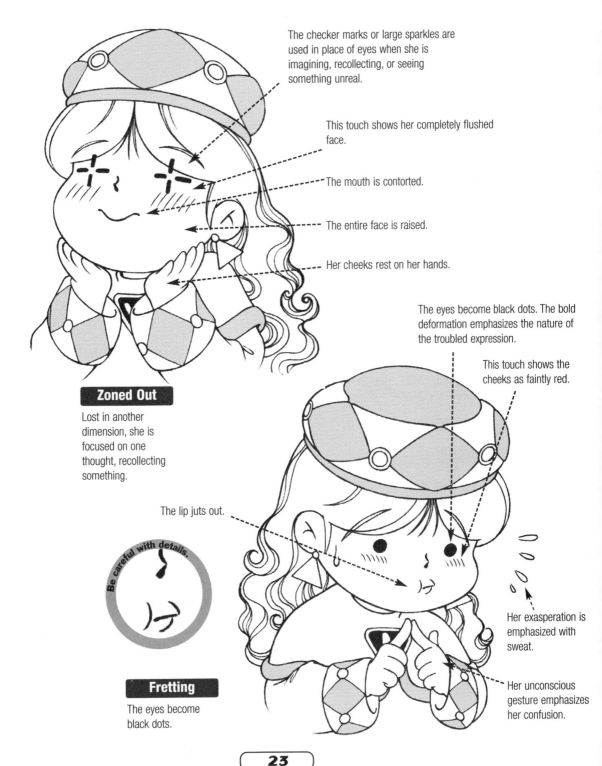

The checker marks or large sparkles are used in place of eyes when she is imagining, recollecting, or seeing something unreal.

This touch shows her completely flushed face.

The mouth is contorted.

The entire face is raised.

Her cheeks rest on her hands.

Zoned Out

Lost in another dimension, she is focused on one thought, recollecting something.

The eyes become black dots. The bold deformation emphasizes the nature of the troubled expression.

This touch shows the cheeks as faintly red.

The lip juts out.

Be careful with details.

Fretting

The eyes become black dots.

Her exasperation is emphasized with sweat.

Her unconscious gesture emphasizes her confusion.

Comic Child Character (Boy)

Just as with the girl character, the outline of the face is puffed around the cheeks.

Large and thick eyebrows are a symbol of his active, boyish, strong sense of justice.

The eyes and the eyebrows are lowered.

With the eyes shut, he is expressing more strongly than the girl.

The position of the mouth is high and shut in a straight line.

The mouth is opened wide with both edges raised.

Expressionless

Smile

Both the ends of the eyes and the eyebrows are clearly raised.

The folds are deep.

His eyebrows are sharply lowered.

This touch expresses his high excitement.

The edge of the mouth is lowered to emphasize his inconsolableness. His mouth is clearly open (more than that of the girl) and the teeth are shown.

The mouth is opened in a square and the teeth are visible.

The teardrops are drawn the same as that of the girl.

Anger

Anguish

To show him worrying, the lines of the eyelids are all made straight.

The vertical folds show his stress.

For a natural feeling, the mouth is small and round.

The ends of his eyes and eyebrows are clearly raised, more than that of the girl.

The mouth is large and its ends are clearly raised.

Unease

Smug

Visualize the Nature of this Character

This is a supporting character who half unwillingly ends up becoming involved in an adventure fantasy whose mission is to save the princess. He is quick to react to trouble, although his actions often times aren't very well thought through. He has his share of blunders as well as moments of fretting and sweating but he always maintains his light-heartedness. Even when expressing his discontent or anger, he leaves no ill feelings behind. Compared to the girl character, there should be more emphasis on his expressions.

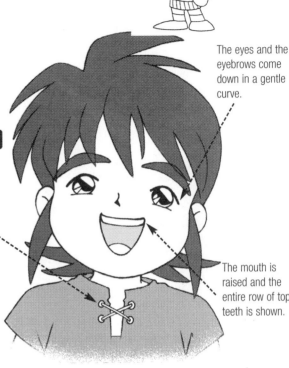

His entire body is overly expressive.

The eyes and the eyebrows come down in a gentle curve.

Smile

This is how the cord and metal fittings are drawn.

Be careful with details.

The mouth is raised and the entire row of top teeth is shown.

His laugh reveals his frank and open childishness.

The sideburns are drawn large and wide to emphasize his excitement.

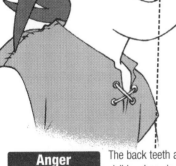

The folds between his eyebrows are deep.

The magnitude of his anger is emphasized when his face is viewed from below.

Anger

The back teeth are visible when viewed from below.

Be careful with details.

The shoulders are stiffened and raised.

The mouth is open wide and even his back teeth are visible.

As his whole body is trying to avoid the terror, both his face and upper body are pulled up.

Terror

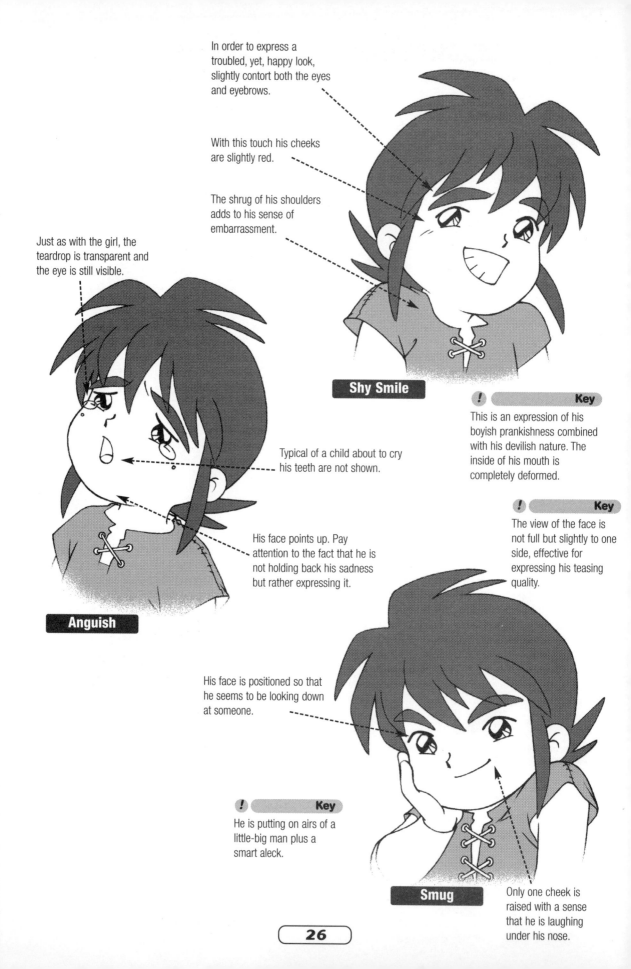

In order to express a troubled, yet, happy look, slightly contort both the eyes and eyebrows.

With this touch his cheeks are slightly red.

The shrug of his shoulders adds to his sense of embarrassment.

Just as with the girl, the teardrop is transparent and the eye is still visible.

Shy Smile

! **Key**

This is an expression of his boyish prankishness combined with his devilish nature. The inside of his mouth is completely deformed.

Typical of a child about to cry his teeth are not shown.

! **Key**

The view of the face is not full but slightly to one side, effective for expressing his teasing quality.

His face points up. Pay attention to the fact that he is not holding back his sadness but rather expressing it.

Anguish

His face is positioned so that he seems to be looking down at someone.

! **Key**

He is putting on airs of a little-big man plus a smart aleck.

Smug

Only one cheek is raised with a sense that he is laughing under his nose.

Rarely Seen Expressions

Give this character a strong comical element. He is active, mischievous, and funny. His head spins when he blunders so draw him with rich expressions. These expressions at first seem removed from the story but they are in fact emblematic of his behavior.

His full body expressions are on page 86.

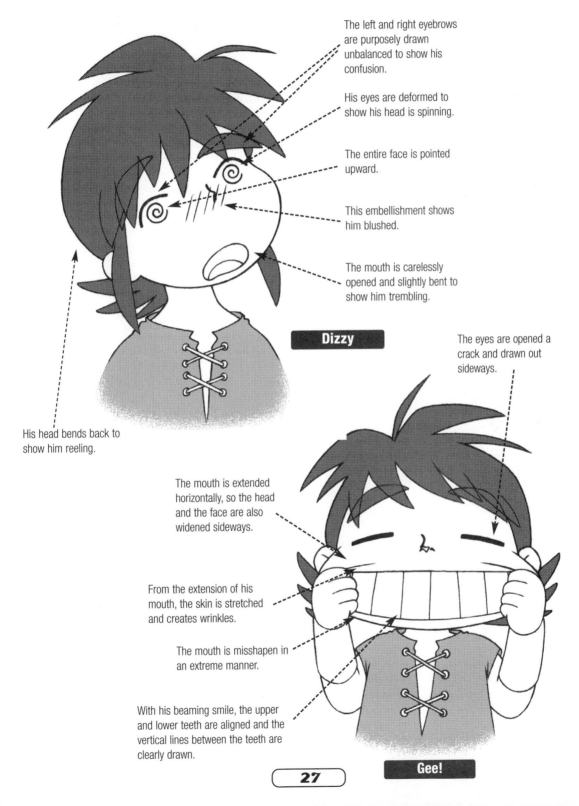

The left and right eyebrows are purposely drawn unbalanced to show his confusion.

His eyes are deformed to show his head is spinning.

The entire face is pointed upward.

This embellishment shows him blushed.

The mouth is carelessly opened and slightly bent to show him trembling.

Dizzy

His head bends back to show him reeling.

The eyes are opened a crack and drawn out sideways.

The mouth is extended horizontally, so the head and the face are also widened sideways.

From the extension of his mouth, the skin is stretched and creates wrinkles.

The mouth is misshapen in an extreme manner.

With his beaming smile, the upper and lower teeth are aligned and the vertical lines between the teeth are clearly drawn.

Gee!

OVA Character (Girl)

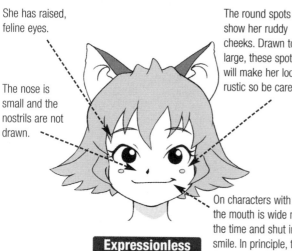

She has raised, feline eyes.

The nose is small and the nostrils are not drawn.

The round spots show her ruddy cheeks. Drawn too large, these spots will make her look rustic so be careful.

On characters with cat ears, the mouth is wide most of the time and shut in a gleeful smile. In principle, the lower lip is not drawn.

Expressionless

The eyebrows are clearly raised in a curve and the space between the eyebrows is widened.

A fold resulting from squeezing her eyes shut.

The eyes are shut when she laughs. Th[e] line of the eyelid is not a single line but given a contour to express the thicknes[s] of the eyelids and th[e] eyelashes.

The top and bottom ar[e] clearly opened. The tee[th] are not drawn.

Joy

About one quarter from the ends of the eyes, the eyebrows are sharply arched.

The top and bottom are largely opened but compared to "Joy" the shape of the mouth is closer to a square. Be careful to round the corners of the mouth, otherwise she will loose some sense of her girlishness.

Her fangs are shown (as an exception).

There are several folds between the eyebrows.

With this touch, the level of her excitement is shown.

The spots on the cheeks are raised along with the eyes and the eyebrows.

Anger

There are folds between her eyebrows.

The eyebrows are lowered. They are drawn like two sides of a mountain.

The teardrop is transparent so the line inside is not connected. (Compare this to the tears of the Comic Child Character (Girl).)

The mouth is a dramatic break from a girl's standard set of expressions. Increasing its formlessness deepens the level of her anguish.

As the eyes are shut very tight, they form wrinkles here as well.

Anguish

The lowered and curved eyebrows are pushed outward.

Wrinkles from the eyebrow and eyelid are lowered together.

With the upper eyelids lower than in "Expressionless" a sweet element is added. (Be careful to distinguish this from drooped eyes.)

On the opposite side of the raised corner of the mouth, the eyebrow is arched for balance.

The mouth is small and is a vertical oval. The size of the mouth of this character varies a great deal and can communicate a comical nature.

Unease

About one-third from the ends of the eyes, the eyebrows arch.

The upper and lower eyelids cover the top and bottom part of the pupil giving her a scornful look.

Only one side of the mouth is raised, giving her a smirk.

Smug

! Key

By breaking the balance between the left and right eyebrows, she looks down at someone and gives a "He! He! He!" expression.

Variations of Expressions

Visualize the Nature of this Character Type

This is a character of feline origin. She is often introduced as a supporting character to the protagonist but at some point she overtakes the protagonist, getting all the attention and the spotlight. Her many moods are clearly distinguished and she is very expressive. When her self-righteousness becomes overwhelming her actions become rash and she walks straight into a blunder. Her incessantly changing emotions are part of her appeal.

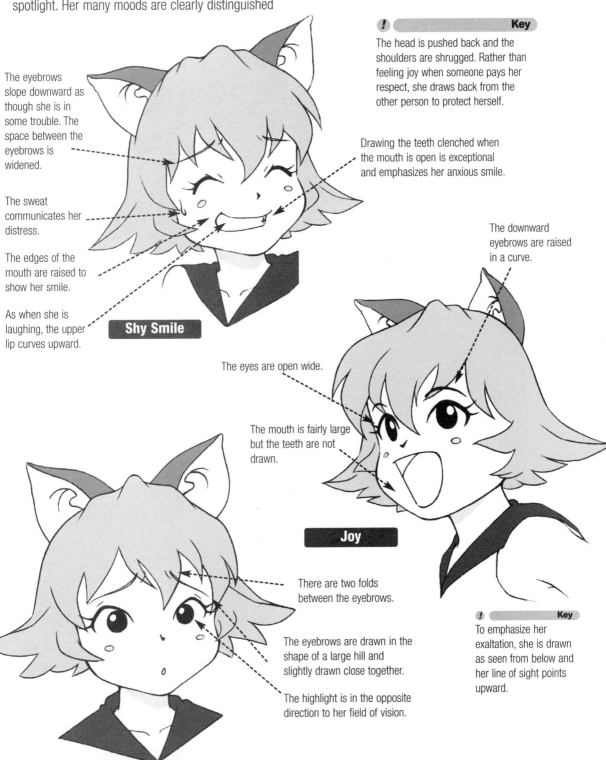

! Key

The head is pushed back and the shoulders are shrugged. Rather than feeling joy when someone pays her respect, she draws back from the other person to protect herself.

The eyebrows slope downward as though she is in some trouble. The space between the eyebrows is widened.

The sweat communicates her distress.

The edges of the mouth are raised to show her smile.

As when she is laughing, the upper lip curves upward.

Drawing the teeth clenched when the mouth is open is exceptional and emphasizes her anxious smile.

Shy Smile

The downward eyebrows are raised in a curve.

The eyes are open wide.

The mouth is fairly large but the teeth are not drawn.

Joy

There are two folds between the eyebrows.

The eyebrows are drawn in the shape of a large hill and slightly drawn close together.

The highlight is in the opposite direction to her field of vision.

! Key

To emphasize her exaltation, she is drawn as seen from below and her line of sight points upward.

Worry

29

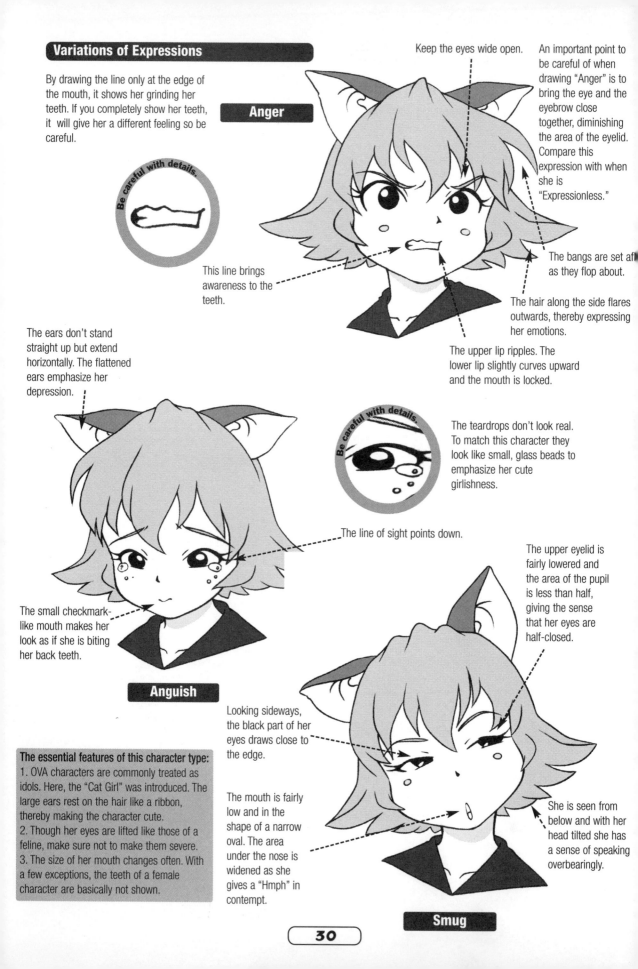

Variations of Expressions

By drawing the line only at the edge of the mouth, it shows her grinding her teeth. If you completely show her teeth, it will give her a different feeling so be careful.

Be careful with details.

This line brings awareness to the teeth.

Anger

Keep the eyes wide open.

An important point to be careful of when drawing "Anger" is to bring the eye and the eyebrow close together, diminishing the area of the eyelid. Compare this expression with when she is "Expressionless."

The bangs are set afl as they flop about.

The hair along the side flares outwards, thereby expressing her emotions.

The upper lip ripples. The lower lip slightly curves upward and the mouth is locked.

The ears don't stand straight up but extend horizontally. The flattened ears emphasize her depression.

The small checkmark-like mouth makes her look as if she is biting her back teeth.

Be careful with details.

The teardrops don't look real. To match this character they look like small, glass beads to emphasize her cute girlishness.

The line of sight points down.

Anguish

The upper eyelid is fairly lowered and the area of the pupil is less than half, giving the sense that her eyes are half-closed.

Looking sideways, the black part of her eyes draws close to the edge.

The essential features of this character type:
1. OVA characters are commonly treated as idols. Here, the "Cat Girl" was introduced. The large ears rest on the hair like a ribbon, thereby making the character cute.
2. Though her eyes are lifted like those of a feline, make sure not to make them severe.
3. The size of her mouth changes often. With a few exceptions, the teeth of a female character are basically not shown.

The mouth is fairly low and in the shape of a narrow oval. The area under the nose is widened as she gives a "Hmph" in contempt.

She is seen from below and with her head tilted she has a sense of speaking overbearingly.

Smug

She is representative of side-kick characters, with a nature clearly different from that of the protagonist. These characters should be drawn with an overpowering cuteness to charm the viewer. Since she is a type that muddles things up, "Rarely Seen Expressions" gives her a comical element that colors her entire nature.

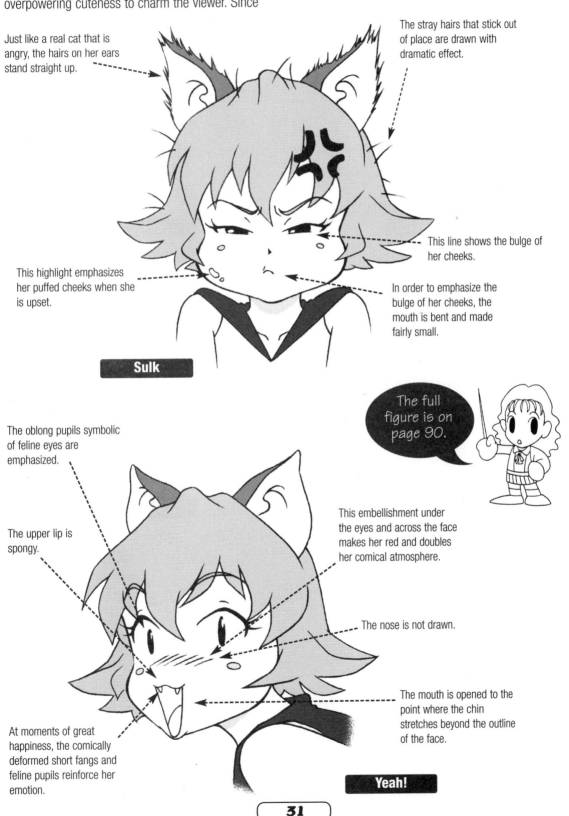

Just like a real cat that is angry, the hairs on her ears stand straight up.

The stray hairs that stick out of place are drawn with dramatic effect.

This highlight emphasizes her puffed cheeks when she is upset.

This line shows the bulge of her cheeks.

In order to emphasize the bulge of her cheeks, the mouth is bent and made fairly small.

Sulk

The full figure is on page 90.

The oblong pupils symbolic of feline eyes are emphasized.

The upper lip is spongy.

This embellishment under the eyes and across the face makes her red and doubles her comical atmosphere.

The nose is not drawn.

At moments of great happiness, the comically deformed short fangs and feline pupils reinforce her emotion.

The mouth is opened to the point where the chin stretches beyond the outline of the face.

Yeah!

31

OVA Character (Boy)

The eyebrow goes directly up. His short temper makes his character simple and easy to understand and expresses the strength of his will.

The eyebrows are drawn in a downward curve.

The shut eyes are like bird's wings. The eyes squeezed shut are more expressive of his joy than opened eyes.

His mouth is not as wide as that of the girl. It is drawn as a straight segment.

The mouth is open and squarish. Both edges are raised sharply.

Expressionless

Joy

The rough edge of his fangs is indicative of his canine nature.

Lifted more than in "Expressionless", the up-turned eyebrow emphasizes the power of his anger.

The eyebrows slope downwards quite steeply.

The upper and lower teeth are drawn clearly as though his teeth are clenched.

Spread wide, the mouth is further opened at one end.

The build-up of tears shows his youth.

The mouth is open but small. Since he is a boy, his teeth are clenched.

Anger

Anguish

The eyebrows are level and are brought together slightly.

Folds between the eyebrows are added.

The upper eyelid is lowered and conceals the top part of the pupil. For a smug look, the pupil is distanced from the lower eyelid, making the whites of the eyes prominent.

The lower eyelid is raised in a curve, showing his tension.

The mouth is small and both the top and bottom lips are bent.

One eyebrow is raised sharply more than the other.

Opposite to the raised eyebrow, the upper lip is pulled up tight.

His fangs are clearly displayed.

Unease

Smug

Visualize the Nature of this Character Type

He is a canine boy who plays opposite the role of the cat girl. As is true of cats and dogs, these two are rivals and their opposition toward one another erupts whatever the topic may be.

Within his genus, he was born with a high status and therefore his pride is high. Wars and persecution have thinned the number of his clan, which remains a bitter fall from grace. Here, he is a character eager to revive his clan. He is envious of the cat girl and even lets loose his venomous spirit but this is part of the character's childishness, and prevents him from being despised.

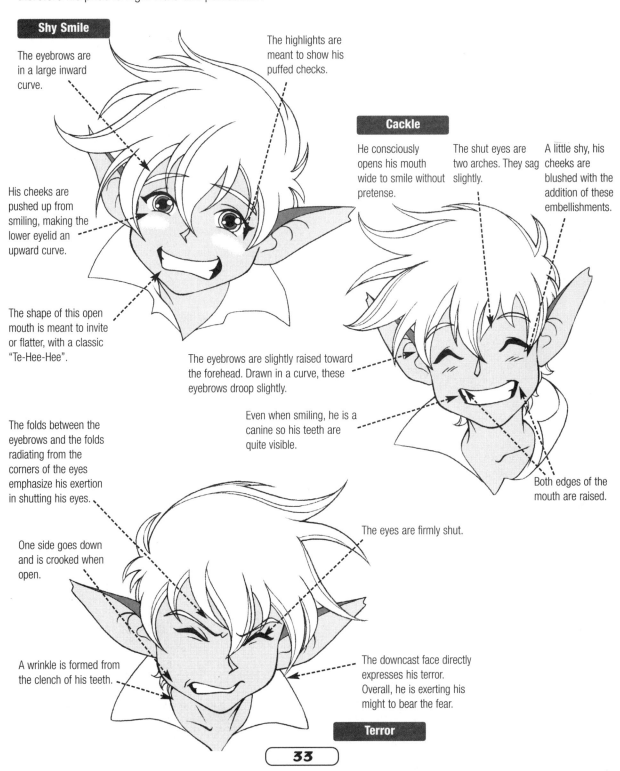

Shy Smile

The eyebrows are in a large inward curve.

The highlights are meant to show his puffed checks.

His cheeks are pushed up from smiling, making the lower eyelid an upward curve.

The shape of this open mouth is meant to invite or flatter, with a classic "Te-Hee-Hee".

Cackle

He consciously opens his mouth wide to smile without pretense.

The shut eyes are two arches. They sag slightly.

A little shy, his cheeks are blushed with the addition of these embellishments.

The eyebrows are slightly raised toward the forehead. Drawn in a curve, these eyebrows droop slightly.

Even when smiling, he is a canine so his teeth are quite visible.

Both edges of the mouth are raised.

The folds between the eyebrows and the folds radiating from the corners of the eyes emphasize his exertion in shutting his eyes.

One side goes down and is crooked when open.

The eyes are firmly shut.

A wrinkle is formed from the clench of his teeth.

The downcast face directly expresses his terror. Overall, he is exerting his might to bear the fear.

Terror

Anger

The eyes are opened to an extreme. The lower eyelid and the pupil are separated and the whites of the eye are visible.

The embellishments are for his flush of excitement.

The chin is pulled down as though he is looking up at his opponent.

He exerts strength at the corner of his eyes, this causes the eyebrow and the upper eyelid to come close and touch each other. The eyebrow is raised at about a 45-degree angle.

The open mouth is large, open and square. The magnitude of his boyish anger is emphasized by the angles of his mouth.

The canines are heavily emphasized with his anger.

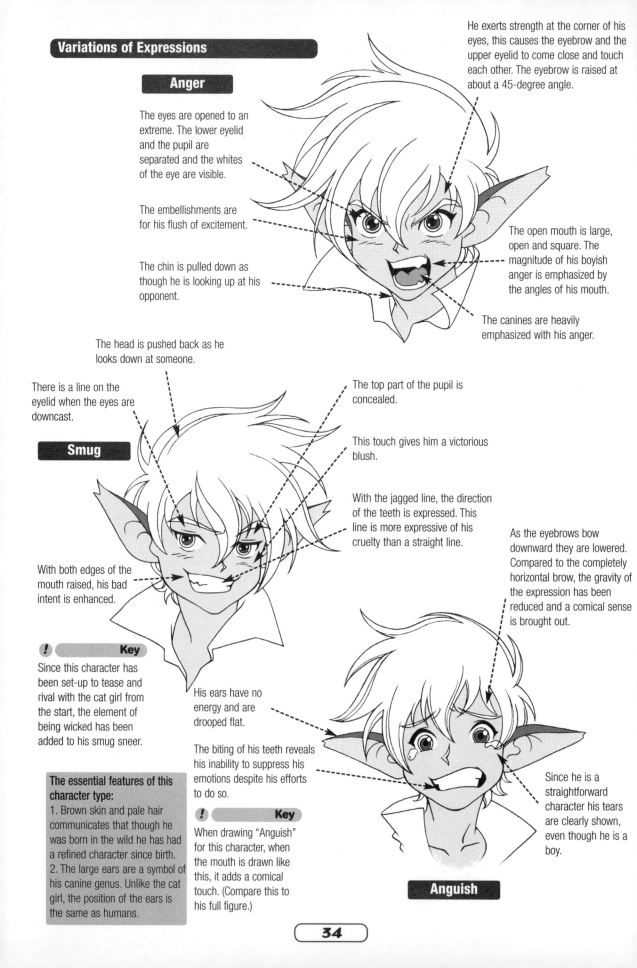

Smug

There is a line on the eyelid when the eyes are downcast.

The head is pushed back as he looks down at someone.

The top part of the pupil is concealed.

This touch gives him a victorious blush.

With the jagged line, the direction of the teeth is expressed. This line is more expressive of his cruelty than a straight line.

With both edges of the mouth raised, his bad intent is enhanced.

As the eyebrows bow downward they are lowered. Compared to the completely horizontal brow, the gravity of the expression has been reduced and a comical sense is brought out.

! Key

Since this character has been set-up to tease and rival with the cat girl from the start, the element of being wicked has been added to his smug sneer.

The essential features of this character type:
1. Brown skin and pale hair communicates that though he was born in the wild he has had a refined character since birth.
2. The large ears are a symbol of his canine genus. Unlike the cat girl, the position of the ears is the same as humans.

His ears have no energy and are drooped flat.

The biting of his teeth reveals his inability to suppress his emotions despite his efforts to do so.

! Key

When drawing "Anguish" for this character, when the mouth is drawn like this, it adds a comical touch. (Compare this to his full figure.)

Since he is a straightforward character his tears are clearly shown, even though he is a boy.

Anguish

Rarely Seen Expressions

He has a clearly defined character. His emotions are easily understood and pure. He does not get wrapped up in being moody. Given his emotive nature, grief is not included even with the "Rarely Seen Expressions". There is a strong comical element added when he makes strange faces.

The full figure is on page 94.

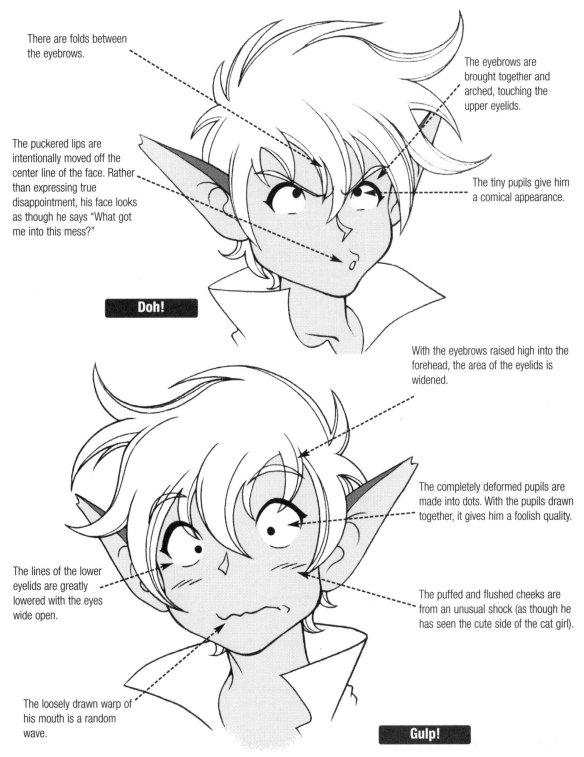

There are folds between the eyebrows.

The eyebrows are brought together and arched, touching the upper eyelids.

The puckered lips are intentionally moved off the center line of the face. Rather than expressing true disappointment, his face looks as though he says "What got me into this mess?"

The tiny pupils give him a comical appearance.

Doh!

With the eyebrows raised high into the forehead, the area of the eyelids is widened.

The completely deformed pupils are made into dots. With the pupils drawn together, it gives him a foolish quality.

The lines of the lower eyelids are greatly lowered with the eyes wide open.

The puffed and flushed cheeks are from an unusual shock (as though he has seen the cute side of the cat girl).

The loosely drawn warp of his mouth is a random wave.

Gulp!

Giant Robot Pilot (Girl)

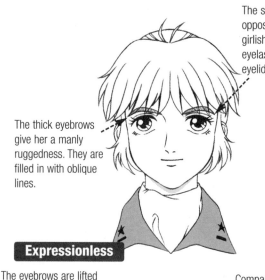

The thick eyebrows give her a manly ruggedness. They are filled in with oblique lines.

The slight sag of the eye opposite the eyebrow is girlish. Don't forget the eyelashes of the lower eyelid.

Expressionless

The eyes and the eyebrows both droop slightly. With the narrowing of the eyes, her amusement can be expressed.

Her mouth is open more than a boy's. The teeth are not drawn.

The lower eyelids are large curves that slightly conceal her black eyes.

Smile

The eyebrows are lifted dramatically.

The knitted brow produces folds.

Even though she usually has drooped eyes, when she is angered, the ends of the eyes are raised.

The mouth is opened large vertically. Compared to the boy, her mouth is rounder.

Anger

Compared to "Expressionless", the whites of her eyes are larger overall. Don't change the size of the black area!

Teardrops well up a little.

The line of her mouth is an arc.

The lower and back teeth are not shown.

The folds between the eyebrows are brought together.

The eyes and eyebrows come down. The eyes narrow so that the top and bottom portions of the black are concealed.

With this highlight of the eye concealed by the upper eyelid, her eyes look downcast.

Anguish

Effort is exerted in the upper and lower eyelids, expressing her unease. The upper eyelids are downward curves and the lower eyelids are upward curves.

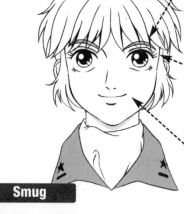

Be careful with details

There are folds between the eyebrows.

The ends of the eyes don't drop as much as in "Anguish". But they are slightly lower than in "Expressionless".

The open mouth is small, as though she is about to ask something.

Unease

The large upward curves of the eyebrows are commonly used for positive expressions.

With the upper eyelids raised the eyes are opened wide.

Both edges of the mouth are clearly raised. The mouth is larger overall than in "Expressionless".

Smug

Visualize the Nature of this Character

Unusual for a girl, this character has the qualification to ride about in a combat robot. She is also a rival, in a good sense, with the boy protagonist, her childhood friend. She takes pride in her expertise as a pilot. A manly woman, she is enraged when women are prohibited from the front-lines of battle. Her character is light but she is self-assertive and with the boy protagonist she is doting to the point of being meddlesome. She doesn't realize it herself, but she is in fact quite charmed by the protagonist.

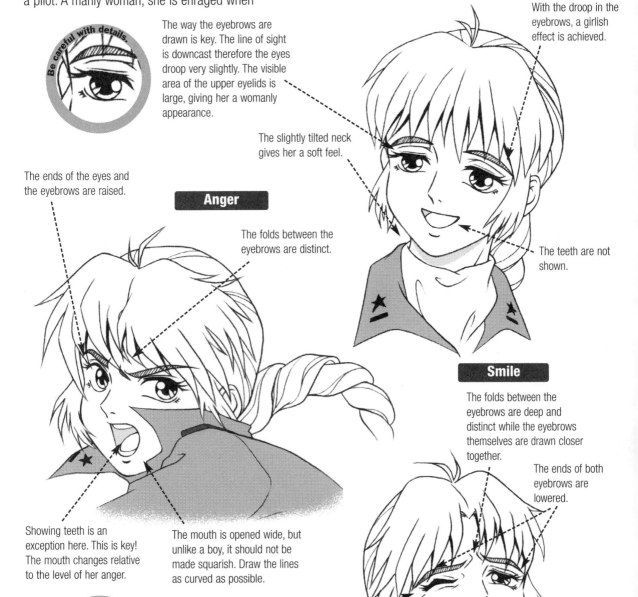

Be careful with details.

The way the eyebrows are drawn is key. The line of sight is downcast therefore the eyes droop very slightly. The visible area of the upper eyelids is large, giving her a womanly appearance.

With the droop in the eyebrows, a girlish effect is achieved.

The slightly tilted neck gives her a soft feel.

The ends of the eyes and the eyebrows are raised.

Anger

The folds between the eyebrows are distinct.

The teeth are not shown.

Smile

The folds between the eyebrows are deep and distinct while the eyebrows themselves are drawn closer together.

The ends of both eyebrows are lowered.

Showing teeth is an exception here. This is key! The mouth changes relative to the level of her anger.

The mouth is opened wide, but unlike a boy, it should not be made squarish. Draw the lines as curved as possible.

Be careful with details.

One eye is shut tight, producing radiating wrinkles.

For the goal of rendering unease, the entire face is slanted with the emotion "I don't want to turn my face away but I can't help it."

The exertion of effort makes the mouth a single bent line. The line of the lower lip is added to show her jaw clenched.

Unease

These embellishments show her blushing cheeks.

The same as in "Pride," the mouth is raised, showing the pride in her heart. Paired with the drooped eyes, this mouth is key to expressing her shyness.

Shy Smile

The space between the eyebrows is wider than that of "Unease." Be careful not to bring them too far apart.

The eyes are downcast.

With only the edges of the mouth brought down, her anguish and attempt to hold back her tears is expressed with these sealed lips.

Anguish

Only one eyebrow is frowned. Paired with the mouth, this shows a severe emotion.

This is key! The tearing face of a girl, particularly strong-willed girls, is the highlight of a scene. It is highly effective for heightened emotions. An absolutely necessary element is that the tears are always drawn beautifully.

A bad example.

Be careful with details.

One eyebrow is raised largely in a curve toward the forehead. It shows her innermost smugness.

The essential features of this character type:
1. The length of hair is long but as a combat robot pilot, the hair is bundled at the back, giving her a boyish feel.
2. Generally, she does not wear accessories. The military uniform with her rank on the shoulder is an essential element.

Having confidence, the mouth is sharply raised and sealed.

Smug

38

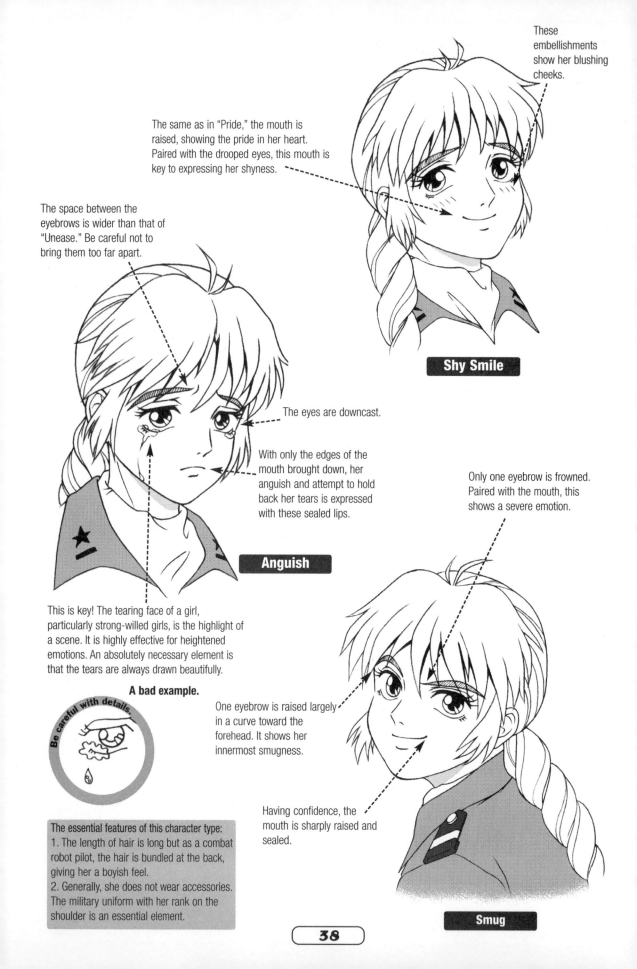

Rarely Seen Expressions

The eyes and the eyebrows are separated, giving her the impression of having her eyes wide open. Don't forget the lines of the eyelids.

The body language of the full form is on page 98.

The hair is drawn as simple tufts. The disheveled hair makes her surprised and flustered and gives her a large change in expression.

! Key

Simple deformations are very important. Giving the hair a real disheveled look will make an overbearing impression.

Be careful with details.

The pupils are made smaller than in "Expressionless". They approach dots in size and have a comical feel.

The flush of her face is as though she is thinking "No way?!"

For a dumbfounded look, the mouth is drawn low (making the distance between the mouth and the nose wide).

Yikes!

The eyebrows are raised to avoid creating a contrast between the two. (Otherwise, the difference between them will make the expression resemble "Anger".) Folds are put between the eyebrows.

Don't forget this line either.

To emphasize her scowl, the lines of the eyelids are straight and cover one-third of the pupil.

The mouth is purposely twisted vertically. Drawn in a downward direction, it expresses her sullen mood.

Hmph!

The embellishments are added to make her cheek flushed. It also evokes a subtle shyness.

Giant Robot Pilot (Boy)

The straight eyebrows show his sense of justice.

His clear and easy-to-understand character is shown with the bold and slightly raised eyes.

The mouth is shut tight.

The eyebrows and upper eyelids are a little rounder than in "Expressionless".

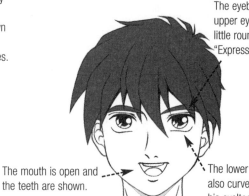

The mouth is open and the teeth are shown.

The lower eyelids are also curved, showing his exalted emotion.

Expressionless

Smile

The eyes and the upper eyelids are raised greatly.

The folds between the eyebrows are drawn with clean and fat lines.

Unlike his smiling face, the mouth is opened wide in the shape of a trapezoid.

The lift in the center of his lower lip shows his displeasure.

With the pupils of both eyes slightly drawn close, his expression becomes severe.

The folds between the eyebrows are drawn with lines thinner than when he is angry.

The ends of the eyes and the eyebrows are lowered greatly.

The back teeth are shown clearly.

The position of the pupils is as in "Expressionless" and only the eyelids hang.

The ends of the mouth come down sharply. The upward curve of the lower lip expresses the extent of his anguish.

Anger

Anguish

The folds between eyebrows are like the two sides of a mountain.

The ends of the eyes and the eyebrows are slightly lower than in "Expressionless".

The mouth is open a crack.

The edges of the lower eyelids are upward curves, giving the eyes a grimacing feel.

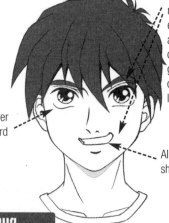

As when he is laughing, the lower eyelids are upward curves.

Simultaneously raising the right eyebrow as well as the right side of the mouth gives him a contemptuous look.

All the teeth are shown.

Unease

Smug

Visualize the Nature of this Character

He had wanted to become a giant combat robot pilot ever since he was small. He is a spirited boy. His skill as a pilot is outstanding but he also makes some hot-blooded moves. This character is often introduced to the story as one who holds no reservations about battle; he even enjoys it. However, he gradually begins to question the meaning of battle itself as human lives are lost on both sides. He is a light-hearted character with no worries. His sense of justice is strong though he can be rash, at times. He is easily influenced by encouraging words or praise but is much loved.

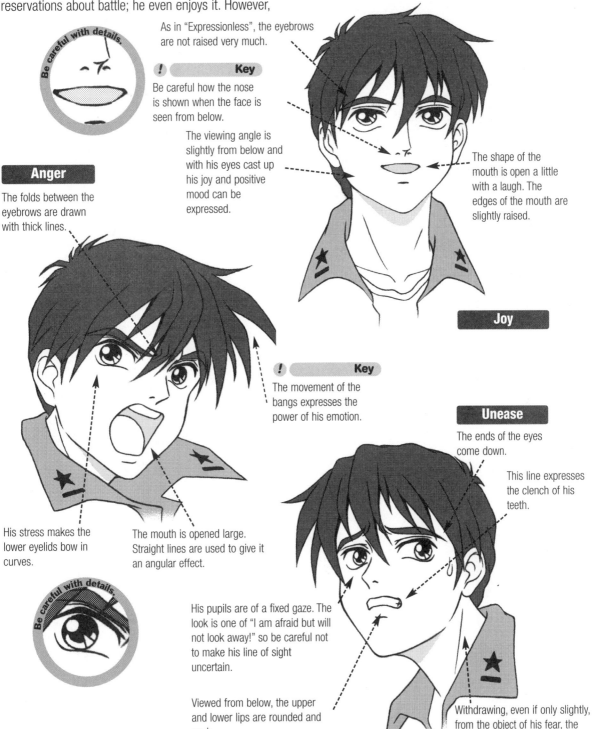

Be careful with details.

As in "Expressionless", the eyebrows are not raised very much.

! Key

Be careful how the nose is shown when the face is seen from below.

The viewing angle is slightly from below and with his eyes cast up his joy and positive mood can be expressed.

The shape of the mouth is open a little with a laugh. The edges of the mouth are slightly raised.

Joy

Anger

The folds between the eyebrows are drawn with thick lines.

! Key

The movement of the bangs expresses the power of his emotion.

His stress makes the lower eyelids bow in curves.

The mouth is opened large. Straight lines are used to give it an angular effect.

Be careful with details.

His pupils are of a fixed gaze. The look is one of "I am afraid but will not look away!" so be careful not to make his line of sight uncertain.

Viewed from below, the upper and lower lips are rounded and peak.

Unease

The ends of the eyes come down.

This line expresses the clench of his teeth.

Withdrawing, even if only slightly, from the object of his fear, the head is bent backward, making the line of the neck visible. Viewing the face from below is effective here.

The folds between the eyebrows express his agitation as he wonders what he should do.

A side-long glance with drooped eyes makes him a gentle young man.

The embellishments make his cheeks blush.

A simple smile.

Shy Smile

The large tear drops express his character.

To express downcast eyes, the bottom halves of the pupils are concealed by the lower eyelids.

With the entire head tilted a little, his childishness is expressed.

The ends of the eyes and the eyebrows are both lowered greatly.

The lower lip is distorted and is larger in width than the upper lip.

Anguish

Moving along with the eyebrow, this line shows the eyelid half shut.

The eyebrows are drawn much higher and separated from the eyes.

Be careful with details.

Be careful how the eyelids are drawn when they are slanted.

The top half of the pupil is concealed by the eyelid. So when he looks from the side, his cheeky expression is stronger.

The head is pushed back, looking down at the other person.

The essential features of this character type:
1. The most notable feature about a boy introduced in a giant robot story is his hair. Since he operates in a world of mechanics, even his hair is drawn with rigid lines and acute angles. Apart from scenes where his hair is windswept, it is not rustled.
*Even though the hairstyle here is adult, it is fine to stylize the hair, making it long or short.

Smug

Raising one side of the mouth gives him a grin.

Rarely Seen Expressions

His active nature gives him many charming aspects though he is weak to flattery and on many occasions rushes forward rashly on arbitrary decisions. Here are some rather comical expressions that show his frivolous side, the part of him weak to flattery. The difference to his cool composure is dramatic so don't give him these expression often. Use great balance when enacting them.

The body language of the full form is on page 98.

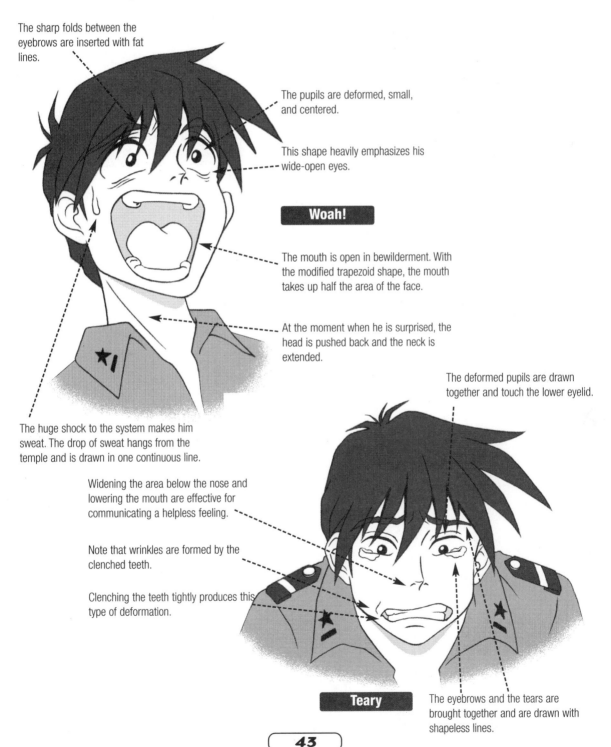

The sharp folds between the eyebrows are inserted with fat lines.

The pupils are deformed, small, and centered.

This shape heavily emphasizes his wide-open eyes.

Woah!

The mouth is open in bewilderment. With the modified trapezoid shape, the mouth takes up half the area of the face.

At the moment when he is surprised, the head is pushed back and the neck is extended.

The deformed pupils are drawn together and touch the lower eyelid.

The huge shock to the system makes him sweat. The drop of sweat hangs from the temple and is drawn in one continuous line.

Widening the area below the nose and lowering the mouth are effective for communicating a helpless feeling.

Note that wrinkles are formed by the clenched teeth.

Clenching the teeth tightly produces this type of deformation.

Teary

The eyebrows and the tears are brought together and are drawn with shapeless lines.

43

Aesthetic Character (Boy)

The eyebrows are small and thin. Keep in mind a girl's eyebrows while you draw.

The eyelid lines also express emotion.

The mouth is made smaller than the eyes. The lips are made a bit thicker.

This character has slightly drooped eyes. The pupils are almost completely shown.

Expressionless

! Key

Practice "Vibrant" expressions to distinguish his emotion since his smile tends to be more calm or sad.

About one-third from the inner corners of the eyes, the eyebrows arch, from which point they become bent curves as they drop.

The lower eyelids are slightly higher than in "Expressionless" and approach the pupils.

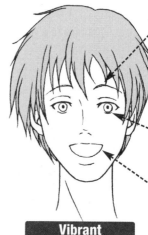

The mouth is a half-moon and is larger than the eyes. The teeth and tongue are not drawn.

Vibrant

The folds are not emphasized much.

The upper eyelid and the eyebrow touch the corner of the eye.

The mouth is a single, bent line. With the jaw clenched, the left and right edges are slightly bigger than in "Expressionless".

The ends of the eyes are raised and the upper parts of the pupils are concealed, giving him harsh-looking eyes.

To show his youth, thin eyelashes are drawn with thick lines instead of thin ones. Be careful not to lower the lines of the shut eyes too much.

Anger

The eyebrow angles down quickly. It becomes thinner toward its end.

The line of the eyelid is closer to the eye when it is closed.

The mouth is the same size as in "Expressionless" but its ends are slightly lowered.

Anguish

The upper eyelid is lowered and a quarter of the pupil is concealed.

Compared to the shape in "Anguish", the end of the eyebrow is raised subtly.

The mouth is basically the same as in "Anguish". It is shut tight, giving a sense of tension.

The lines of the eyelids fall in the center between the eyes and the eyebrows.

The lower eyelids are raised and touch the pupils.

The width of the mouth is two-thirds smaller than normal. The thickness of the lips is doubled for a sharpened feel.

Unease

Compared to "Expressionless", the eyes and the eyebrows are subtly raised. The ends and heads of the eyebrows are level.

The upper eyelids conceal about a quarter of the pupils. The lower eyelids are unchanged.

For a cheeky effect the white space is largely visibly below the pupil.

Smug

Visualize the Nature of this Character Type

With aesthetic characters the role of the "young lady" is commonly taken up by a young boy. We shall introduce here two types of character: the young boy and the young man.

The young boy secretly and whole-heartedly longs for the protagonist, the young man. When he realizes his own feelings, he becomes quite upset and tries to stomp it out, but, the more he gets to know the protagonist, he is further drawn to him.

He is delicate on the outside but as steadfast character so strong that he is just shy of showing a completely manly side to himself. He is wrapped up in the words and deeds of the protagonist, trying his best to get as close to him as possible. He is a heroic and brave young boy.

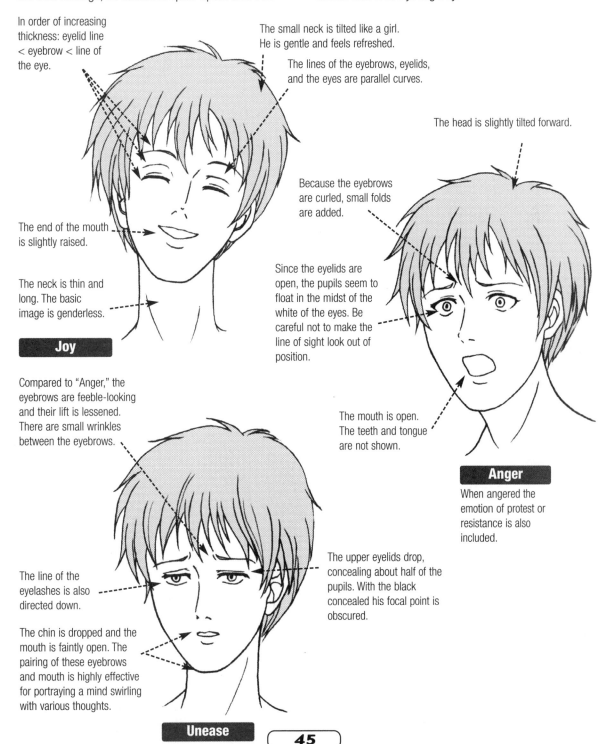

In order of increasing thickness: eyelid line < eyebrow < line of the eye.

The small neck is tilted like a girl. He is gentle and feels refreshed.

The lines of the eyebrows, eyelids, and the eyes are parallel curves.

The head is slightly tilted forward.

The end of the mouth is slightly raised.

Because the eyebrows are curled, small folds are added.

The neck is thin and long. The basic image is genderless.

Joy

Since the eyelids are open, the pupils seem to float in the midst of the white of the eyes. Be careful not to make the line of sight look out of position.

Compared to "Anger," the eyebrows are feeble-looking and their lift is lessened. There are small wrinkles between the eyebrows.

The mouth is open. The teeth and tongue are not shown.

Anger

When angered the emotion of protest or resistance is also included.

The line of the eyelashes is also directed down.

The upper eyelids drop, concealing about half of the pupils. With the black concealed his focal point is obscured.

The chin is dropped and the mouth is faintly open. The pairing of these eyebrows and mouth is highly effective for portraying a mind swirling with various thoughts.

Unease

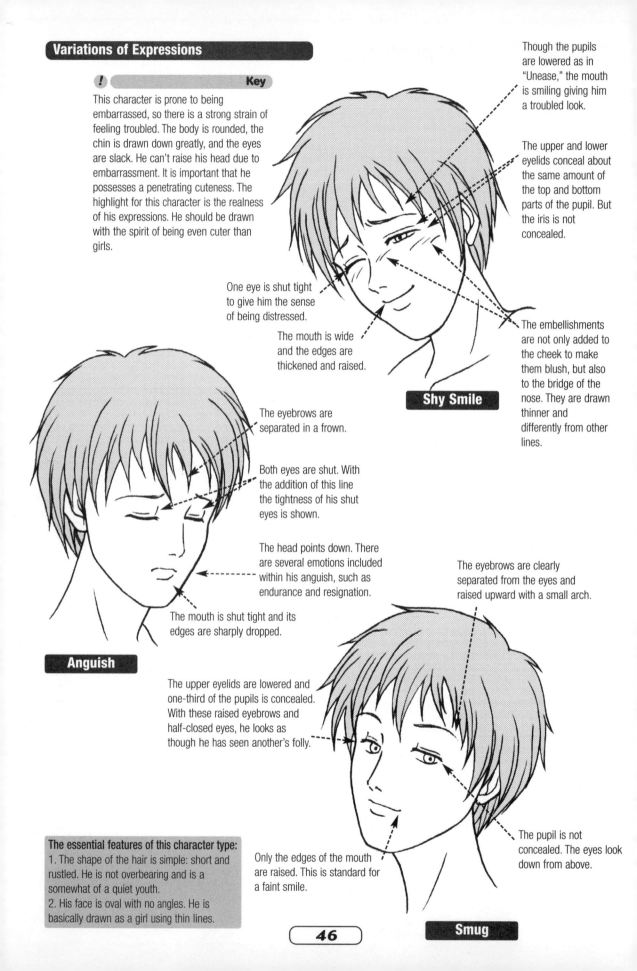

Variations of Expressions

Key

This character is prone to being embarrassed, so there is a strong strain of feeling troubled. The body is rounded, the chin is drawn down greatly, and the eyes are slack. He can't raise his head due to embarrassment. It is important that he possesses a penetrating cuteness. The highlight for this character is the realness of his expressions. He should be drawn with the spirit of being even cuter than girls.

Though the pupils are lowered as in "Unease," the mouth is smiling giving him a troubled look.

The upper and lower eyelids conceal about the same amount of the top and bottom parts of the pupil. But the iris is not concealed.

One eye is shut tight to give him the sense of being distressed.

The mouth is wide and the edges are thickened and raised.

The embellishments are not only added to the cheek to make them blush, but also to the bridge of the nose. They are drawn thinner and differently from other lines.

Shy Smile

The eyebrows are separated in a frown.

Both eyes are shut. With the addition of this line the tightness of his shut eyes is shown.

The head points down. There are several emotions included within his anguish, such as endurance and resignation.

The mouth is shut tight and its edges are sharply dropped.

Anguish

The eyebrows are clearly separated from the eyes and raised upward with a small arch.

The upper eyelids are lowered and one-third of the pupils is concealed. With these raised eyebrows and half-closed eyes, he looks as though he has seen another's folly.

The pupil is not concealed. The eyes look down from above.

The essential features of this character type:
1. The shape of the hair is simple: short and rustled. He is not overbearing and is a somewhat of a quiet youth.
2. His face is oval with no angles. He is basically drawn as a girl using thin lines.

Only the edges of the mouth are raised. This is standard for a faint smile.

Smug

Rarely Seen Expressions

Compared to the principal character (the young man), the viewer quickly has affinity for him. He has a quiet, reserved look as well as personality. He doesn't have extremes of emotion and remains cool and disinterested, intentionally not revealing his inner self. Therefore, in unexpected situations, certain aspects of himself are revealed much to his regret; these are the expressions seen here. As with his shyness, his cuteness should be kept in mind when drawing.

Shock!

He is completely surprised and caught off guard. The mouth and eyes are open and the face points up. He has been pulled out of his shell and revealed himself.

The eyelash line points up.

The mouth is open and the chin is raised.

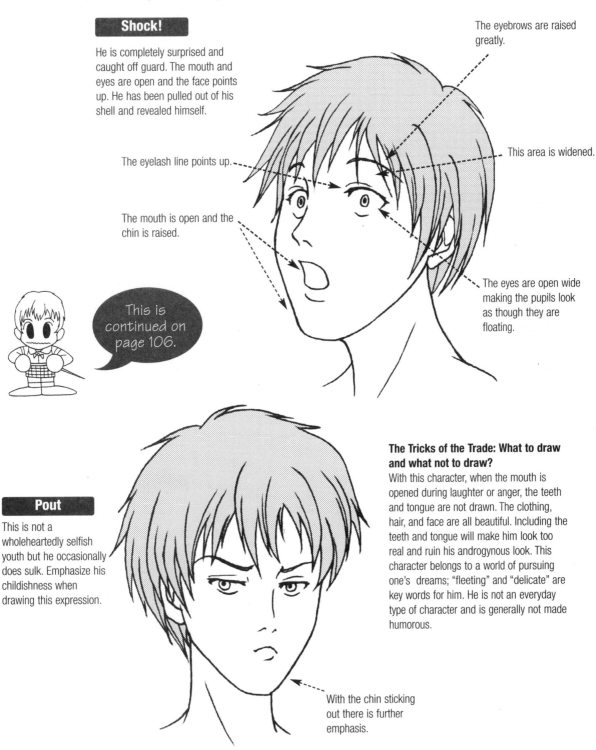

This is continued on page 106.

The eyebrows are raised greatly.

This area is widened.

The eyes are open wide making the pupils look as though they are floating.

Pout

This is not a wholeheartedly selfish youth but he occasionally does sulk. Emphasize his childishness when drawing this expression.

The Tricks of the Trade: What to draw and what not to draw?
With this character, when the mouth is opened during laughter or anger, the teeth and tongue are not drawn. The clothing, hair, and face are all beautiful. Including the teeth and tongue will make him look too real and ruin his androgynous look. This character belongs to a world of pursuing one's dreams; "fleeting" and "delicate" are key words for him. He is not an everyday type of character and is generally not made humorous.

With the chin sticking out there is further emphasis.

Aesthetic Character (Young Man)

The lines of the eyes are distinct and thickly outlined. The ends of the eyes are lifted higher than the corners of the eyes, giving him a severe character.

The edges of the mouth are generally lower than the center.

With this line, the bridge of the nose is high and the character has a strong profile.

The squarish chin drawn with straight lines shows the strength of his will.

Expressionless

The ends and the corners of the eyes are level with each other.

The lines of the eyebrows are bent more than in "Expressionless" but are not lowered.

The upper lip is drawn with a horizontal line and the lower lip with a curved line. The edges are raised slightly.

The positive expression is more cheerfulness than laughter.

Cheerful

The eyebrow is lifted at a 45-degree angle.

The folds between the eyebrows and below the eyes are key for effectively rendering a feeling of excitement.

Without changing its width, the mouth is opened large vertically. The center of the upper lip sinks and the center of the bottom lip raises, making the mouth uneven.

Anger

The size of the eye is determined by the line of the eyelash inserted between the end and the corner of the eye. However, the line is made thin and not too showy.

The space between the eyebrows is slightly reduced and wrinkles of bent segments are drawn.

A wrinkle is drawn on both sides.

The edge of the mouth is lower than in "Expressionless".

Anguish

The ends of the eyebrows are lower than in "Expressionless" but do not sink lower past horizontal.

The upper eyelids are lowered and the pupils are half concealed (but not the iris). The lower eyelids are raised, touching the pupils.

Unease

The bases of the eyebrows just barely produce vertical folds.

The upper eyelid conceals half of the pupil and about one-fourth of the iris.

The edge of the mouth is lower than in "Expressionless" and looks like bird's wings.

It is greatly wider than in "Expressionless". Both edges are clearly raised.

The eyebrow is the same shape as in "cheerful".

The area of the eyelid is widened while inserting this line makes the eye looks as though it has been consciously half-closed.

Arrogance

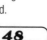

Visualize the Nature of this Character

He comes from a wealthy home thus was never materially deprived. Though there weren't any restrictions while he grew up, the past remains a psychological scar for him. He is scared of revealing his weakness or nature to others and will make postures to cover them up.

He is accustomed to being misunderstood by others and carries an offensive demeanor. Actually, in the bottom of his heart, he really wants to be understood by his friends but he has not yet realized this himself. His actions are flamboyant and he comes off as an aggressive and conspicuous type. He puts people to the test with his sharp jokes and warped sense and readily says what is on his mind.

The eyebrows are drawn as curved lines.

The upper eyelids are raised and the irises are completely visible.

The eyebrows are raised 45 degrees or more. The ends of the eyebrows are thinned.

The vantage point is slightly from below, giving him a positive outlook.

The mouth is opened wide and is in the shape of a half-moon.

Cheerful Smile

Anger

He is drawn with a sharp glare when taking on another person head-on.

The pupil is pushed up and the top part of the iris is concealed. The ends of the eyes are sharply raised, giving him a severe stare.

The eyebrows are close to straight lines, with their ends lowered and bases distorted and raised.

To make the eye droop, the lower part of the pupil is concealed by the line of the eyelid.

The mouth's edge is sharply lowered and it is widened.

Unease

49

Surprise

Since shy smiling is rarely seen this character, in order to enter it into the category of "Rarely Seen Expressions" we introduce "Surprise" here.

With the eyes wide open, the pupil seems to float in the middle of the white. It is effective to draw the pupil smaller than in "Expressionless".

The eyebrows are raised high as with "Anger" as they dart up. Take note of how the eyebrows become quite distant from the eyes.

The upper lip is a curve and the bottom lip is a straight line. This gives him a "Huh!" expression with the mouth opened.

The eyebrows slant up but not as much as in "Anger."

The vertical folds between the eyebrows show his suffering.

The teeth are clenched. Drawing the teeth is exceptional with this type of character.

The addition of the beading sweat is an effective touch.

Anguish

This character hates to show expressions of "Anguish" and other emotions where he feels himself to be weak. For this reason, "Anguish" has a flustered element added to it.

The folds between the eyebrows show his disapproval of the other person.

He doesn't take the other person too seriously, emphasizing his egoism. His line of sight looking down on another from above is the most effective element for this expression.

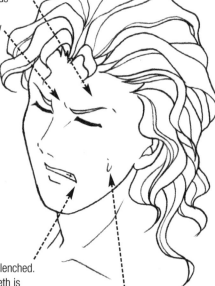

The essential features of this character type:
1. To bring out the appearance of someone who has never experienced poverty, the hair is treated flamboyantly, thereby giving him a gorgeous looking appeal.
2. To make a sharp contrast with other characters, this young boy character is drawn with an adult sensibility. The eyes are in a fairly high position on the face.

The eyebrows are the same shape as in "Expressionless" and are subtly raised.

Don't forget the line of the eyelid.

The upper and lower lines of the eyelids are brought together, concealing the top and bottom on the pupil. The pupil is not concealed. His side-long glance increases this cheekiness.

Arrogant

Rarely Seen Expressions

This character is always striking a pose. In one way, he protects himself by assuming poses. At times, this character also reveals a gentle side to himself; this expression is included here, as it is rarely seen. These expressions are proof that he is not on guard with the other person. It further creates a gap between him and how he tries to portray himself. This comes in as a refreshing surprise and adds to his charm.

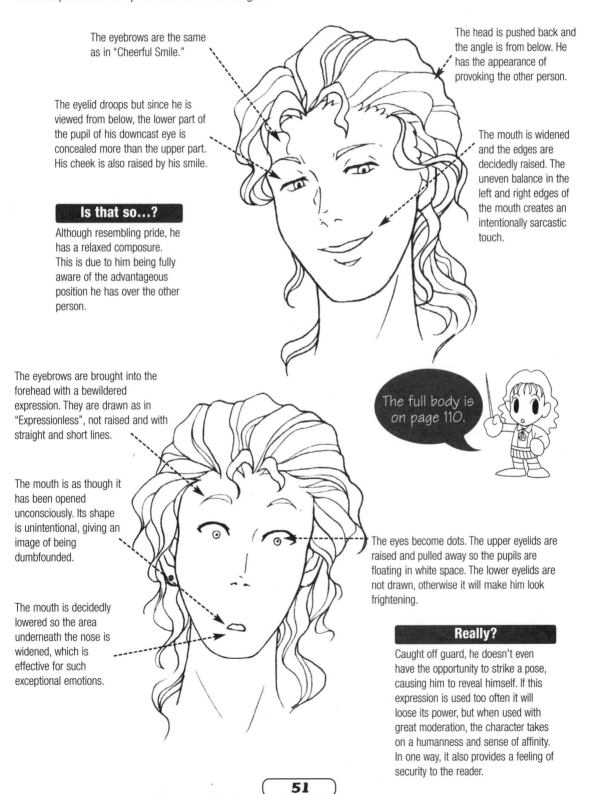

The eyebrows are the same as in "Cheerful Smile."

The eyelid droops but since he is viewed from below, the lower part of the pupil of his downcast eye is concealed more than the upper part. His cheek is also raised by his smile.

The head is pushed back and the angle is from below. He has the appearance of provoking the other person.

The mouth is widened and the edges are decidedly raised. The uneven balance in the left and right edges of the mouth creates an intentionally sarcastic touch.

Is that so...?

Although resembling pride, he has a relaxed composure. This is due to him being fully aware of the advantageous position he has over the other person.

The eyebrows are brought into the forehead with a bewildered expression. They are drawn as in "Expressionless", not raised and with straight and short lines.

The mouth is as though it has been opened unconsciously. Its shape is unintentional, giving an image of being dumbfounded.

The mouth is decidedly lowered so the area underneath the nose is widened, which is effective for such exceptional emotions.

The eyes become dots. The upper eyelids are raised and pulled away so the pupils are floating in white space. The lower eyelids are not drawn, otherwise it will make him look frightening.

The full body is on page 110.

Really?

Caught off guard, he doesn't even have the opportunity to strike a pose, causing him to reveal himself. If this expression is used too often it will loose its power, but when used with great moderation, the character takes on a humanness and sense of affinity. In one way, it also provides a feeling of security to the reader.

Detective Story Character (Girl)

The features are deep-set so the eyebrows and the corners of the eyes are close together.

The proportion of the pupil is large.

The quality of this character is gentle so the eyes are large and slightly drooped to give her a kind-hearted feeling.

Making the lips too narrow will give her a cold quality.

Expressionless

The eyebrows are gentle curves.

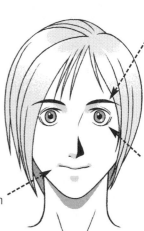

The eyes are spread vertically and the pupils are entirely visible.

The mouth is wider than in "Expressionless" and its edges are clearly raised.

Cheerful

The eyebrows are arched from about a quarter from the corners of the eyes.

Small folds are inserted between the eyebrows.

The width of the mouth is narrowed and both edges are sharply lowered.

Anger

The eyebrows are more sternly brought together than in "Unease."

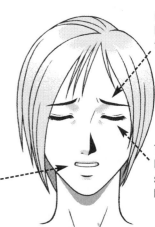

The width of the mouth is narrow and the mouth is slightly opened.

The eyes are shut. Emphasizing that she is trying to hold back emotions.

Anguish

The eyebrows gently slope down.

The upper eyelids hang down and conceal one part of the pupils.

The mouth is a straight line and its edges are dropped.

The eyelashes point down.

Unease

The eyes are closed as they peak in the shape of bent segments.

The mouth is opened clearly and both edges are raised.

The ends of the eyes are lowered slightly.

Smile

Visualize the Nature of this Character

She is saved from trouble by the leading male character, from which point they act together. She behaves as though she is his partner, attempts to be of help, and has a strong will to take action, but in a time of crisis her lack of experience puts her in a further bind. She always has power but she is too soft. As in the story, she realizes her shortcomings and develops as a character when she falls into a dilemma. She has guts and is serious. Even though she has strength of character and can make her way for herself, she, in fact, has a very womanly side too.

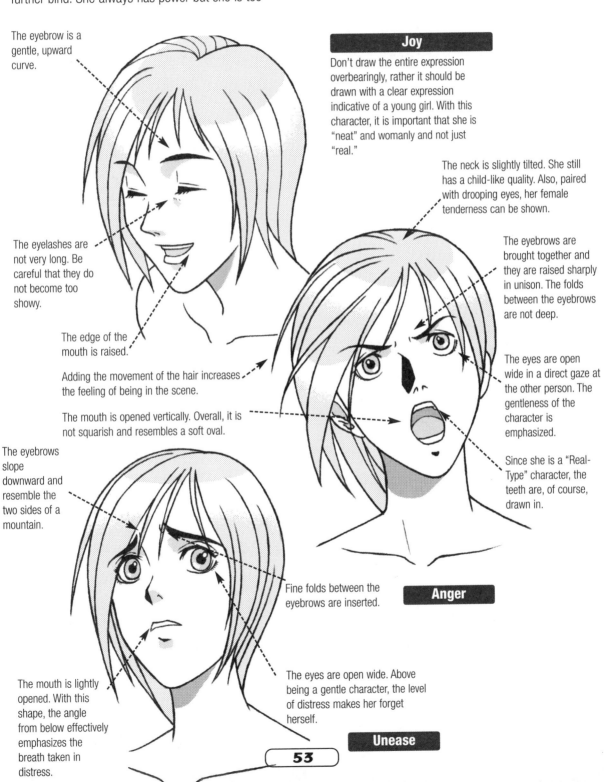

The eyebrow is a gentle, upward curve.

Joy

Don't draw the entire expression overbearingly, rather it should be drawn with a clear expression indicative of a young girl. With this character, it is important that she is "neat" and womanly and not just "real."

The eyelashes are not very long. Be careful that they do not become too showy.

The edge of the mouth is raised.

Adding the movement of the hair increases the feeling of being in the scene.

The mouth is opened vertically. Overall, it is not squarish and resembles a soft oval.

The neck is slightly tilted. She still has a child-like quality. Also, paired with drooping eyes, her female tenderness can be shown.

The eyebrows are brought together and they are raised sharply in unison. The folds between the eyebrows are not deep.

The eyes are open wide in a direct gaze at the other person. The gentleness of the character is emphasized.

Since she is a "Real-Type" character, the teeth are, of course, drawn in.

The eyebrows slope downward and resemble the two sides of a mountain.

Fine folds between the eyebrows are inserted.

Anger

The mouth is lightly opened. With this shape, the angle from below effectively emphasizes the breath taken in distress.

The eyes are open wide. Above being a gentle character, the level of distress makes her forget herself.

Unease

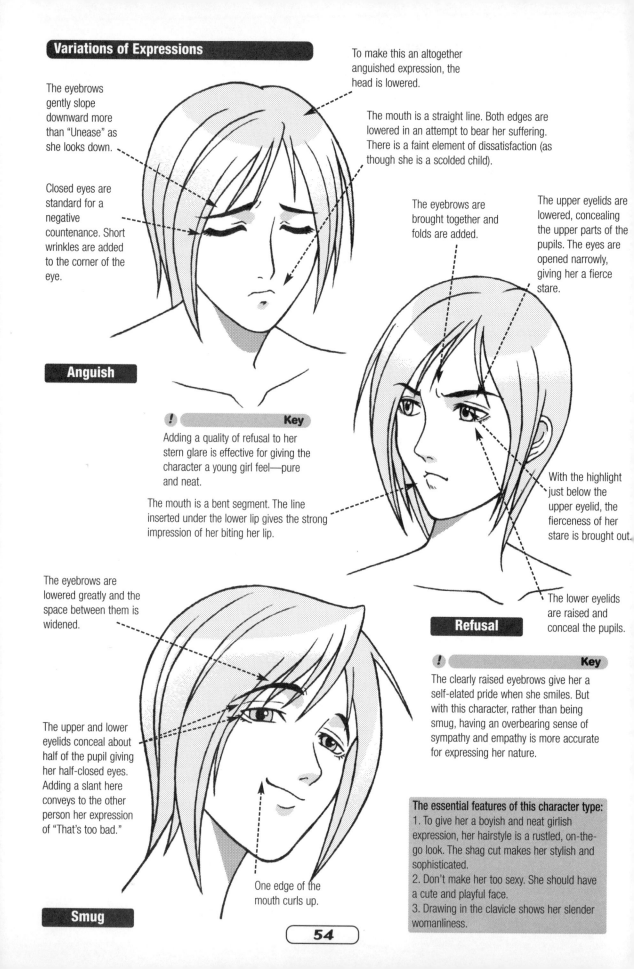

Variations of Expressions

To make this an altogether anguished expression, the head is lowered.

The eyebrows gently slope downward more than "Unease" as she looks down.

Closed eyes are standard for a negative countenance. Short wrinkles are added to the corner of the eye.

The mouth is a straight line. Both edges are lowered in an attempt to bear her suffering. There is a faint element of dissatisfaction (as though she is a scolded child).

The eyebrows are brought together and folds are added.

The upper eyelids are lowered, concealing the upper parts of the pupils. The eyes are opened narrowly, giving her a fierce stare.

Anguish

! Key

Adding a quality of refusal to her stern glare is effective for giving the character a young girl feel—pure and neat.

The mouth is a bent segment. The line inserted under the lower lip gives the strong impression of her biting her lip.

With the highlight just below the upper eyelid, the fierceness of her stare is brought out.

The lower eyelids are raised and conceal the pupils.

Refusal

! Key

The clearly raised eyebrows give her a self-elated pride when she smiles. But with this character, rather than being smug, having an overbearing sense of sympathy and empathy is more accurate for expressing her nature.

The eyebrows are lowered greatly and the space between them is widened.

The upper and lower eyelids conceal about half of the pupil giving her half-closed eyes. Adding a slant here conveys to the other person her expression of "That's too bad."

One edge of the mouth curls up.

Smug

The essential features of this character type:
1. To give her a boyish and neat girlish expression, her hairstyle is a rustled, on-the-go look. The shag cut makes her stylish and sophisticated.
2. Don't make her too sexy. She should have a cute and playful face.
3. Drawing in the clavicle shows her slender womanliness.

Rarely Seen Expressions

This character does not want to appear weak, so she always straightens her back and says to herself "I'm just fine on my own!" Coming undone just at the moment when she has put on an air of being cool and collected only adds to her cuteness. Showing this unseasoned and childish part of her draws close to the true nature of this character.

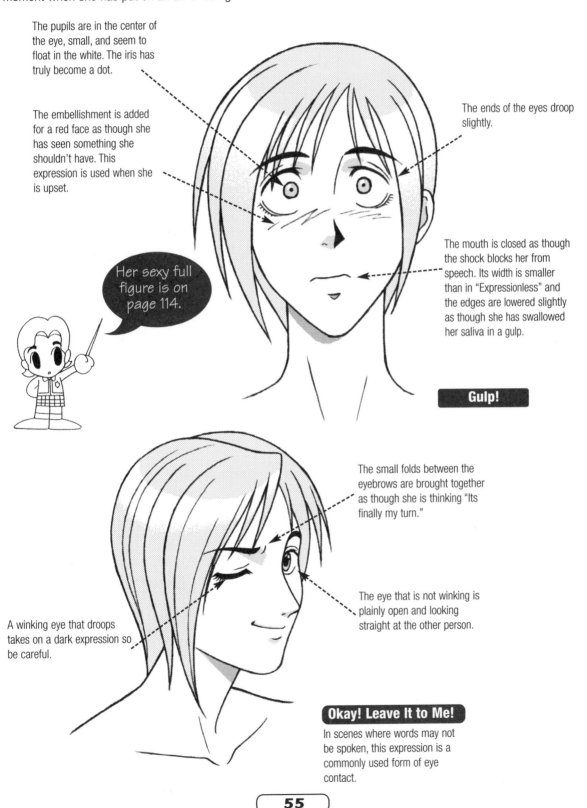

The pupils are in the center of the eye, small, and seem to float in the white. The iris has truly become a dot.

The embellishment is added for a red face as though she has seen something she shouldn't have. This expression is used when she is upset.

The ends of the eyes droop slightly.

Her sexy full figure is on page 114.

The mouth is closed as though the shock blocks her from speech. Its width is smaller than in "Expressionless" and the edges are lowered slightly as though she has swallowed her saliva in a gulp.

Gulp!

The small folds between the eyebrows are brought together as though she is thinking "Its finally my turn."

The eye that is not winking is plainly open and looking straight at the other person.

A winking eye that droops takes on a dark expression so be careful.

Okay! Leave It to Me!

In scenes where words may not be spoken, this expression is a commonly used form of eye contact.

Detective Story Character (Young Man)

Even in "Expressionless", there are deep-set folds between the eyebrows.

He has trained his body so his neck is thick. The eyebrow and eye are drooped together. It represents warmth, not only his toughness.

Wrinkles at the ends of the eyes are effective for making look as though he has a friendly smile.

The nose is rugged and powerful, showing his strong will.

Expressionless

The eyebrows are clearly lowered more than in "Expressionless". He seems relaxed and warm-hearted.

The moustache is a symbol of his adult manliness.

The mouth is a wide, straight line. It is not level but slightly raised on one side, giving him a rough, manly countenance.

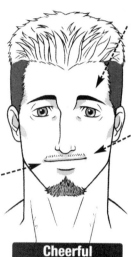

Cheerful

The corners of the eyes and the bases of the eyebrows are connected and from that point the eyebrows rise fiercely.

The teeth are drawn in, showing the extent of his emotion.

The ends of the eyes are subtly lifted more than in "Expressionless".

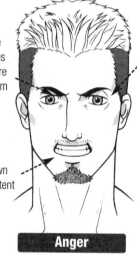

Anger

The eyebrows undulate as they lower, giving him an upset expression.

The pupils are off to one side as though his mind is disjointed from his body.

The mouth is opened thinly. The edge is lowered, making the mouth tremble.

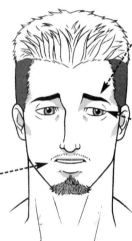

Anguish

The folds here show his eyes shut tight.

To make the eyes shut tight, these lines are drawn thick.

One edge is slightly open and the mouth looks as though the back teeth are grinding together.

The end of one eyebrow is not raised to the extent as in "Anger" but is lifted while the space between the eyebrows is narrowed.

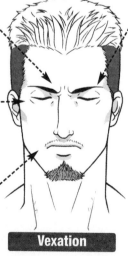

Vexation

The eyebrow is brought toward the forehead in a gentle curve. The space between the eyebrows is widened.

With the eyebrows raised, the area of the eyelids is widened.

The mouth is widened and its edge is slightly raised.

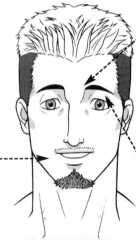

Smile

Visualize the Nature of this Character

He has the typical manliness of a detective story character, strong and tough, but he also is a little of a comedian. He looks hard to deal with but he, in fact, is a good -natured person and can be moved to tears. He also gets thoroughly deceived by beautiful, but evil women. When he is together with the detective story woman, they have a comic rapport. He is a feminist, takes pity on those weaker than himself, and is open-minded. His actions overflow with vitality, making him a very active character.

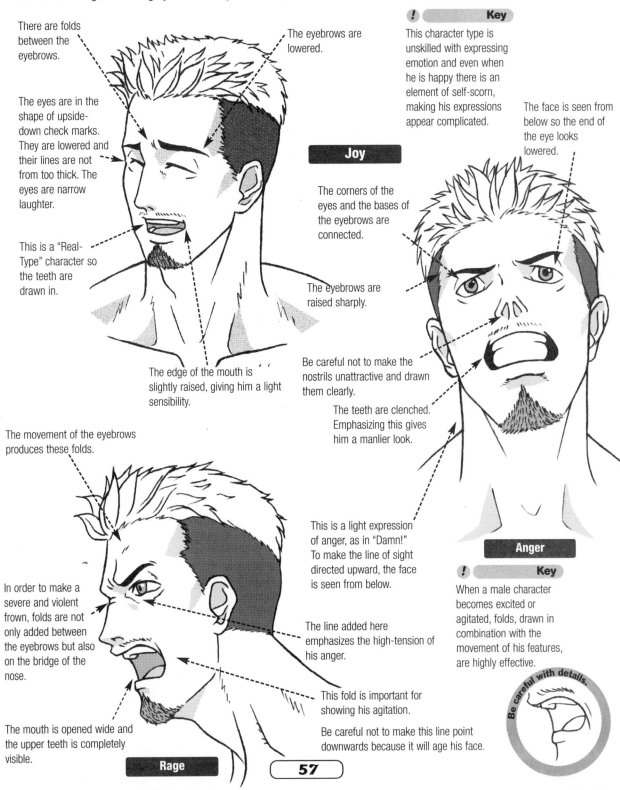

There are folds between the eyebrows.

The eyes are in the shape of upside-down check marks. They are lowered and their lines are not from too thick. The eyes are narrow laughter.

This is a "Real-Type" character so the teeth are drawn in.

The edge of the mouth is slightly raised, giving him a light sensibility.

The eyebrows are lowered.

Key

This character type is unskilled with expressing emotion and even when he is happy there is an element of self-scorn, making his expressions appear complicated.

The face is seen from below so the end of the eye looks lowered.

Joy

The corners of the eyes and the bases of the eyebrows are connected.

The eyebrows are raised sharply.

Be careful not to make the nostrils unattractive and drawn them clearly.

The teeth are clenched. Emphasizing this gives him a manlier look.

The movement of the eyebrows produces these folds.

In order to make a severe and violent frown, folds are not only added between the eyebrows but also on the bridge of the nose.

The mouth is opened wide and the upper teeth is completely visible.

This is a light expression of anger, as in "Damn!" To make the line of sight directed upward, the face is seen from below.

The line added here emphasizes the high-tension of his anger.

This fold is important for showing his agitation.

Be careful not to make this line point downwards because it will age his face.

Anger

Key

When a male character becomes excited or agitated, folds, drawn in combination with the movement of his features, are highly effective.

Be careful with details.

Rage

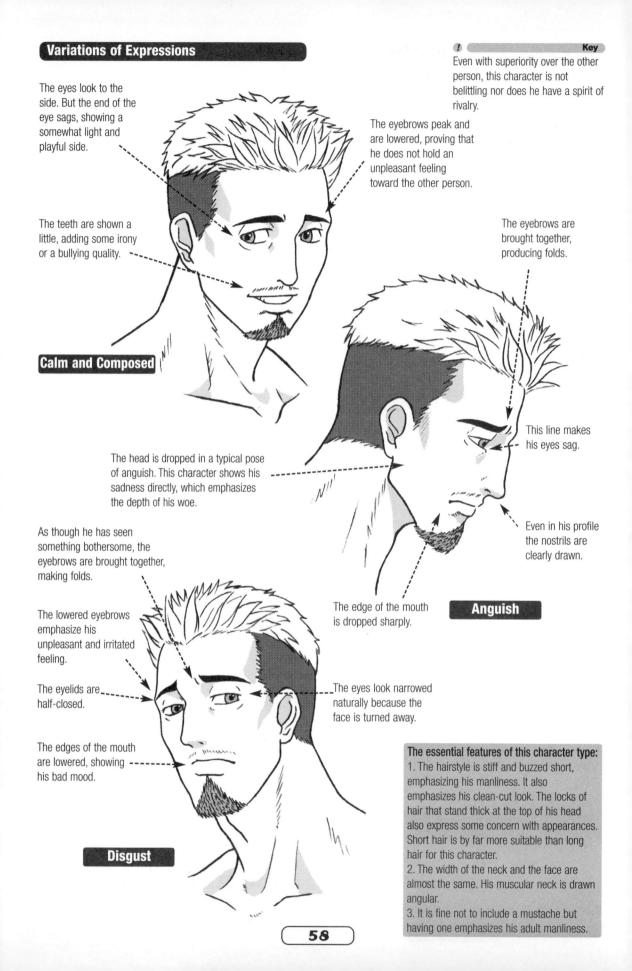

Variations of Expressions

Key

Even with superiority over the other person, this character is not belittling nor does he have a spirit of rivalry.

The eyes look to the side. But the end of the eye sags, showing a somewhat light and playful side.

The eyebrows peak and are lowered, proving that he does not hold an unpleasant feeling toward the other person.

The teeth are shown a little, adding some irony or a bullying quality.

The eyebrows are brought together, producing folds.

Calm and Composed

The head is dropped in a typical pose of anguish. This character shows his sadness directly, which emphasizes the depth of his woe.

This line makes his eyes sag.

As though he has seen something bothersome, the eyebrows are brought together, making folds.

Even in his profile the nostrils are clearly drawn.

The lowered eyebrows emphasize his unpleasant and irritated feeling.

The edge of the mouth is dropped sharply.

Anguish

The eyelids are half-closed.

The eyes look narrowed naturally because the face is turned away.

The edges of the mouth are lowered, showing his bad mood.

Disgust

The essential features of this character type:
1. The hairstyle is stiff and buzzed short, emphasizing his manliness. It also emphasizes his clean-cut look. The locks of hair that stand thick at the top of his head also express some concern with appearances. Short hair is by far more suitable than long hair for this character.
2. The width of the neck and the face are almost the same. His muscular neck is drawn angular.
3. It is fine not to include a mustache but having one emphasizes his adult manliness.

As a man in a detective story, he obstinately sticks to his principles and value-system and hates to have his opinions stepped upon. In so doing, he puts up with whatever harm, physical or mental. He mostly endures attacks on his pride. But this very same person will also express a humorous, gentle side though only when he is in the company of friends with whom he can let his guard down. The expressions here show these emotions.

Relax!

The space between the eyebrows is spread for a feigned innocent look.

The eyes are spread wide and the whites of the eyes are shown above the pupils.

The eyebrows are directed toward the forehead in a curve.

The curved line of the mouth is like that of a caricature. The moustache follows this and also curves upward, giving him a comical expression.

His full macho figure is on page 118.

The neck is cocked to one side. The eyebrows lowered in conjunction with the cocked head give him a slightly forced image.

The eyes are as though he is looking up diagonally.

The mouth is puckered on purpose to create a playful atmosphere.

He is not a bully even though he deceives intentionally the other person in this scene. He is interacting with a close friend so this expression has a playful nature though he is making a false show of power.

Wha?! I didn't know that. . .

Student Character (Girl)

The eyebrows are slightly hill-like. Her face will look boyish if extended.

The line of the nose is not drawn.

The width of the mouth is slightly larger than the space between the eyebrows.

Expressionless

The eyes match the hill shape of the eyebrows. The upper and lower eyelids are clearly shut, emphasizing her distinct character.

The eyebrows are clearly made into hills more so than in "Expressionless".

The mouth is opened wide with its edges raised. It is in the shape of an upside-down triangle.

Joy

The folds between the eyebrows are doubled.

The level of her anger can be adjusted with the arch of the eyebrows. The eyebrow nearly touches the eye, emphasizing the arch.

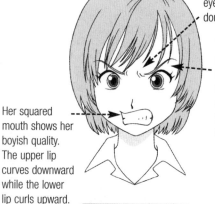

Her squared mouth shows her boyish quality. The upper lip curves downward while the lower lip curls upward.

Anger

The level of her anguish is adjusted by lowering the eyebrow. Here, it is lowered more than in "Terror."

As she bears her sadness in her smile, both edges of the mouth are raised.

The lower eyelid is drawn in a curve to express that she is trying to endure sadness and smile.

Anguish

The eyebrows are nearly level and their ends are lowered.

The space between the eyebrows is narrowed.

The mouth is a small and vertical oval as if she has taken in a sharp breath.

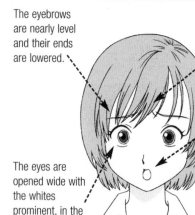

The eyes are opened wide with the whites prominent, in the middle of which the pupils float.

Terror

The eyebrows are highly curved and brought toward the center of the forehead. The area of the eyelid is widened.

Deforming the mouth and adding these lines give the character a naughty quality.

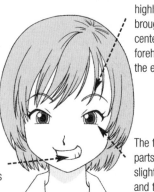

The top and bottom parts of the pupil are slightly concealed and the line of the eyelid is raised. This is a "lifted and narrowed eye."

Smug

Visualize the Nature of this Character

This character is the childhood friend of the protagonist boy. They share recollections of their time together as children. At one point the boy changes schools and the two are forced to separate but they are reunited in high school.

Her attitude is clear, strong, and even boyish, though she has an open-hearted character and is popular among her girlfriends. She is also a good student and her athleticism is outstanding, making her the star of the club. But on the other hand, she is unusually pure-hearted and at times unable to be firm. She is very much a romantic girl with dreams. Establishing the places and things of her recollections with the boy is effective.

The eyelashes are clearly upturned in a curve.

When the face is turned sideways, the tip of the nose is faintly drawn out to give a sense of the roundness of the tip of her nose.

The mouth is opened wide and the lower teeth are completely visible from above so even the tops of the teeth can be seen.

Be careful with details.

The head lifted up is a sign of a positive attitude.

With the upward wink, the shut eye produces folds at the corner of the eye.

Joy

The whirl of the hair on her head is drawn to give a sense of the spherical shape. Without this, her head would seem flat.

Be careful with details.

The head is tilted forward and slightly off to one side, making her head seem cocked. Be careful not to slant the head backward as this will give her a smug countenance.

The small folds between the eyebrows give her a slightly troubled feel.

The eyes are bent in a clear, upward curve.

The angular lines of the folds here show her exertion of strength.

One continuous line would be too strong so draw the line of the teeth in fragmented segments.

Shy Smile

The edges of the mouth are clearly raised. The teeth are shown, showing her boyish quality.

The white underneath the pupil is shown, seeming to push back the lower eyelid and widen the eye.

The mouth is close to a square and opened large with the lower teeth shown. The line of the teeth is not made too sharp.

Anger

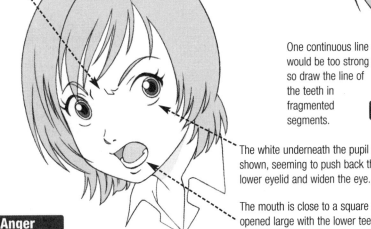

To give an uneasy expression, the eyebrows are close to level but the corner is raised while the end is lowered.

This gaze has one fixed point. The shape of the pupil and the position of the highlight are drawn exactly the same for both eyes. Be careful to avoid a daydreaming stare.

Unease + Worry

With this line added to the corner of the mouth, she has her teeth clenched.

The lower lip is not one line because its thickness produces a shadow.

The upper eyelid is a straight line concealing the top section of the pupil, giving her a drooped eye. The lower eyelid is not raised making it clear she is not consciously narrowing her eyes.

Though this is a negative emotion, she is not shut off within herself. Rather, she is confronting the other person so the angle for this expression is from below.

The eyebrow is slightly curved and lowered. There are folds between the eyebrows.

! Key

The mouth is smiling though the eyes are tearing. The small desperate smile betrays her girlish character in her attempt to conceal her suffering

Be careful with details

In an effort to hold back her tears, the teardrops just barely flow.

! Key

Rather than making her too smug, drawing this character as poking fun at the other person truly expresses her character.

The eyebrows are drawn up to the forehead and the area of the eyelid is widened.

By adjoining the upper eyelid with the curve of the pupil, the eye seems to be turned up.

The small mouth shows her desolation.

Anguish

The upper and lower lips are parallel curves. The edge is driven up.

Be careful not to draw the vertical lines between the teeth fully as it will make her look too real or make her look like a bully.

The essential features of this character type:
1. The hair is straight and she takes care to be stylish: the shaggy hairstyle flows along the side as though it was set with a hairdryer. 2. A short cut shows her boyish vigor and good humor. Though she may not be extremely beautiful, her many emotions express a charming cuteness.

Smug

She is a leader among her friends and stellar with her studies and sports. Sometimes she becomes a daydreamer and would like to soak herself in maidenhood but for some reason she is stuck to the pace of her boy classmate and winds up making some comical move. At such times the expressions seen here are shown. The expressions should be given bold and comic deformations.

This girl's full figure starts on page 122.

Only one eyebrow is raised. Unlike always, the peak of the arch is closer to the base of the eyebrow rather than its end, making this an amazed expression.

The sweat drop is caricatured and large.

The upper eyelid is drawn with a thick line, making her comical rather than severe. The slanted, straight line conceals the pupil and the area of the eyelid is widened.

The line of the eyebrow is randomly bent as it is lowered.

The eyelid is drawn fairly large descending towards the end, allowing to create a disappointed look.

On the opposite side of the raised eyebrow, the edge of the mouth is raised. This combination of mouth and eyebrow is often used when teasing someone.

The mouth drops beyond the chinline as if all strength has been lost.

! Key

This expression shows her small surprise toward the other person or something contrary to her expectation. Showing the extent of her amazement, this expression is drawn as though all her body's strength has been lost. The mouth and the eyebrows lowered.

Wha?!

Be careful with details.

The eyebrows are connected and both edges are lowered. It's drawn tangled like a string to show her utter confusion.

The highlights are like holes in a lotus root, giving a watery look to the eyes.

In order not to make the tears look real and watery, highlights are not drawn in it.

The neck is caricatured and drawn extremely thin.

The line of the mouth joins the outline of the head and it also warps, as though she is so frustrated she cannot even speak.

Be careful and caricature the body to the same extent as the face, otherwise the illustration will look very unnatural.

Puffy Eyes

Student Character (Boy)

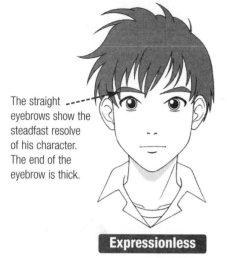

The straight eyebrows show the steadfast resolve of his character. The end of the eyebrow is thick.

The eye is drawn in a curve greater than that of the eyebrow. When expressing joy, the shut eyes express the extent of his emotion.

Overall the mouth is a trapezoid and its edge is raised. More rugged than the girl, the upper and lower teeth are drawn.

Expressionless

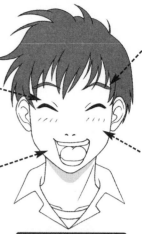

The eyebrows are drawn in a curve closer to the forehead than in "Expressionless".

The embellishment gives him a blush and demonstrates that he still has a childish quality.

Joy

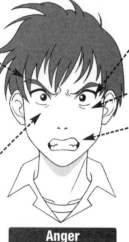

The end of the eyebrow almost stands up straight. The corner of the eye touches the eyelid.

These wrinkles are deep and like the two sides of a mountain. They are symmetric.

With raised eyes, the smallness of the pupil emphasizes the extent of his anger.

His scowl in "Anger" produces wrinkles.

The center of the upper lip curves down and the lower lip curves up. Adding the line of the teeth at both edges makes his teeth grind. The curve of the upper lip is stronger.

Anger

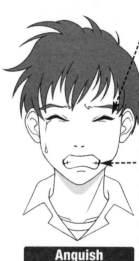

The upward curve of the shut eye is flatter than that of "Joy". The radial pattern of wrinkles about the upper and lower eyelids makes his eyes seem sealed tight.

Compared to "Anger," the line of the teeth is simple, as though the teeth are clenched. Adding the jagged line of "Anger" will give him an offensive countenance.

Anguish

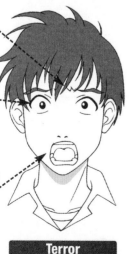

The folds between the eyebrows are long and the eyebrow is bent downward.

The eyebrows are separated and the shrunken pupil seems to float in the center.

The mouth is close to being a trapezoid. Both upper and lower teeth are added.

Terror

Only one side is arched severely.

The mouth is shut in an upward curve. The line of the lower lip is straight.

The area of the eyelid is widened.

About one-third of the pupil is concealed by the upper eyelid.

Smug

Visualize the Nature of this Character

He is the childhood friend of the girl protagonist. As was explained with the girl character, these two characters were separated but in an attempt to make up for lost time, he becomes too frantic and his excessive actions backfire. Even if things don't go well he is a type that tries very hard.
He has a wide range of manners that he takes with his action. This creates a lot of misunderstanding and he becomes down trodden a lot. When he can cross over something unforeseen, he is in a state of ecstasy. The gap between what he thinks and the results of his actions are comedic. He gets carried away by his innocent rashness, frivolity, and youthful enthusiasm. As this is all for the girl that he likes, it makes his character even more likeable.

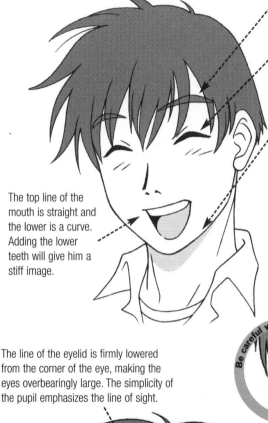

The eyebrows are brought slightly close to the forehead.

Unlike the shy smile, the eyes are not shut tight so wrinkles are not produced.

Cheerful

The chin is pulled down as though he is laughing out loud.

The folds give him a slightly troubled look.

The ear is slightly angular, like that of a young boy.

The top line of the mouth is straight and the lower is a curve. Adding the lower teeth will give him a stiff image.

This is a standard element for the "Shy Smile."

The line of the eyelid is firmly lowered from the corner of the eye, making the eyes overbearingly large. The simplicity of the pupil emphasizes the line of sight.

Be careful with details

The eyes are shut tight. The wrinkles are greater in number as well as clearly drawn here than in "Cheerful".

The neck is slightly tilted.

Shy Smile

The exertion of effort produces wrinkles.

Don't forget this line to make his teeth grind.

The line of the lower eyelid swoops up to meet the edge. It is largely separated from the pupil, showing his cruelty.

Even though he is laughing, the clenched teeth express two types of emotion: happy and troubled.

Anger

Variations of Expressions

In order to bear his agony, there is an exertion between the eyebrows, producing folds.

The pupils are drawn simply so as not to make them deep-set, adding a comical element.

Matching his caricatured eyes, the tears are drawn like glass beads.

The mouth is comical and shows his utter confusion. Both edges have clear folds added.

This is an expression of " but given his character, h emotions do not become t serious, so this expression drawn with a comical touc

Terror

The wrinkles are the stretch of opening the eyes wide.

With the caricatured outline of the eyes and mouth, only the interior of the mouth is drawn with realness. This difference emphasizes the terror of his emotion.

Be careful with details.

Anguish

The pupils are shrunken and centered showing his shock and terror.

Only one eyebrow is sharply arched.

With the addition of the line of the clenched teeth, his smile looks as though he is egging on and provoking someone.

As the line approaches the center it narrows and becomes uneven in thickness. By not drawing the line all the way to the center, the expression avoids being rugged and retains a softness.

Caused by smiling, the lower eyelid becomes a loose curve, as though it has been forced up by the mass of his cheek.

Be careful with details.

Smug

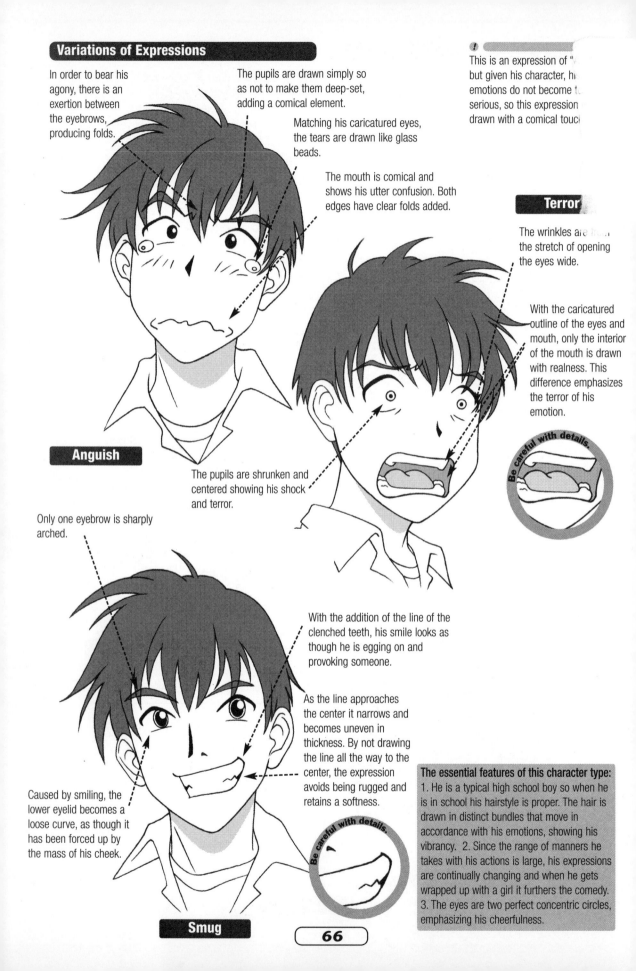

The essential features of this character type:
1. He is a typical high school boy so when he is in school his hairstyle is proper. The hair is drawn in distinct bundles that move in accordance with his emotions, showing his vibrancy. 2. Since the range of manners he takes with his actions is large, his expressions are continually changing and when he gets wrapped up with a girl it furthers the comedy. 3. The eyes are two perfect concentric circles, emphasizing his cheerfulness.

Rarely Seen Expressions

This character is in part a comedian, albeit an awkward one. There are two types of expressions introduced here: one is greatly divergent and intentionally so while the other expression he puts on is something of an obvious, foppish expression. The continual and dramatic change in his emotions moves along the story and are very important expressions. Use them only when they will have the greatest impact.

The full body is on page 127.

The upturned eyes glare at the other person. The pupils are simplified and touch the upper eyelid. The upper eyelid and the eyebrow are unified.

! Key

He is so disappointed that he cannot even utter a peep. His entire expression is caricatured and directed by this emotion. With this expression, the character's childishness can be represented.

Drawn in large and multiple lines, the embellishment makes him exhilarated.

Fuming

The even line of the clenched teeth is simplified.

Be careful with details.

His mouth juts out past his chin. The line of the lower lip is not completely connected (otherwise it would be overemphasized).

The hand is drawn, with a degree of realness, as a tightened and vertical fist.

! Key

This is a much-valued expression for the character. He thinks without a doubt that casting this exceptional, smiling face in the direction of a girl will charm her.

The pupils are drawn with more gradation than in "Expressionless" and with more of an absorbed quality.

A gentle and upward curve.

Overall, the emotion becomes exalted with the composition drawn from below.

With the line of sight fully frontal, the impression will be too strong. So, in order to maintain some comical quality, the head is subtly turned to one side and the lower eyelid is raised in a curve to emphasize his smile.

The highlight shows his white teeth. The sparkle is intentionally made large to reinforce a comical quality.

Twinkle

Advice from Young Illustrators

Chika Mashima

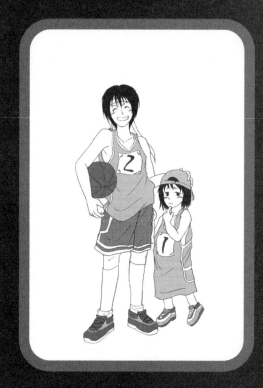

Chika Mashima
D.O.B. August 29th, 1976
Yamagata Prefecture
Graduate of a technical college, she is currently involved in illustration and creating textures for 3-D games.

I am more of a newcomer than a young hand. I don't have much experience and I don't have much technical training yet, for which I must apologize. So, I will write about what I feel is happening in the field currently.

For people who want to work in animation or game graphics, it is important to have the technique to make your illustrations flexible. Working on an assigned project, you must function as a professional and not a "young illustrator" because your work must correspond to the project. Though it is useful to have particular interests and a refined knowledge in those fields, it's not good to be limited.

To be flexible, you need to have the fundamental drawing skills and set aside your likes and dislikes to study the representative works of various different genres. Whatever the creative atmosphere may be, use this world as a base. And it is good to have some sense of history. Your experiences and your knowledge will integrate into your work. Which is why your illustrations won't develop if all you do is draw. Even if you don't start drawing until the age of twenty and direct your interests toward something else, it won't be a waste. Something will come of it.

Finally, the last key element is the desire to draw. Try your best!

Chapter 2
Expressing with the Full Figure

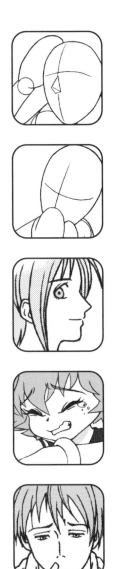

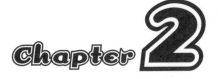

Body Postures that Convey Emotion

From my experiences teaching illustration and talking with students, I can say that a student's greatest concern is not being able to draw poses well. Don't think having difficulty with drawing poses means you lack talent. Being able to do illustrations comes from practice. But that is the not main factor either. The number one reason why students cannot draw poses well is because the meaning of the pose relative to the story hasn't been clearly established.

Each illustration doesn't move the story along step by step. And making a story isn't some monumental production either. Even without the effort of climbing a mountain, your characters can be angered, cry, and be more than sufficient to carry the story. The most important thing is to always be aware of the character's full body even with a close-up face shot, where only the face is in the frame.

Here, let's take a look at what image is conveyed with the position of the hand and head and introduce some fixed (symbolic) poses. According to these, large divisions between Up, Down, Positive, and Negative type emotions can be made.

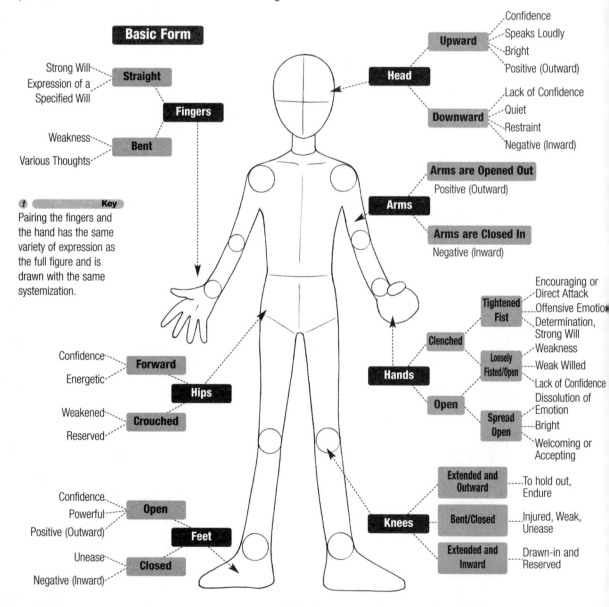

Basic Form

Straight — Strong Will, Expression of a Specified Will
Bent — Weakness, Various Thoughts

Fingers

! Key
Pairing the fingers and the hand has the same variety of expression as the full figure and is drawn with the same systemization.

Head
Upward — Confidence, Speaks Loudly, Bright, Positive (Outward)
Downward — Lack of Confidence, Quiet, Restraint, Negative (Inward)

Arms
Arms are Opened Out — Positive (Outward)
Arms are Closed In — Negative (Inward)

Hips
Forward — Confidence, Energetic
Crouched — Weakened, Reserved

Hands
Clenched — Tightened Fist — Encouraging or Direct Attack, Offensive Emotion, Determination, Strong Will
Loosely Fisted/Open — Weakness, Weak Willed, Lack of Confidence
Open — Spread Open — Dissolution of Emotion, Bright, Welcoming or Accepting

Feet
Open — Confidence, Powerful, Positive (Outward)
Closed — Unease, Negative (Inward)

Knees
Extended and Outward — To hold out, Endure
Bent/Closed — Injured, Weak, Unease
Extended and Inward — Drawn-in and Reserved

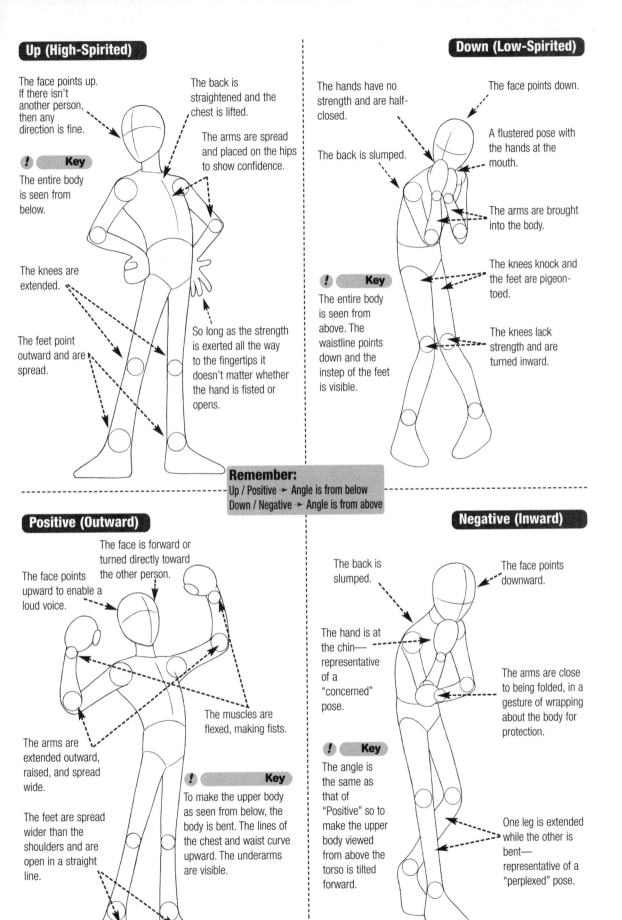

Up (High-Spirited)

The face points up. If there isn't another person, then any direction is fine.

The back is straightened and the chest is lifted.

The arms are spread and placed on the hips to show confidence.

! Key

The entire body is seen from below.

The knees are extended.

The feet point outward and are spread.

So long as the strength is exerted all the way to the fingertips it doesn't matter whether the hand is fisted or opens.

Down (Low-Spirited)

The hands have no strength and are half-closed.

The face points down.

A flustered pose with the hands at the mouth.

The back is slumped.

The arms are brought into the body.

The knees knock and the feet are pigeon-toed.

! Key

The entire body is seen from above. The waistline points down and the instep of the feet is visible.

The knees lack strength and are turned inward.

Remember:
Up / Positive → Angle is from below
Down / Negative → Angle is from above

Positive (Outward)

The face is forward or turned directly toward the other person.

The face points upward to enable a loud voice.

The muscles are flexed, making fists.

The arms are extended outward, raised, and spread wide.

The feet are spread wider than the shoulders and are open in a straight line.

! Key

To make the upper body as seen from below, the body is bent. The lines of the chest and waist curve upward. The underarms are visible.

Negative (Inward)

The back is slumped.

The face points downward.

The hand is at the chin—representative of a "concerned" pose.

The arms are close to being folded, in a gesture of wrapping about the body for protection.

! Key

The angle is the same as that of "Positive" so to make the upper body viewed from above the torso is tilted forward.

One leg is extended while the other is bent—representative of a "perplexed" pose.

Varying the Arms Changes the Emotion

The upper body seen from above, the curved back, and the slack knees. Both illustrations are variations of the negative pose previously introduced. However, notice how the image changes quite significantly as one figure has the arms extended while the other has them folded inwards.

Injured

The face points downward. In this case the mouth is open and the tongue is visible, taking quick and deep breaths.

With the action of the upper body and the arms, the bend in the knees gives the impression of a weakened body.

The arm rests on the knee like a support stick. The upper body is bent due to loss of strength.

Concern + Unease

The head similarly points downward but with this pose the mouth is drawn as a bent segment and is firmly shut.

With the arms folded, the upper body seems to be bent as though lost in thought.

Lost in thought, his determination is lowered and his body seems to bend over unconsciously.

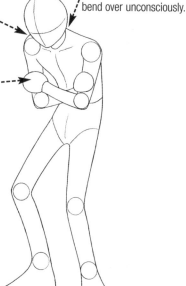

Focus on Hand Positions.

Without the lower body, the close-up shot of the upper body has a completely different impression though it is the same illustration. Remember that there is a marked difference depending on the position of the hand when enacting only the upper body.

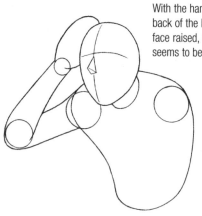

With the hand on the back of the head and the face raised, the character seems to be laughing.

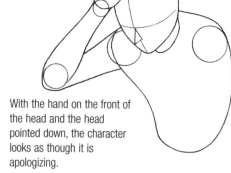

With the hand on the front of the head and the head pointed down, the character looks as though it is apologizing.

Various Combinations of Hand and Upper Body

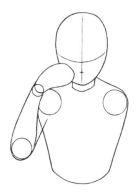
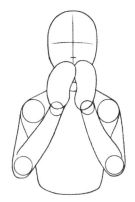
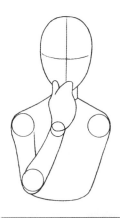
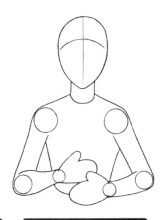

Crying

The hand or fingers touch downcast eyes. The welling of tears is representative of this drama. The expression for crocodile tears borrows this pose.

Surprised

The hands touch the mouth— a pose representative of a girl's reaction. With this pose, terror and unease can be expressed with changes in the eyes and eyebrows.

Thinking

The face is slightly lowered and the hand touches the chin—a pose representative of being lost in thought. By making the head tilts forward, concern or doubt can be expressed.

Laughing

The face is lifted and the hands are on the belly as though the character is cackling.

Pay Attention!

The poses introduced up until now will not carry over into action poses as is. For example, as can be seen in the illustration on the left, the character's back is bent. Although this "full-body expression" represents negativity in a static situation, when it comes to action poses, this does not apply as it is used to convey speed.

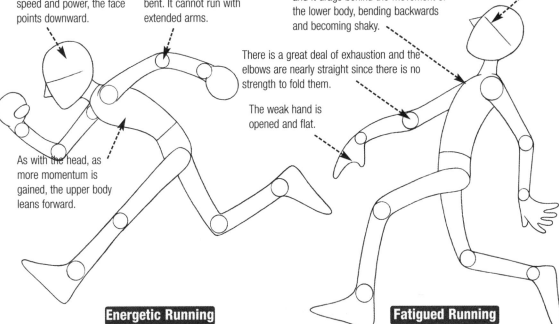

When there is a degree of speed and power, the face points downward.

The arms are consciously bent. It cannot run with extended arms.

As with the head, as more momentum is gained, the upper body leans forward.

The upper body has lost its strength and it drags behind the movement of the lower body, bending backwards and becoming shaky.

There is a great deal of exhaustion and the elbows are nearly straight since there is no strength to fold them.

The weak hand is opened and flat.

The greater the exhaustion, the higher the chin is raised, pointing the head upward.

Energetic Running

Fatigued Running

Game Character (Girl)

Expressing Emotions with Gestures
This character is truly vigorous hence her emotions are boldly outward and her expressions are made with liberated poses. Both legs are usually a little open and the movement of the arms is sprightly.

Think of her poses as being boyish. Her well-trained physique is "tight" rather than "pumped". Draw her with the lightness of a female Ninja, while visualizing her elation as she defeats a big and strong enemy.

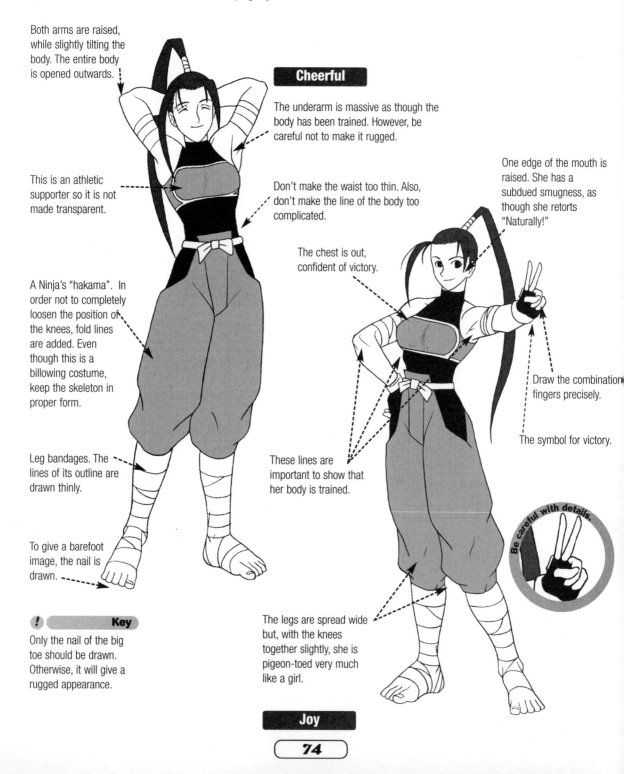

Both arms are raised, while slightly tilting the body. The entire body is opened outwards.

Cheerful

The underarm is massive as though the body has been trained. However, be careful not to make it rugged.

One edge of the mouth is raised. She has a subdued smugness, as though she retorts "Naturally!"

This is an athletic supporter so it is not made transparent.

Don't make the waist too thin. Also, don't make the line of the body too complicated.

The chest is out, confident of victory.

A Ninja's "hakama". In order not to completely loosen the position of the knees, fold lines are added. Even though this is a billowing costume, keep the skeleton in proper form.

Draw the combination fingers precisely.

The symbol for victory.

Leg bandages. The lines of its outline are drawn thinly.

These lines are important to show that her body is trained.

To give a barefoot image, the nail is drawn.

Be careful with details.

! Key
Only the nail of the big toe should be drawn. Otherwise, it will give a rugged appearance.

The legs are spread wide but, with the knees together slightly, she is pigeon-toed very much like a girl.

Joy

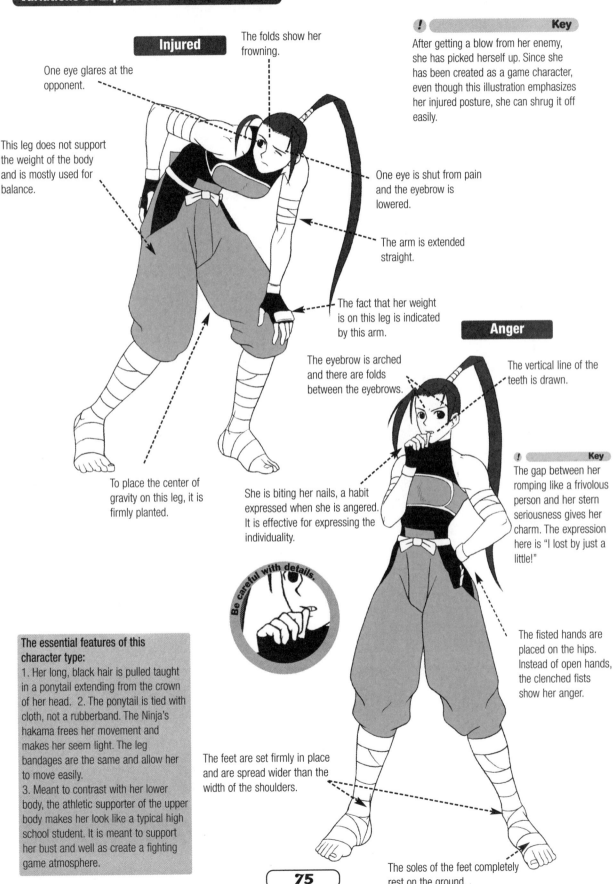

Injured

One eye glares at the opponent.

The folds show her frowning.

This leg does not support the weight of the body and is mostly used for balance.

Key
After getting a blow from her enemy, she has picked herself up. Since she has been created as a game character, even though this illustration emphasizes her injured posture, she can shrug it off easily.

One eye is shut from pain and the eyebrow is lowered.

The arm is extended straight.

The fact that her weight is on this leg is indicated by this arm.

To place the center of gravity on this leg, it is firmly planted.

The eyebrow is arched and there are folds between the eyebrows.

Anger

The vertical line of the teeth is drawn.

She is biting her nails, a habit expressed when she is angered. It is effective for expressing the individuality.

Key
The gap between her romping like a frivolous person and her stern seriousness gives her charm. The expression here is "I lost by just a little!"

Be careful with details.

The fisted hands are placed on the hips. Instead of open hands, the clenched fists show her anger.

The essential features of this character type:
1. Her long, black hair is pulled taught in a ponytail extending from the crown of her head. 2. The ponytail is tied with cloth, not a rubberband. The Ninja's hakama frees her movement and makes her seem light. The leg bandages are the same and allow her to move easily.
3. Meant to contrast with her lower body, the athletic supporter of the upper body makes her look like a typical high school student. It is meant to support her bust and well as create a fighting game atmosphere.

The feet are set firmly in place and are spread wider than the width of the shoulders.

The soles of the feet completely rest on the ground.

Variations of Expressions

The fist is brought close to the mouth, which is effective for expressing her slightly devilish quality. To emphasize the childish, mischievous side, even when she is being a goody-goody, the pose lacks the refinement associated with the ladylike gesture of concealing the mouth. The pointed finger, the raised mouth, and the thrust thumb are meant to provoke the other person. The hand aligned with the jaw adds a moderate amount of girlishness.

One eyebrow is arched slightly higher than the other one.

The mouth is a triangle with one side open and raised.

The vertical lines of the teeth give her a conscious snicker.

! Key

This character has an ample provocative element that lacks an overbearing smugness. This action has the atmosphere of: "Did you see? Did you see what just happened? So strange!"

! Key

Unless the line of sight is made the same as the direction of the finger, this illustration will become meaningless.

Smug

The eyebrows are brought together and there are folds between the eyebrows.

The head is dropped in depression. It is tilted downward more than 45 degrees.

The head touches the hand in a dramatic pose, emphasizing the boldness of expression.

Since the head points down the mouth is a small, lowered line underneath the nose. The lips look as though they are being bitten.

! Key

This character has a clear and distinct set of expressions, so when she is in her "Injured" mode all the parts of the body are directed inward. As though she has just lost a match, she endlessly blames herself saying, "I should have . . ." She does not hold grudges.

The hand and fingers have lost all spirit and there is no strength at all. Master drawing such downtrodden fingers.

The legs are closed with the knees brought together.

Be careful with details.

Anguish

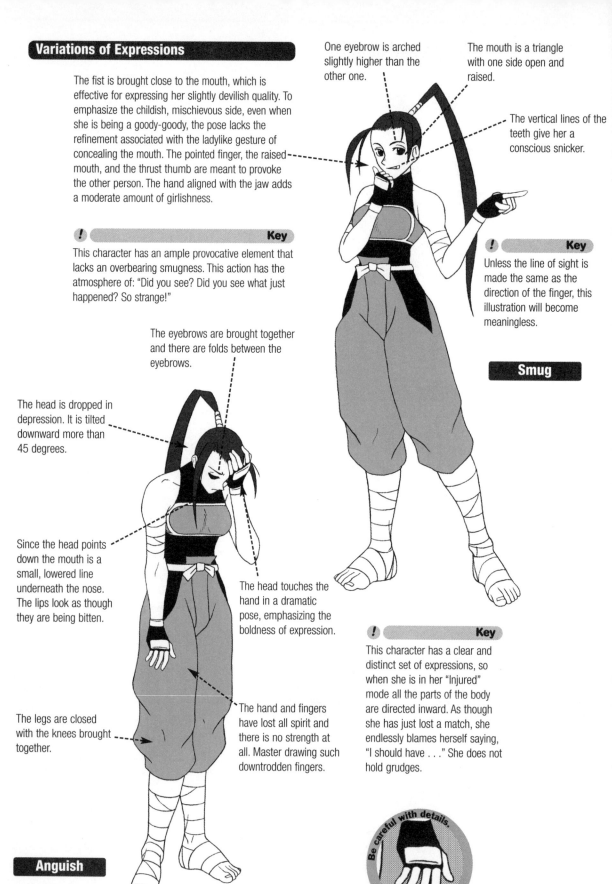

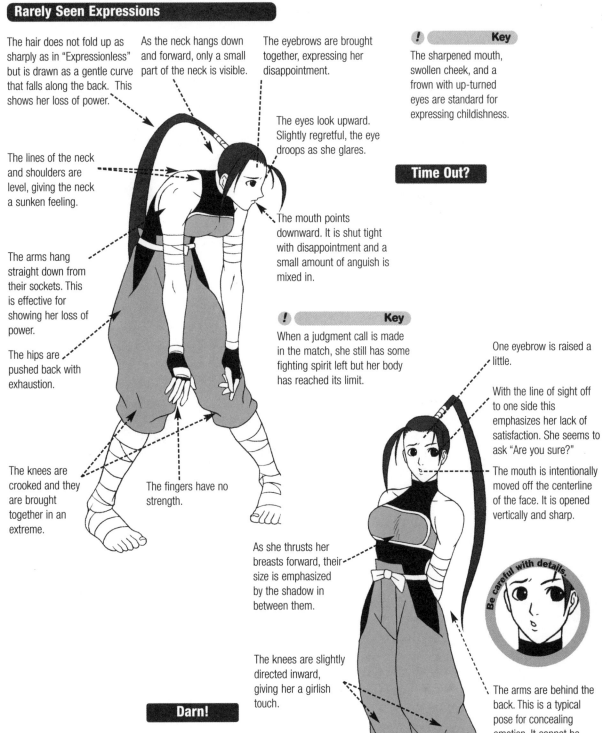

The hair does not fold up as sharply as in "Expressionless" but is drawn as a gentle curve that falls along the back. This shows her loss of power.

As the neck hangs down and forward, only a small part of the neck is visible.

The eyebrows are brought together, expressing her disappointment.

Key

The sharpened mouth, swollen cheek, and a frown with up-turned eyes are standard for expressing childishness.

The eyes look upward. Slightly regretful, the eye droops as she glares.

The lines of the neck and shoulders are level, giving the neck a sunken feeling.

Time Out?

The mouth points downward. It is shut tight with disappointment and a small amount of anguish is mixed in.

The arms hang straight down from their sockets. This is effective for showing her loss of power.

Key

When a judgment call is made in the match, she still has some fighting spirit left but her body has reached its limit.

One eyebrow is raised a little.

The hips are pushed back with exhaustion.

With the line of sight off to one side this emphasizes her lack of satisfaction. She seems to ask "Are you sure?"

The mouth is intentionally moved off the centerline of the face. It is opened vertically and sharp.

The knees are crooked and they are brought together in an extreme.

The fingers have no strength.

Be careful with details

As she thrusts her breasts forward, their size is emphasized by the shadow in between them.

The arms are behind the back. This is a typical pose for concealing emotion. It cannot be said openly, but she is thoroughly dissatisfied.

The knees are slightly directed inward, giving her a girlish touch.

Darn!

Key

Imagine her in a "Draw" game. This pose brings out the character's conviction that she should have won the match.

Game Character (Boy)

Expressing Emotions with Gestures

This character's trained physique and quick reflexes are his main characteristics. Before using deformation effects, make sure to research muscle structure well; this is a must. Drawing excessively developed muscles with no regard to bone structure will make the illustration seem like poor, unrefined craftsmanship.

His action is powerful and big. Apart from the "Rarely Seen Expressions," he always has power in his fingers with his hands usually in fists.

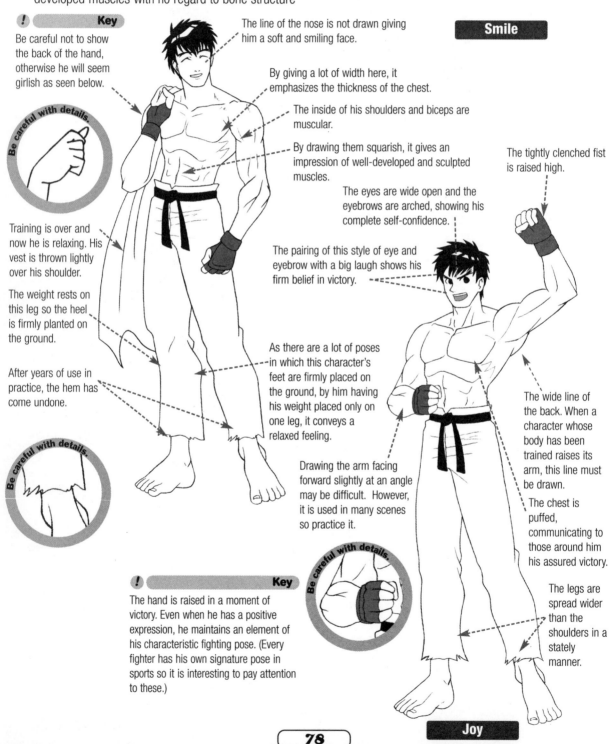

! **Key**

Be careful not to show the back of the hand, otherwise he will seem girlish as seen below.

Be careful with details.

Training is over and now he is relaxing. His vest is thrown lightly over his shoulder.

The weight rests on this leg so the heel is firmly planted on the ground.

After years of use in practice, the hem has come undone.

Be careful with details.

The line of the nose is not drawn giving him a soft and smiling face.

By giving a lot of width here, it emphasizes the thickness of the chest.

The inside of his shoulders and biceps are muscular.

By drawing them squarish, it gives an impression of well-developed and sculpted muscles.

The eyes are wide open and the eyebrows are arched, showing his complete self-confidence.

The pairing of this style of eye and eyebrow with a big laugh shows his firm belief in victory.

As there are a lot of poses in which this character's feet are firmly placed on the ground, by him having his weight placed only on one leg, it conveys a relaxed feeling.

Drawing the arm facing forward slightly at an angle may be difficult. However, it is used in many scenes so practice it.

Smile

The tightly clenched fist is raised high.

The wide line of the back. When a character whose body has been trained raises its arm, this line must be drawn.

The chest is puffed, communicating to those around him his assured victory.

The legs are spread wider than the shoulders in a stately manner.

! **Key**

The hand is raised in a moment of victory. Even when he has a positive expression, he maintains an element of his characteristic fighting pose. (Every fighter has his own signature pose in sports so it is interesting to pay attention to these.)

Be careful with details.

Joy

The face does not point downward. It communicates to his opponent that he has not given up.

One eye is shut and the eyebrow is lowered from terrible pain. The other eye is open, glaring at his opponent.

The arms are dropped. Compare this to the mass of his muscles when he exerts his strength.

! **Key**

Receiving a powerful blow is followed by a brief period of collecting himself which is followed by an angered offensive. This is the last stage. After this, his deadly skills will be unleashed. In a Manga, if an exploding effect is used, it is effective to draw the aura of anger as flames.

The essential features of this character type:
1. Foremost, this character is thick-boned and muscular! Without being aware of this, this character cannot be drawn. 2. He is popular as a game character but can crossover into many different situations. However, he can be the most difficult one to draw. This is because his upper body is bare most of the time which forbids the illustrator to cut corners with costumes. 3. Making even a simple fight scene convey a real feeling to it requires a professional's touch as the muscles must be drawn properly. 4. For those who seriously want to study body proportions, you may want to watch boxing or K-1 games to learn the structure of the body. Also, you may want to refer to HOW TO DRAW MANGA: Illustrating Human Bodies (Available Fall 2001) Without this first step, the drawings will not advance.

! **Key**

This is a "Flinching" where he has just gotten a heavy blow and is unable to react quickly. However, this character has an indomitable spirit and he has not accepted defeat. He shows his opponent his strong will to continue the fight.

The weight of the body is on this leg as he struggles to stand up. Make sure the hand is shown pressed into the thigh.

The fingers are consciously spread open evenly. This shows that it doesn't lack power; there is still strength remaining.

If this were an "Aesthetic Character" then the curve of the back would be smooth. With this character, the bones are thick so the shoulder blades bulge out like two mountains.

The sinewy lines of the muscles are thicker than in "Expressionless".

The wisps of hair are angular and stand on end. This is highly effective for displaying the thrust of his power.

The eyes are wide open and the line of sight is focused straight at his opponent.

The hips are lowered. This stable pose is standard for swiftly defending oneself as well as attacking.

The mouth is a square and opened to its limit directly underneath the nose. The level of his anger is determined by the size of the mouth.

The hands are fisted. With the hands drawn larger than normal, he is given a powerful image.

The flex of his muscles produces this bulge.

The feet are spread about 1.5 times the width of the shoulders. The weight is distributed evenly across both legs so both feet are firmly planted on the ground.

Variations of Expressions

The bottom eyelid conceals the bottom part of the pupil. The downcast eyes are very effective for making him look down upon his opponent.

This line represents the chin. With the chin up the face is seen from below, giving him a relaxed composure.

The chest is flared, a symbol of his confidence.

The hand is on the hip—a pose of ease and composure.

! Key

Rather than being smug, this pose is more along the lines of "So, let's get at it!" Though he is provoking his opponent, there is a small element of ease in this expression.

Anguish

! Key

"Time is Up. Lost by Decision." He himself acknowledges his defeat. This leads to anguish.

Smug

The combination of the lowered eyebrows, smile, and an eased posture result in a playful image. One of the charms of this character is his pure nature. Making him unpleasant is completely off limits.

He has strength even in the back of his hand and his fingers are lightly bent.

His hand is lightly calling on his opponent.

This character is positive at heart so even when he feels down his chin is up. Turning his head to one side, he tries to suppress his anguish and disappointment as he mulls something over.

Be careful with details.

There are wrinkles at the corner of the eye, making his eyes seem shut tight.

He is a very manly character so tears are out of the question!

The mouth is shut in a bent segment and the jaws are clenched.

As the arms are folded tightly, the musculature is emphasized in this area.

The legs are slightly closed; they are spread less than the width of the shoulders. To open the legs would be symbolic of his manliness.

The feet are nearly parallel and not opened out.

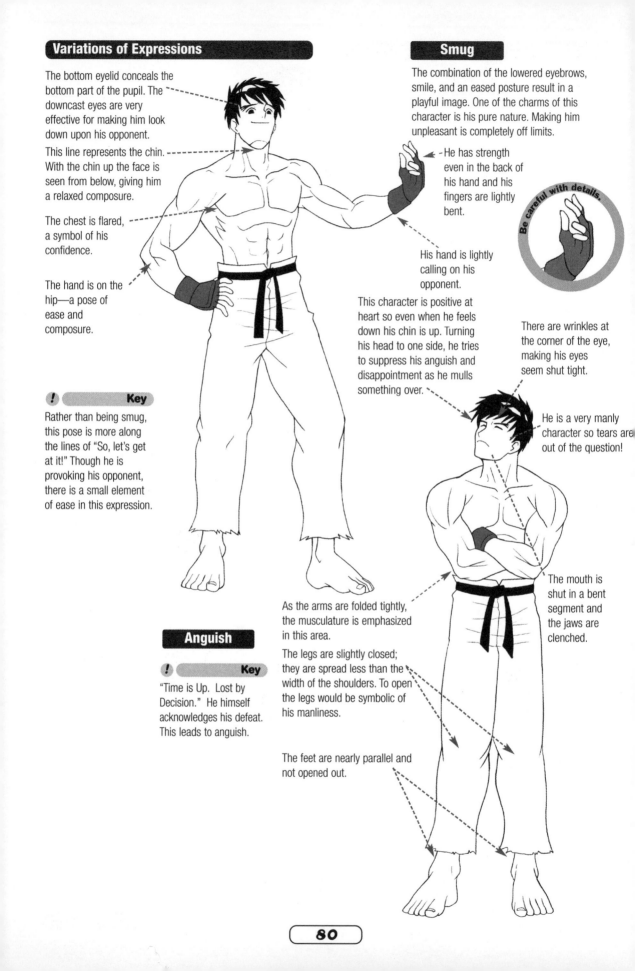

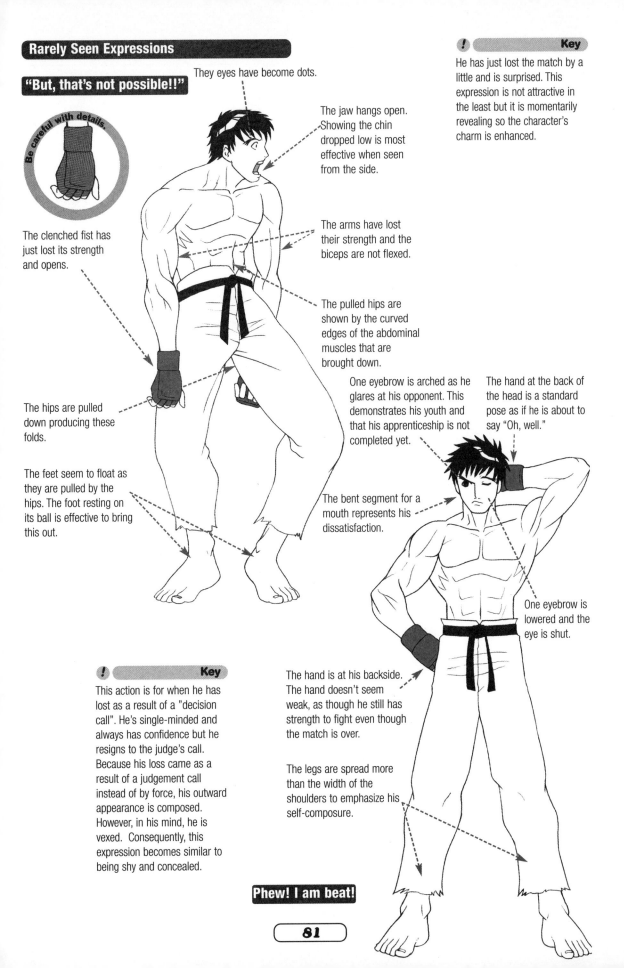

"But, that's not possible!!"

Be careful with details.

They eyes have become dots.

The jaw hangs open. Showing the chin dropped low is most effective when seen from the side.

The clenched fist has just lost its strength and opens.

The arms have lost their strength and the biceps are not flexed.

The pulled hips are shown by the curved edges of the abdominal muscles that are brought down.

The hips are pulled down producing these folds.

The feet seem to float as they are pulled by the hips. The foot resting on its ball is effective to bring this out.

One eyebrow is arched as he glares at his opponent. This demonstrates his youth and that his apprenticeship is not completed yet.

The hand at the back of the head is a standard pose as if he is about to say "Oh, well."

The bent segment for a mouth represents his dissatisfaction.

One eyebrow is lowered and the eye is shut.

The hand is at his backside. The hand doesn't seem weak, as though he still has strength to fight even though the match is over.

The legs are spread more than the width of the shoulders to emphasize his self-composure.

Phew! I am beat!

81

Comical Child Character (Girl)

Expressing Emotions with Gestures

This character is a young princess so she has a selfish and obstinate side that ties in with her cuteness. Her entire body is drawn in expression of her emotions.

When the eyes are closed, a downward curve makes her look gentle. Therefore, emphasize her brightness with an upward curve.

The shoulders are slightly narrowed and the neck is off to one side, giving her an innocent and lovable expression.

To endure her laughing fit, one eye is slightly closed.

Her over-zealous laughter makes her tear.

Shy Smile

True to her child nature, even her fingers are spread wide as though she is deeply amused.

The essential features of this character type:

1. The dress is simple and child-like and the broach is essential. The material of the dress is thick and does not reveal the form of her body.

2. Her small feet are covered with something like stretch-boots that fit them perfectly, making it easier to express the cuteness of her movements.

The body folds over as she pushes down her stomach and gives out a huge laugh.

The feet are pigeon-toed and though she is a child she still has femininity.

Cackle

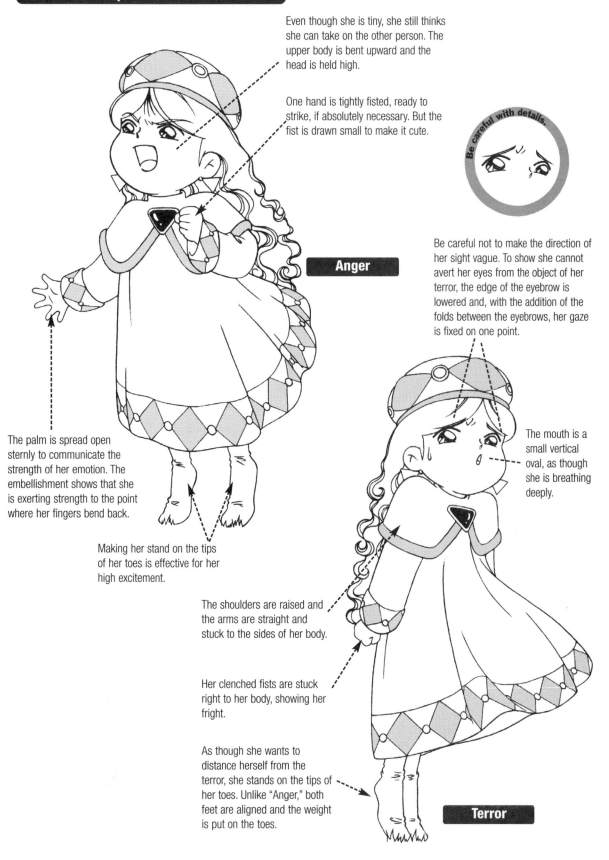

Even though she is tiny, she still thinks she can take on the other person. The upper body is bent upward and the head is held high.

One hand is tightly fisted, ready to strike, if absolutely necessary. But the fist is drawn small to make it cute.

Be careful with details.

Anger

Be careful not to make the direction of her sight vague. To show she cannot avert her eyes from the object of her terror, the edge of the eyebrow is lowered and, with the addition of the folds between the eyebrows, her gaze is fixed on one point.

The palm is spread open sternly to communicate the strength of her emotion. The embellishment shows that she is exerting strength to the point where her fingers bend back.

The mouth is a small vertical oval, as though she is breathing deeply.

Making her stand on the tips of her toes is effective for her high excitement.

The shoulders are raised and the arms are straight and stuck to the sides of her body.

Her clenched fists are stuck right to her body, showing her fright.

As though she wants to distance herself from the terror, she stands on the tips of her toes. Unlike "Anger," both feet are aligned and the weight is put on the toes.

Terror

The eyebrows are raised slightly as though she has confidence.

The head is tilted back and to one side as though she is looking down at someone.

To make her eyes look down, the pupils are lowered. The line of the lower eyelashes is slightly curved. Also, the whole pupil is slightly narrower than in "Expressionless".

Be careful with details.

To make her cheeky, the hands are crossed at the back.

She has no embarrassment in lifting her face to cry in a childlike manner.

The action of the hand is large and dramatic. The hands touch the face in a gesture of a baby.

Smug

The tears fly off her face, as though she is engrossed with her sobbing.

To show the level of her exalted emotion, her hair billows in the air even though there is no wind.

The Tricks of the Trade: The Teary Eye
In reality, tears are transparent so the line of the lower eyelid within the drop should be visible from corner to corner. However, in this caricaturization, the lines are not as a form of deformation. This is because when the lines are connected, it becomes too distracting. This trick is done to give the tears a sense of existence while bringing in the element refraction.

To show her childishness, the feet are pigeon-toed. Different from "Cackle" the feet are not aligned in order to emphasize her helplessness.

The body is slightly bent to emphasize the level of her anguish.

Anguish

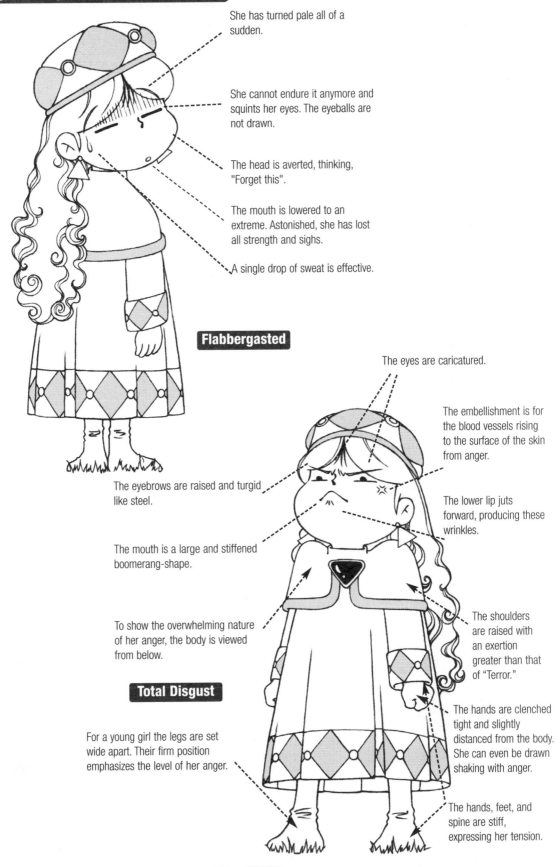

She has turned pale all of a sudden.

She cannot endure it anymore and squints her eyes. The eyeballs are not drawn.

The head is averted, thinking, "Forget this".

The mouth is lowered to an extreme. Astonished, she has lost all strength and sighs.

A single drop of sweat is effective.

Flabbergasted

The eyes are caricatured.

The embellishment is for the blood vessels rising to the surface of the skin from anger.

The eyebrows are raised and turgid like steel.

The lower lip juts forward, producing these wrinkles.

The mouth is a large and stiffened boomerang-shape.

To show the overwhelming nature of her anger, the body is viewed from below.

The shoulders are raised with an exertion greater than that of "Terror."

Total Disgust

The hands are clenched tight and slightly distanced from the body. She can even be drawn shaking with anger.

For a young girl the legs are set wide apart. Their firm position emphasizes the level of her anger.

The hands, feet, and spine are stiff, expressing her tension.

Comic Child Character (Boy)

Expressing Emotions with Gestures

He is naughty and rash. At the very least, emphasize his high energy when drawing him. Always having his feet in motion is an important element for the expression of his emotions. His gestures are bigger than the girl's gestures. He gets up, sits down, up, down, up, down . . . make him move a lot.

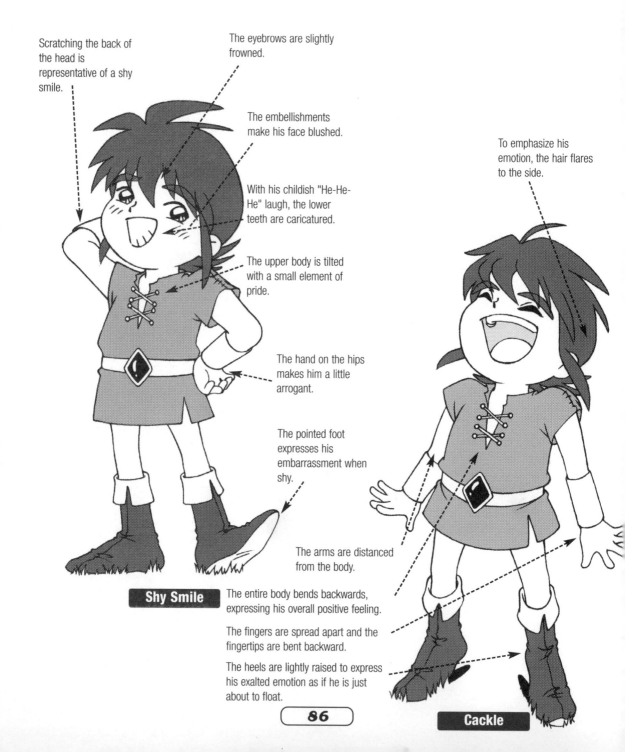

Scratching the back of the head is representative of a shy smile.

The eyebrows are slightly frowned.

The embellishments make his face blushed.

With his childish "He-He-He" laugh, the lower teeth are caricatured.

The upper body is tilted with a small element of pride.

The hand on the hips makes him a little arrogant.

The pointed foot expresses his embarrassment when shy.

To emphasize his emotion, the hair flares to the side.

Shy Smile

The arms are distanced from the body.

The entire body bends backwards, expressing his overall positive feeling.

The fingers are spread apart and the fingertips are bent backward.

The heels are lightly raised to express his exalted emotion as if he is just about to float.

Cackle

Variations of Expressions

This touch makes his cheeks flushed with anger.

The mouth is open wide such that the back row of his teeth is visible.

The hands are tight fists and assume this posture.

The hips are dropped and the knees are slightly bent, a posture prepared for his opponent's approach.

The feet are spread wider than the shoulders and the heels rest firmly on the ground.

To emphasize his blubbering, the wisps of hair stand on end.

The mouth is open wide and the back row of teeth as well as the tongue are completely shown.

His clothing slips off his shoulders, emphasizing the magnitude of his confusion.

Anger

The full-face is not drawn precisely. The left and right eyebrows and eyes are unbalanced, expressing his warped crying face.

The feet are spread out wider than the width of the shoulders. Lost in his sobbing, he blubbers desperately.

Be careful with details.

Be careful how the soles of the shoe are drawn. Leather has a soft quality that produces these folds near the arch.

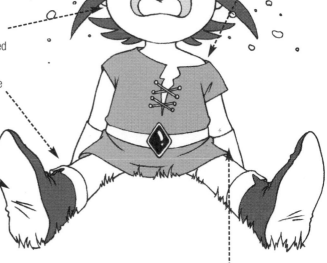

The essential features of this character type:
To emphasize that he is a vigorous youth raised in the wild, he wears simple, easy-to-move-in clothing. The ethnic element of his lace-up clothing gives the feeling of a fantasy. His feet are bigger than the girl's and he wears simple shoes made from tree bark or animal hide.

Anguish

The hands are behind him showing that he won't even try to wipe away his tears.

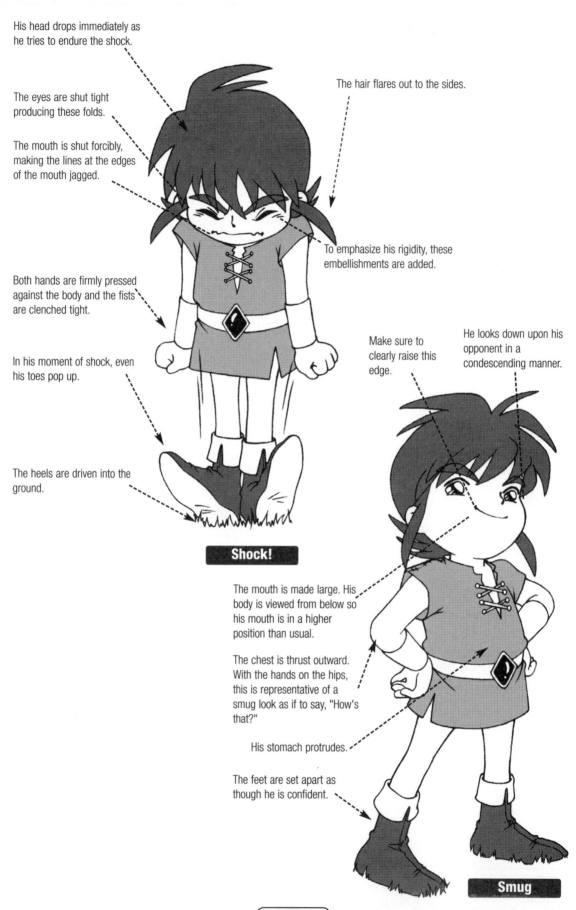

His head drops immediately as he tries to endure the shock.

The hair flares out to the sides.

The eyes are shut tight producing these folds.

The mouth is shut forcibly, making the lines at the edges of the mouth jagged.

To emphasize his rigidity, these embellishments are added.

Both hands are firmly pressed against the body and the fists are clenched tight.

In his moment of shock, even his toes pop up.

The heels are driven into the ground.

Shock!

Make sure to clearly raise this edge.

He looks down upon his opponent in a condescending manner.

The mouth is made large. His body is viewed from below so his mouth is in a higher position than usual.

The chest is thrust outward. With the hands on the hips, this is representative of a smug look as if to say, "How's that?"

His stomach protrudes.

The feet are set apart as though he is confident.

Smug

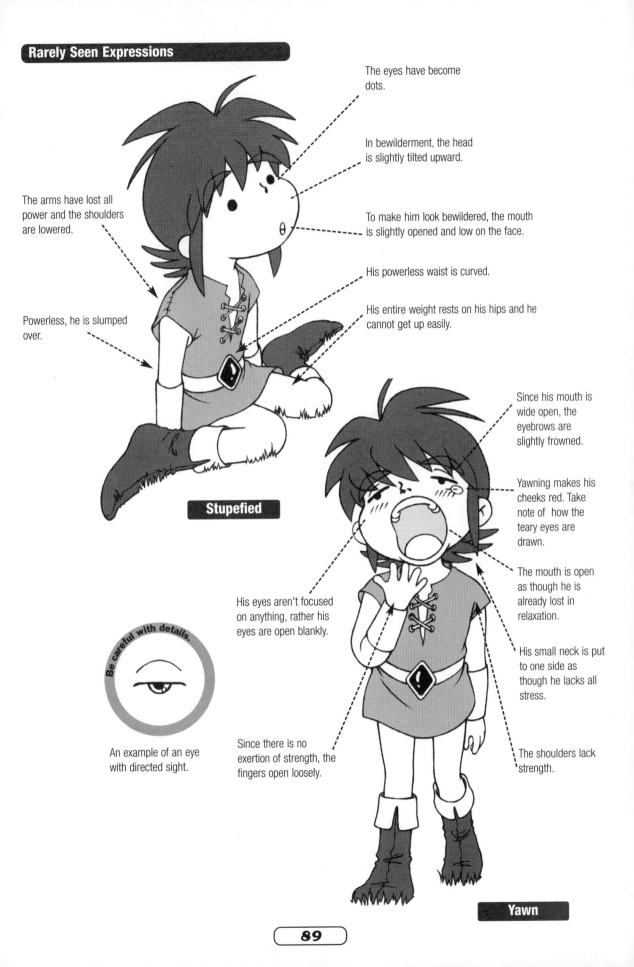

The eyes have become dots.

In bewilderment, the head is slightly tilted upward.

To make him look bewildered, the mouth is slightly opened and low on the face.

His powerless waist is curved.

His entire weight rests on his hips and he cannot get up easily.

The arms have lost all power and the shoulders are lowered.

Powerless, he is slumped over.

Stupefied

Be careful with details.

An example of an eye with directed sight.

His eyes aren't focused on anything, rather his eyes are open blankly.

Since there is no exertion of strength, the fingers open loosely.

Since his mouth is wide open, the eyebrows are slightly frowned.

Yawning makes his cheeks red. Take note of how the teary eyes are drawn.

The mouth is open as though he is already lost in relaxation.

His small neck is put to one side as though he lacks all stress.

The shoulders lack strength.

Yawn

OVA Character Type (Girl)

Expressing Emotions with Gestures

She is 100% a girl! The element of her childish cuteness is her biggest charm point. The legs are always turned in. With her cat-like and supple movements, her innocent actions are those of a female child. The ears and tail move a lot. She should be drawn with easy-to-understand expressions.

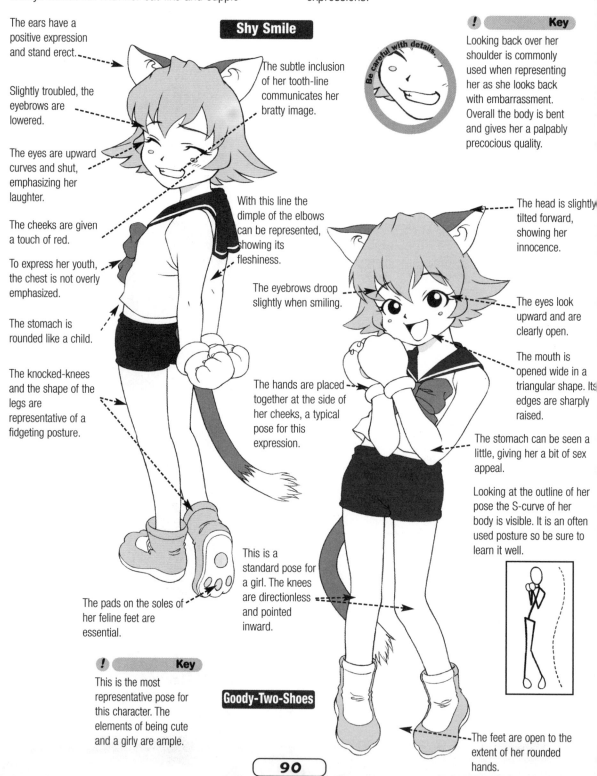

The ears have a positive expression and stand erect.

Slightly troubled, the eyebrows are lowered.

The eyes are upward curves and shut, emphasizing her laughter.

The cheeks are given a touch of red.

To express her youth, the chest is not overly emphasized.

The stomach is rounded like a child.

The knocked-knees and the shape of the legs are representative of a fidgeting posture.

The pads on the soles of her feline feet are essential.

Shy Smile

The subtle inclusion of her tooth-line communicates her bratty image.

With this line the dimple of the elbows can be represented, showing its fleshiness.

The eyebrows droop slightly when smiling.

The hands are placed together at the side of her cheeks, a typical pose for this expression.

This is a standard pose for a girl. The knees are directionless and pointed inward.

! **Key**

This is the most representative pose for this character. The elements of being cute and a girly are ample.

Goody-Two-Shoes

Be careful with details.

! **Key**

Looking back over her shoulder is commonly used when representing her as she looks back with embarrassment. Overall the body is bent and gives her a palpably precocious quality.

The head is slightly tilted forward, showing her innocence.

The eyes look upward and are clearly open.

The mouth is opened wide in a triangular shape. Its edges are sharply raised.

The stomach can be seen a little, giving her a bit of sex appeal.

Looking at the outline of her pose the S-curve of her body is visible. It is an often used posture so be sure to learn it well.

The feet are open to the extent of her rounded hands.

Variations of Expressions

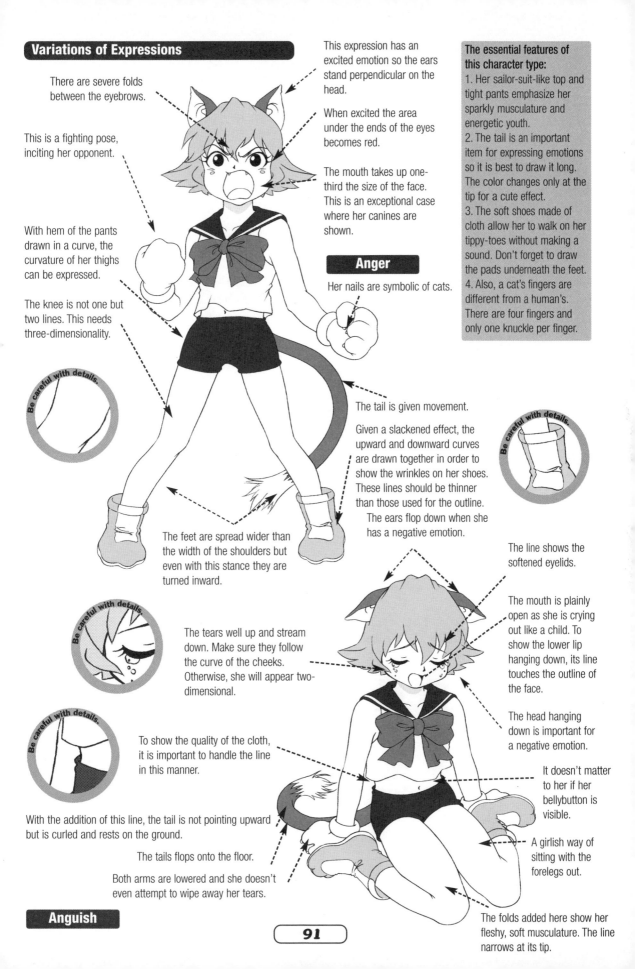

There are severe folds between the eyebrows.

This is a fighting pose, inciting her opponent.

With hem of the pants drawn in a curve, the curvature of her thighs can be expressed.

The knee is not one but two lines. This needs three-dimensionality.

Be careful with details.

This expression has an excited emotion so the ears stand perpendicular on the head.

When excited the area under the ends of the eyes becomes red.

The mouth takes up one-third the size of the face. This is an exceptional case where her canines are shown.

Anger

Her nails are symbolic of cats.

The essential features of this character type:
1. Her sailor-suit-like top and tight pants emphasize her sparkly musculature and energetic youth.
2. The tail is an important item for expressing emotions so it is best to draw it long. The color changes only at the tip for a cute effect.
3. The soft shoes made of cloth allow her to walk on her tippy-toes without making a sound. Don't forget to draw the pads underneath the feet.
4. Also, a cat's fingers are different from a human's. There are four fingers and only one knuckle per finger.

The tail is given movement.

Given a slackened effect, the upward and downward curves are drawn together in order to show the wrinkles on her shoes. These lines should be thinner than those used for the outline.

The ears flop down when she has a negative emotion.

Be careful with details.

The feet are spread wider than the width of the shoulders but even with this stance they are turned inward.

The tears well up and stream down. Make sure they follow the curve of the cheeks. Otherwise, she will appear two-dimensional.

Be careful with details.

Be careful with details.

To show the quality of the cloth, it is important to handle the line in this manner.

With the addition of this line, the tail is not pointing upward but is curled and rests on the ground.

The tails flops onto the floor.

Both arms are lowered and she doesn't even attempt to wipe away her tears.

Anguish

The line shows the softened eyelids.

The mouth is plainly open as she is crying out like a child. To show the lower lip hanging down, its line touches the outline of the face.

The head hanging down is important for a negative emotion.

It doesn't matter to her if her bellybutton is visible.

A girlish way of sitting with the forelegs out.

The folds added here show her fleshy, soft musculature. The line narrows at its tip.

Variations of Expressions

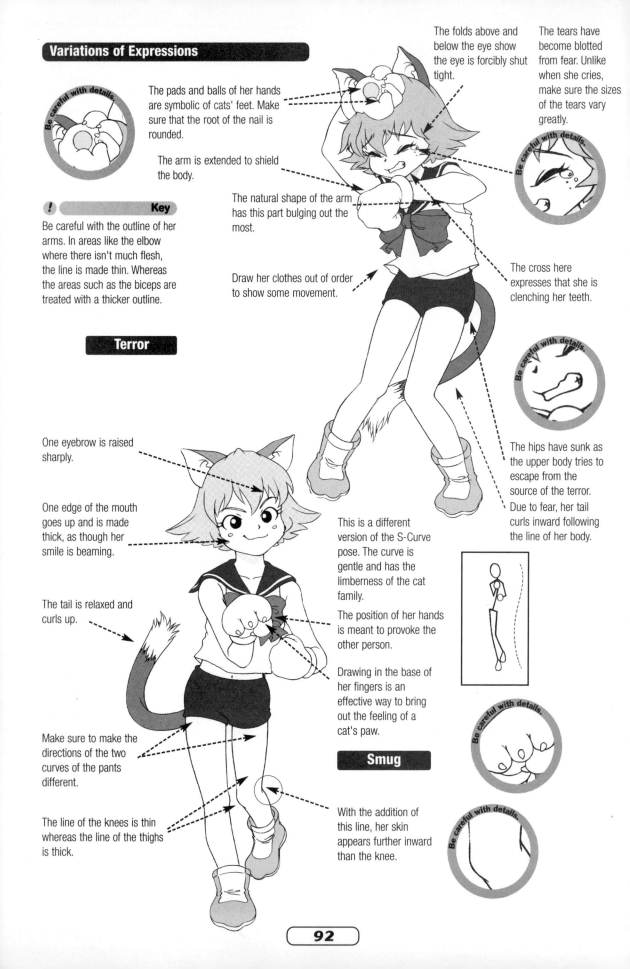

Be careful with details

The pads and balls of her hands are symbolic of cats' feet. Make sure that the root of the nail is rounded.

The arm is extended to shield the body.

! **Key**

Be careful with the outline of her arms. In areas like the elbow where there isn't much flesh, the line is made thin. Whereas the areas such as the biceps are treated with a thicker outline.

Terror

The folds above and below the eye show the eye is forcibly shut tight.

The tears have become blotted from fear. Unlike when she cries, make sure the sizes of the tears vary greatly.

Be careful with details.

The natural shape of the arm has this part bulging out the most.

Draw her clothes out of order to show some movement.

The cross here expresses that she is clenching her teeth.

Be careful with details.

The hips have sunk as the upper body tries to escape from the source of the terror.

Due to fear, her tail curls inward following the line of her body.

One eyebrow is raised sharply.

One edge of the mouth goes up and is made thick, as though her smile is beaming.

The tail is relaxed and curls up.

This is a different version of the S-Curve pose. The curve is gentle and has the limberness of the cat family.

The position of her hands is meant to provoke the other person.

Drawing in the base of her fingers is an effective way to bring out the feeling of a cat's paw.

Smug

Be careful with details.

Make sure to make the directions of the two curves of the pants different.

The line of the knees is thin whereas the line of the thighs is thick.

With the addition of this line, her skin appears further inward than the knee.

Be careful with details.

92

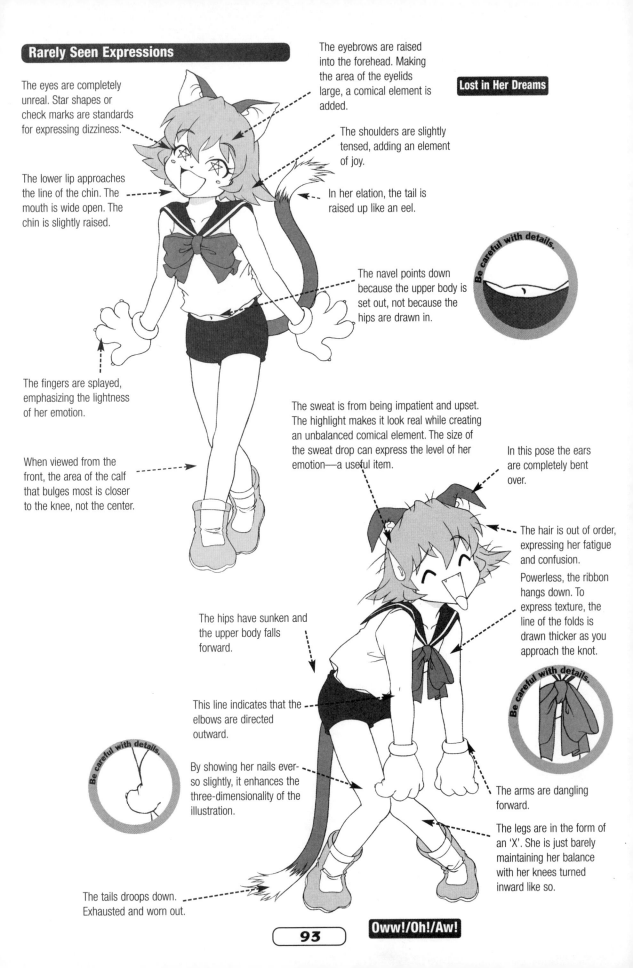

The eyes are completely unreal. Star shapes or check marks are standards for expressing dizziness.

The lower lip approaches the line of the chin. The mouth is wide open. The chin is slightly raised.

The eyebrows are raised into the forehead. Making the area of the eyelids large, a comical element is added.

Lost in Her Dreams

The shoulders are slightly tensed, adding an element of joy.

In her elation, the tail is raised up like an eel.

The navel points down because the upper body is set out, not because the hips are drawn in.

Be careful with details.

The fingers are splayed, emphasizing the lightness of her emotion.

When viewed from the front, the area of the calf that bulges most is closer to the knee, not the center.

The sweat is from being impatient and upset. The highlight makes it look real while creating an unbalanced comical element. The size of the sweat drop can express the level of her emotion—a useful item.

In this pose the ears are completely bent over.

The hair is out of order, expressing her fatigue and confusion.

Powerless, the ribbon hangs down. To express texture, the line of the folds is drawn thicker as you approach the knot.

The hips have sunken and the upper body falls forward.

This line indicates that the elbows are directed outward.

By showing her nails ever-so slightly, it enhances the three-dimensionality of the illustration.

Be careful with details.

Be careful with details.

The arms are dangling forward.

The legs are in the form of an 'X'. She is just barely maintaining her balance with her knees turned inward like so.

The tails droops down. Exhausted and worn out.

Oww!/Oh!/Aw!

OVA Type Character (Boy)

Expressing Emotions with Gestures

Because he is a canine boy, emotions are easy to understand and he is dynamic. His tail and ears allow for a rich variety of expressions. When he is feeling positive, the tail points up and moves out from the body while the reverse applies for negative emotions. As the entire body is used to express his emotions, he is often shown in reclining and leaping poses. At the very least, draw this character with the image of an energetic puppy in mind.

The elbow is not fleshy at all and is simply the volume of the bone. His bones are still narrow, so the corners should be relatively sharp.

The chest rests flat and their outline is drawn with more or less in a straight line.

Draw the belt loops and the buckle properly to preserve volume.

Here, the abrupt break in continuity expresses the position of his crotch. The folds radiate out from this point and from below the line of the buckle.

The folds show the soft material of his shoes.

The eyebrows are lowered. The lower parts of the pupils are concealed in part by the upward curve of the lower eyelid thereby creating a smile with up-cast eyes.

The sleeve shows the curve of the shoulders. The folds radiate from the armpits.

By making this part of the arm the thickest, the shape of a childlike body can be expressed.

With the legs spread and the arms drooped, he has the image of a sitting dog.

His backside is drawn in wave.

The neck is slightly bent forward and the face is subtly pointed downward.

Cackle

The eyebrows are lowered and the eyes are shut when he laughs. The eyelid is drawn very slightly from the corner of the eye. (See details on the right)

The cheeks have become red from laughing too much.

The mouth is opened large and the teeth are visible.

The tails curls up to show his high feeling.

 Key

Be careful of the curve of the biceps. They are drawn with the same thickness from the shoulders to the elbows. The lack of bulging muscles shows the slender body of his youth.

The white, oval highlights here express the luster of his cheeks when happy.

Both edges of his mouth are pulled up. The vertical lines of the teeth are not drawn here as they would make him look severe.

This point shows the bone of the elbow.

He is in high spirits so the tail is raised and distanced from the body.

The slightly tilted neck expresses his childishness.

Shy Smile 94

The wrist bones are drawn clearly. Don't connect them to the arm in a straight line. Also, study and remember the shape of the clasped hands.

Anger

The eyebrows are raised close to a 45-degree angle while being connected to the upper eyelid pretty much until mid-point.

Be careful with details.

Since the cloth does not have any thickness, the outline of the collar should be drawn as a line.

The tail curls up to prove that he is not afraid of his opponent.

Be careful with details.

The muscle bulges out greatly, and is emphasized as an exception.

Be careful with details.

The buckle as seen from above. Be careful with drawing its thickness.

The fisted hand puts him in his fighting pose.

The twist of the hips produces these folds.

The crotch is not a simple curve connecting the two legs. By adding in this semi-horizontal line, it adds realism to the illustration.

The legs are spread apart twice the width of the shoulders. The feet are firmly planted and he is showing himself to be large.

Be careful with details.

The fingers are ready to draw his weapon. Not all nails need to be drawn precisely. Instead, some can be drawn along the outline of the fingers.

Out of nervousness, his hips are drawn back and he is not standing straight. He seems to stagger.

His entire strength is exerted, making his small muscles flex.

The tail points down when he feels negatively.

Be careful with details.

Be careful with details.

This line shows the bones of the knee. Make sure not to connect it with the shin.

The heels are slightly lifted off the ground, ready to take a leap anytime.

The essential features of this character type:
1. The legs covered with form-fitting pants and the boots made of stretch material show his agility.
2. The tank top and vest expose his arms and give the impression of his energetic and little-devil self.
3. The hems of the pants are tucked into the boots so as not to be a bother (but it also makes them easier to illustrate).

Terror

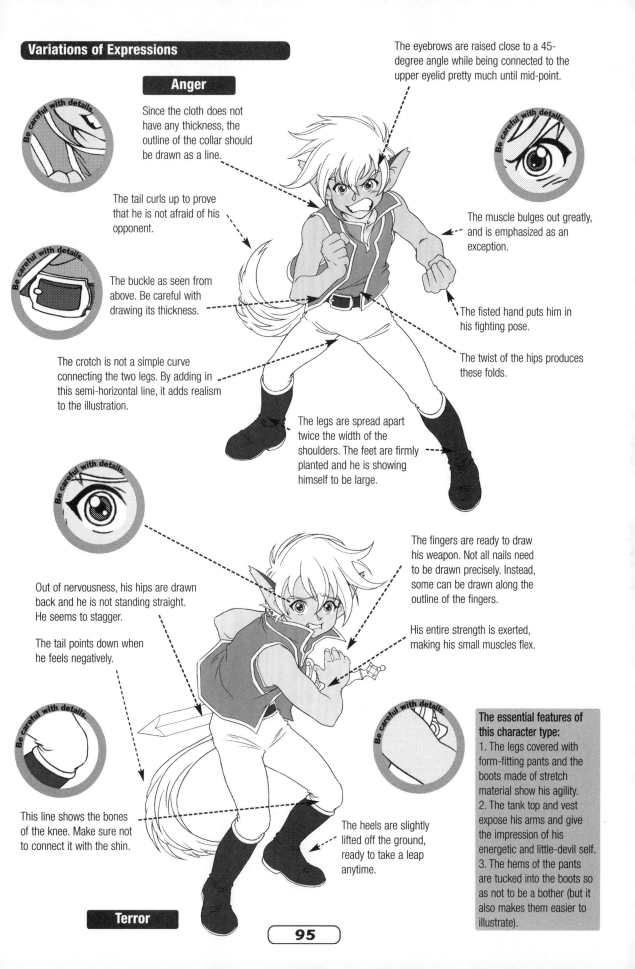

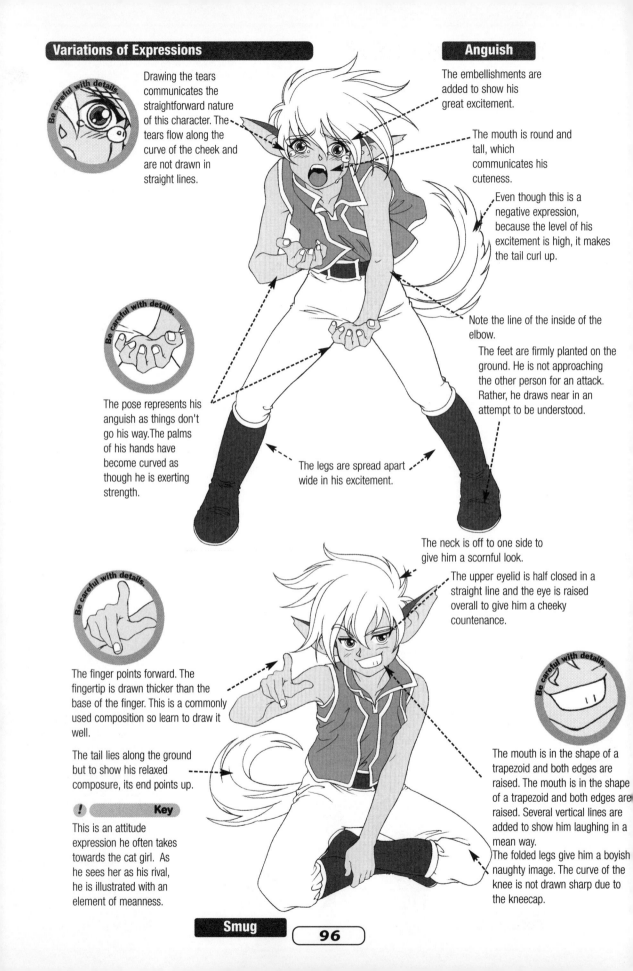

Be careful with details.

Drawing the tears communicates the straightforward nature of this character. The tears flow along the curve of the cheek and are not drawn in straight lines.

The embellishments are added to show his great excitement.

The mouth is round and tall, which communicates his cuteness.

Even though this is a negative expression, because the level of his excitement is high, it makes the tail curl up.

Be careful with details.

The pose represents his anguish as things don't go his way. The palms of his hands have become curved as though he is exerting strength.

Note the line of the inside of the elbow.

The feet are firmly planted on the ground. He is not approaching the other person for an attack. Rather, he draws near in an attempt to be understood.

The legs are spread apart wide in his excitement.

The neck is off to one side to give him a scornful look.

The upper eyelid is half closed in a straight line and the eye is raised overall to give him a cheeky countenance.

Be careful with details.

The finger points forward. The fingertip is drawn thicker than the base of the finger. This is a commonly used composition so learn to draw it well.

The tail lies along the ground but to show his relaxed composure, its end points up.

! Key

This is an attitude expression he often takes towards the cat girl. As he sees her as his rival, he is illustrated with an element of meanness.

Be careful with details.

The mouth is in the shape of a trapezoid and both edges are raised. The mouth is in the shape of a trapezoid and both edges are raised. Several vertical lines are added to show him laughing in a mean way.

The folded legs give him a boyish naughty image. The curve of the knee is not drawn sharp due to the kneecap.

Smug

96

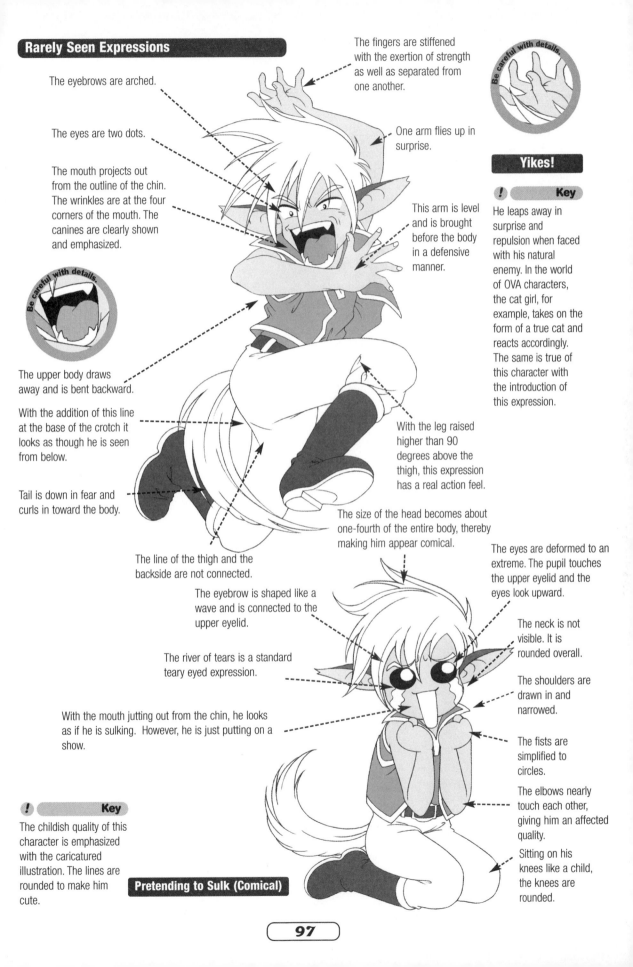

Rarely Seen Expressions

The eyebrows are arched.

The eyes are two dots.

The mouth projects out from the outline of the chin. The wrinkles are at the four corners of the mouth. The canines are clearly shown and emphasized.

The fingers are stiffened with the exertion of strength as well as separated from one another.

One arm flies up in surprise.

Be careful with details.

Yikes!

! Key

He leaps away in surprise and repulsion when faced with his natural enemy. In the world of OVA characters, the cat girl, for example, takes on the form of a true cat and reacts accordingly. The same is true of this character with the introduction of this expression.

This arm is level and is brought before the body in a defensive manner.

Be careful with details.

The upper body draws away and is bent backward.

With the addition of this line at the base of the crotch it looks as though he is seen from below.

Tail is down in fear and curls in toward the body.

With the leg raised higher than 90 degrees above the thigh, this expression has a real action feel.

The line of the thigh and the backside are not connected.

The size of the head becomes about one-fourth of the entire body, thereby making him appear comical.

The eyebrow is shaped like a wave and is connected to the upper eyelid.

The river of tears is a standard teary eyed expression.

The eyes are deformed to an extreme. The pupil touches the upper eyelid and the eyes look upward.

The neck is not visible. It is rounded overall.

The shoulders are drawn in and narrowed.

With the mouth jutting out from the chin, he looks as if he is sulking. However, he is just putting on a show.

The fists are simplified to circles.

The elbows nearly touch each other, giving him an affected quality.

! Key

The childish quality of this character is emphasized with the caricatured illustration. The lines are rounded to make him cute.

Pretending to Sulk (Comical)

Sitting on his knees like a child, the knees are rounded.

Expressing Emotions with Gestures

Her cheerful and positive nature is expressed by keeping her back straight. Due to her outgoing nature, her legs are often times spread outward.

However, on occasions when her girlishness peeps out, they would point inward. She is not coquettish nor nervous about other people's reactions.

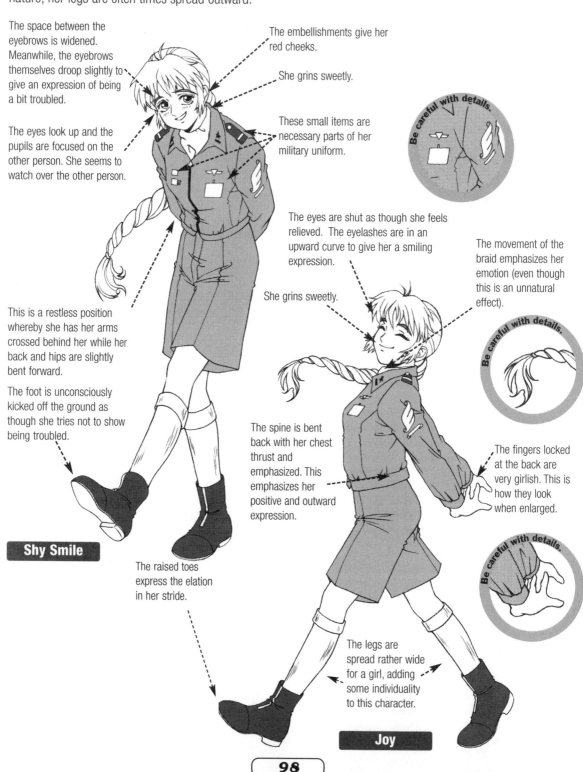

The space between the eyebrows is widened. Meanwhile, the eyebrows themselves droop slightly to give an expression of being a bit troubled.

The eyes look up and the pupils are focused on the other person. She seems to watch over the other person.

This is a restless position whereby she has her arms crossed behind her while her back and hips are slightly bent forward.

The foot is unconsciously kicked off the ground as though she tries not to show being troubled.

Shy Smile

The raised toes express the elation in her stride.

The embellishments give her red cheeks.

She grins sweetly.

These small items are necessary parts of her military uniform.

Be careful with details.

The eyes are shut as though she feels relieved. The eyelashes are in an upward curve to give her a smiling expression.

She grins sweetly.

The movement of the braid emphasizes her emotion (even though this is an unnatural effect).

Be careful with details.

The spine is bent back with her chest thrust and emphasized. This emphasizes her positive and outward expression.

The fingers locked at the back are very girlish. This is how they look when enlarged.

Be careful with details.

The legs are spread rather wide for a girl, adding some individuality to this character.

Joy

Variations of Expressions

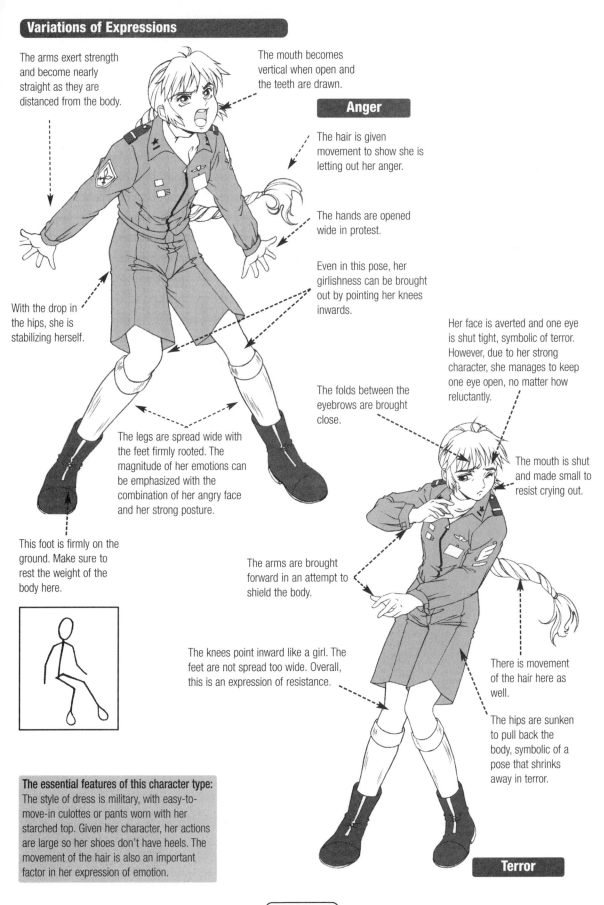

The arms exert strength and become nearly straight as they are distanced from the body.

The mouth becomes vertical when open and the teeth are drawn.

Anger

The hair is given movement to show she is letting out her anger.

The hands are opened wide in protest.

Even in this pose, her girlishness can be brought out by pointing her knees inwards.

With the drop in the hips, she is stabilizing herself.

Her face is averted and one eye is shut tight, symbolic of terror. However, due to her strong character, she manages to keep one eye open, no matter how reluctantly.

The folds between the eyebrows are brought close.

The mouth is shut and made small to resist crying out.

The legs are spread wide with the feet firmly rooted. The magnitude of her emotions can be emphasized with the combination of her angry face and her strong posture.

This foot is firmly on the ground. Make sure to rest the weight of the body here.

The arms are brought forward in an attempt to shield the body.

The knees point inward like a girl. The feet are not spread too wide. Overall, this is an expression of resistance.

There is movement of the hair here as well.

The hips are sunken to pull back the body, symbolic of a pose that shrinks away in terror.

The essential features of this character type:
The style of dress is military, with easy-to-move-in culottes or pants worn with her starched top. Given her character, her actions are large so her shoes don't have heels. The movement of the hair is also an important factor in her expression of emotion.

Terror

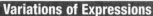

Variations of Expressions

The edges of the mouth are curled up as she chuckles.

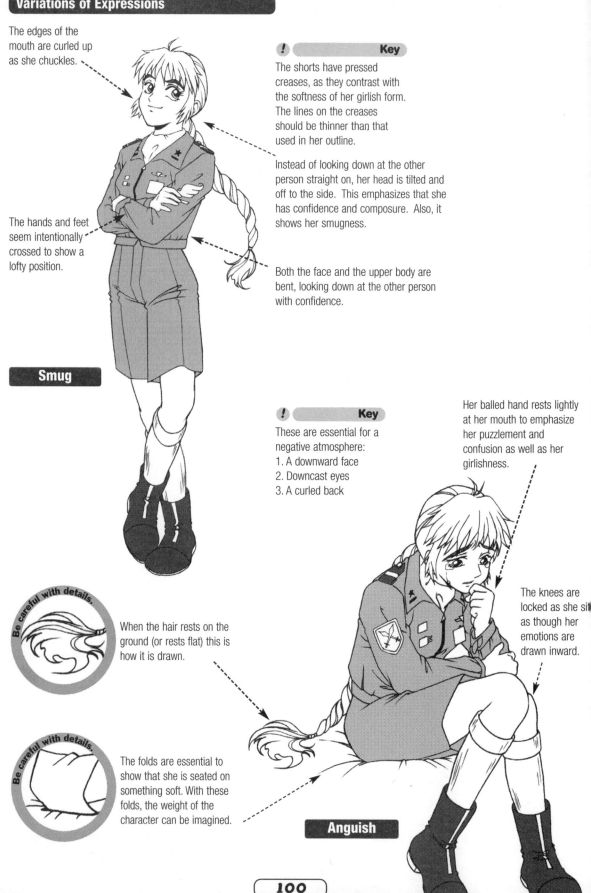

! Key

The shorts have pressed creases, as they contrast with the softness of her girlish form. The lines on the creases should be thinner than that used in her outline.

Instead of looking down at the other person straight on, her head is tilted and off to the side. This emphasizes that she has confidence and composure. Also, it shows her smugness.

Both the face and the upper body are bent, looking down at the other person with confidence.

The hands and feet seem intentionally crossed to show a lofty position.

Smug

! Key

These are essential for a negative atmosphere:
1. A downward face
2. Downcast eyes
3. A curled back

Her balled hand rests lightly at her mouth to emphasize her puzzlement and confusion as well as her girlishness.

The knees are locked as she si as though her emotions are drawn inward.

Be careful with details.

When the hair rests on the ground (or rests flat) this is how it is drawn.

Be careful with details.

The folds are essential to show that she is seated on something soft. With these folds, the weight of the character can be imagined.

Anguish

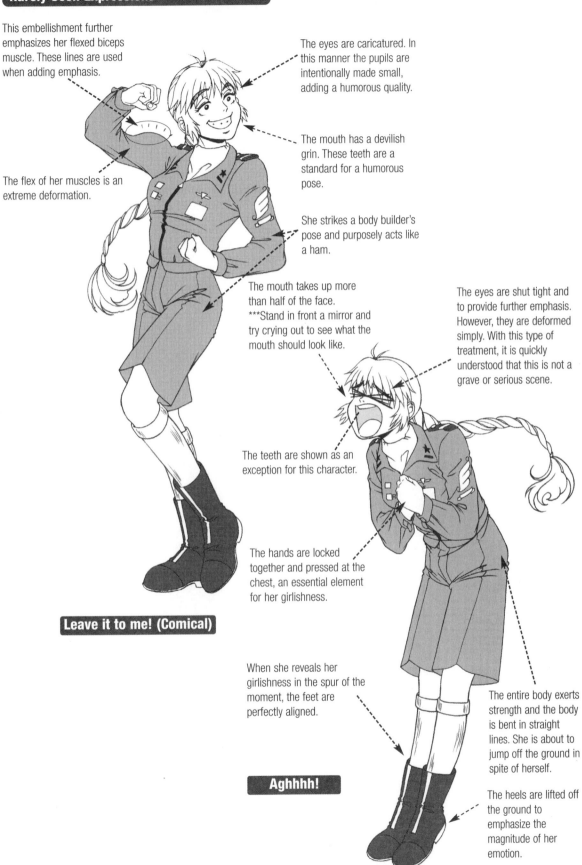

This embellishment further emphasizes her flexed biceps muscle. These lines are used when adding emphasis.

The flex of her muscles is an extreme deformation.

The eyes are caricatured. In this manner the pupils are intentionally made small, adding a humorous quality.

The mouth has a devilish grin. These teeth are a standard for a humorous pose.

She strikes a body builder's pose and purposely acts like a ham.

The mouth takes up more than half of the face.
***Stand in front a mirror and try crying out to see what the mouth should look like.

The teeth are shown as an exception for this character.

Leave it to me! (Comical)

The eyes are shut tight and to provide further emphasis. However, they are deformed simply. With this type of treatment, it is quickly understood that this is not a grave or serious scene.

The hands are locked together and pressed at the chest, an essential element for her girlishness.

When she reveals her girlishness in the spur of the moment, the feet are perfectly aligned.

The entire body exerts strength and the body is bent in straight lines. She is about to jump off the ground in spite of herself.

The heels are lifted off the ground to emphasize the magnitude of her emotion.

Aghhhh!

Giant Robot Pilot (Boy)

Expressing Emotions with Gestures

Male characters in giant robot type situations resemble sports characters. Passionate, his expressions are dynamic and his entire body is full of power. His character is easy to understand. The eyes are shut tight and to provide further emphasis. However, they are deformed simply. With this type of treatment, it is quickly understood that this is not a grave or serious scene. He doesn't make extreme gestures for the most part.

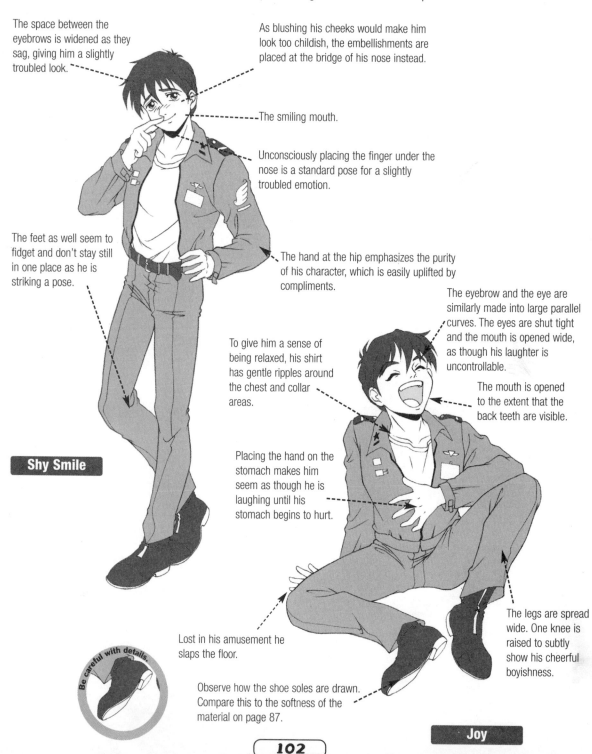

The space between the eyebrows is widened as they sag, giving him a slightly troubled look.

As blushing his cheeks would make him look too childish, the embellishments are placed at the bridge of his nose instead.

The smiling mouth.

Unconsciously placing the finger under the nose is a standard pose for a slightly troubled emotion.

The feet as well seem to fidget and don't stay still in one place as he is striking a pose.

The hand at the hip emphasizes the purity of his character, which is easily uplifted by compliments.

The eyebrow and the eye are similarly made into large parallel curves. The eyes are shut tight and the mouth is opened wide, as though his laughter is uncontrollable.

To give him a sense of being relaxed, his shirt has gentle ripples around the chest and collar areas.

The mouth is opened to the extent that the back teeth are visible.

Shy Smile

Placing the hand on the stomach makes him seem as though he is laughing until his stomach begins to hurt.

The legs are spread wide. One knee is raised to subtly show his cheerful boyishness.

Be careful with details

Lost in his amusement he slaps the floor.

Observe how the shoe soles are drawn. Compare this to the softness of the material on page 87.

Joy

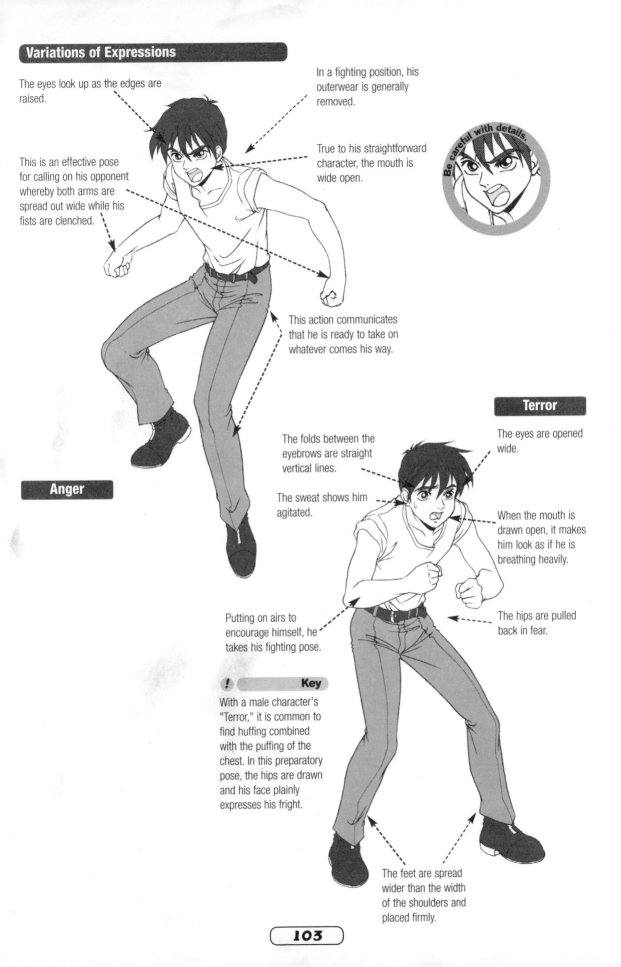

Variations of Expressions

The eyes look up as the edges are raised.

In a fighting position, his outerwear is generally removed.

True to his straightforward character, the mouth is wide open.

This is an effective pose for calling on his opponent whereby both arms are spread out wide while his fists are clenched.

Be careful with details.

This action communicates that he is ready to take on whatever comes his way.

Anger

Terror

The folds between the eyebrows are straight vertical lines.

The sweat shows him agitated.

The·eyes are opened wide.

When the mouth is drawn open, it makes him look as if he is breathing heavily.

Putting on airs to encourage himself, he takes his fighting pose.

The hips are pulled back in fear.

! Key

With a male character's "Terror," it is common to find huffing combined with the puffing of the chest. In this preparatory pose, the hips are drawn and his face plainly expresses his fright.

The feet are spread wider than the width of the shoulders and placed firmly.

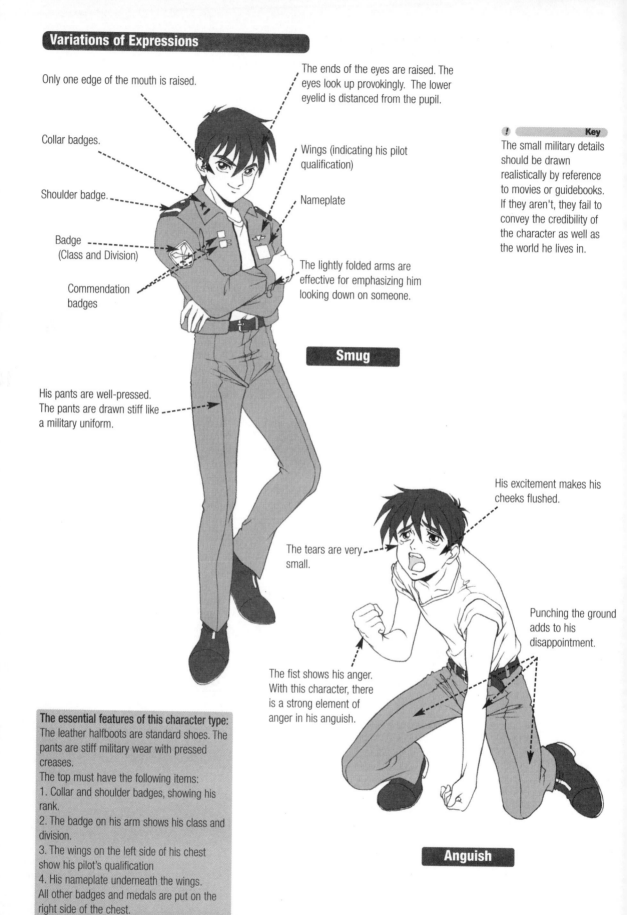

Only one edge of the mouth is raised.

The ends of the eyes are raised. The eyes look up provokingly. The lower eyelid is distanced from the pupil.

Collar badges.

Wings (indicating his pilot qualification)

Shoulder badge.

Nameplate

Badge (Class and Division)

The lightly folded arms are effective for emphasizing him looking down on someone.

Commendation badges

Smug

His pants are well-pressed. The pants are drawn stiff like a military uniform.

His excitement makes his cheeks flushed.

The tears are very small.

Punching the ground adds to his disappointment.

The fist shows his anger. With this character, there is a strong element of anger in his anguish.

Anguish

> **! Key**
> The small military details should be drawn realistically by reference to movies or guidebooks. If they aren't, they fail to convey the credibility of the character as well as the world he lives in.

The essential features of this character type:
The leather halfboots are standard shoes. The pants are stiff military wear with pressed creases.
The top must have the following items:
1. Collar and shoulder badges, showing his rank.
2. The badge on his arm shows his class and division.
3. The wings on the left side of his chest show his pilot's qualification
4. His nameplate underneath the wings.
All other badges and medals are put on the right side of the chest.

Rarely Seen Expressions

The eyebrows are distanced from the eyes. They are slightly frowned and show his surprise.

Distorting the upper lip is effective to convey his startle.

This caricature is a standard for comical scenes. His gazed is fixed on the source of his action/surprise.

The shoulders are raised in surprise.

The leg is raised high off the ground.

Due to the sudden reactions, his legs lose balance.

Startled

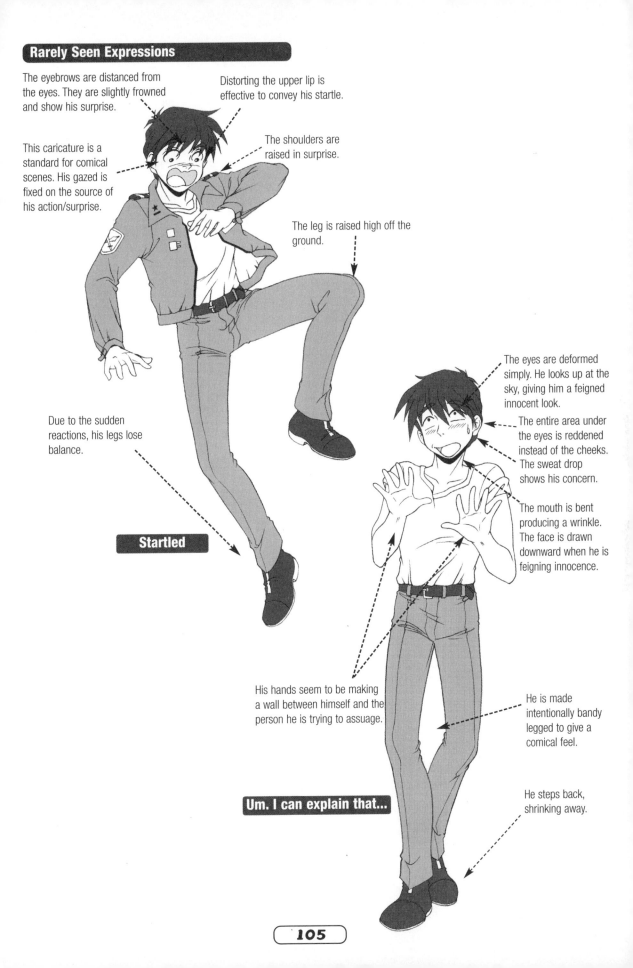

The eyes are deformed simply. He looks up at the sky, giving him a feigned innocent look.

The entire area under the eyes is reddened instead of the cheeks. The sweat drop shows his concern.

The mouth is bent producing a wrinkle. The face is drawn downward when he is feigning innocence.

His hands seem to be making a wall between himself and the person he is trying to assuage.

He is made intentionally bandy legged to give a comical feel.

Um. I can explain that...

He steps back, shrinking away.

Aesthetic Character (Young Boy)

Expressing Emotions with Gestures

In other types of situations, this role is played by a girl, so this young boy's gestures are made girlish. He intentionally plays up the girlishness, giving a close-up view of his single-minded nature. The feet are generally not spread and the arms are not separated from the body. The hands are also lightly closed and he is drawn in a turned-in pose overall.

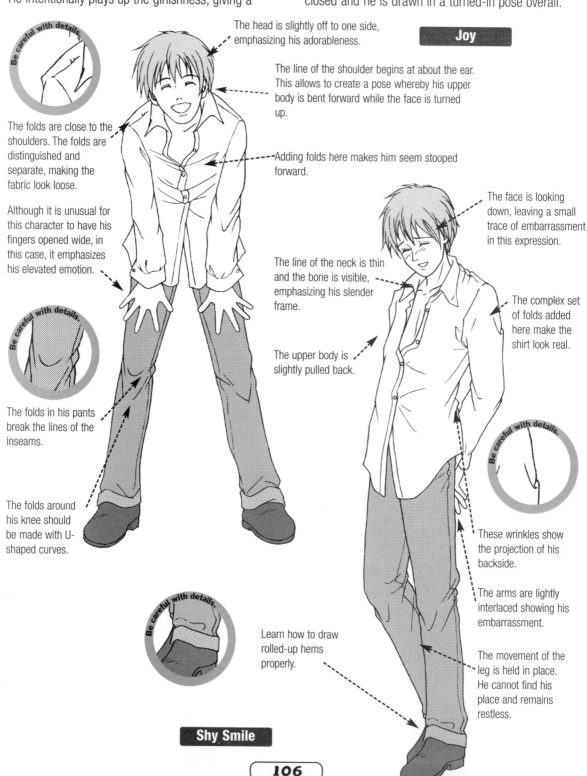

The head is slightly off to one side, emphasizing his adorableness.

Joy

The line of the shoulder begins at about the ear. This allows to create a pose whereby his upper body is bent forward while the face is turned up.

The folds are close to the shoulders. The folds are distinguished and separate, making the fabric look loose.

Adding folds here makes him seem stooped forward.

Although it is unusual for this character to have his fingers opened wide, in this case, it emphasizes his elevated emotion.

The face is looking down, leaving a small trace of embarrassment in this expression.

The line of the neck is thin and the bone is visible, emphasizing his slender frame.

The complex set of folds added here make the shirt look real.

The folds in his pants break the lines of the inseams.

The upper body is slightly pulled back.

The folds around his knee should be made with U-shaped curves.

These wrinkles show the projection of his backside.

The arms are lightly interlaced showing his embarrassment.

Learn how to draw rolled-up hems properly.

The movement of the leg is held in place. He cannot find his place and remains restless.

Shy Smile

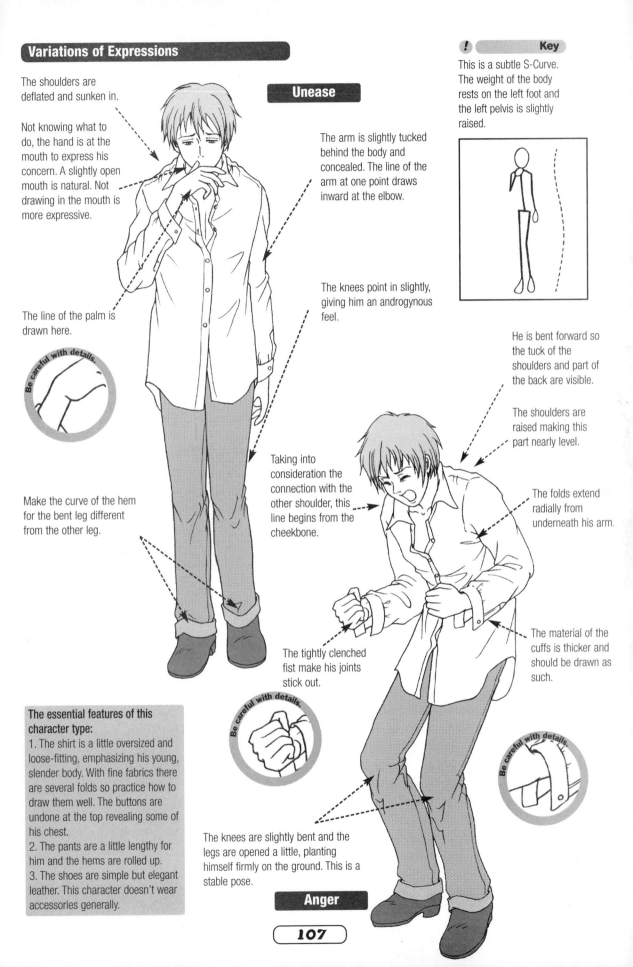

Unease

! Key

This is a subtle S-Curve. The weight of the body rests on the left foot and the left pelvis is slightly raised.

The shoulders are deflated and sunken in.

Not knowing what to do, the hand is at the mouth to express his concern. A slightly open mouth is natural. Not drawing in the mouth is more expressive.

The arm is slightly tucked behind the body and concealed. The line of the arm at one point draws inward at the elbow.

The line of the palm is drawn here.

Be careful with details.

The knees point in slightly, giving him an androgynous feel.

He is bent forward so the tuck of the shoulders and part of the back are visible.

The shoulders are raised making this part nearly level.

Make the curve of the hem for the bent leg different from the other leg.

Taking into consideration the connection with the other shoulder, this line begins from the cheekbone.

The folds extend radially from underneath his arm.

The tightly clenched fist make his joints stick out.

Be careful with details.

The material of the cuffs is thicker and should be drawn as such.

Be careful with details.

The essential features of this character type:
1. The shirt is a little oversized and loose-fitting, emphasizing his young, slender body. With fine fabrics there are several folds so practice how to draw them well. The buttons are undone at the top revealing some of his chest.
2. The pants are a little lengthy for him and the hems are rolled up.
3. The shoes are simple but elegant leather. This character doesn't wear accessories generally.

The knees are slightly bent and the legs are opened a little, planting himself firmly on the ground. This is a stable pose.

Anger

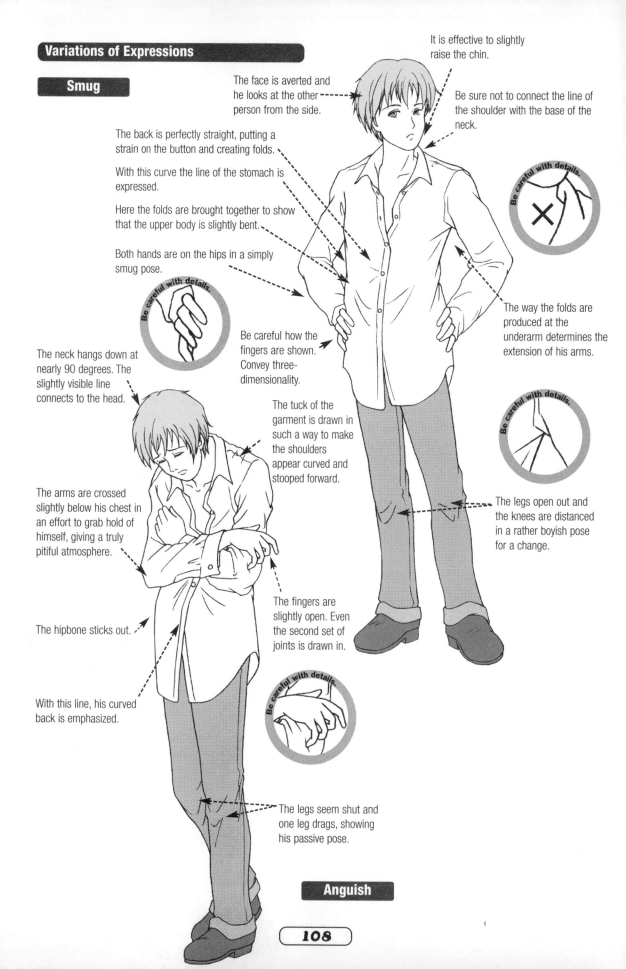

Variations of Expressions

Smug

It is effective to slightly raise the chin.

The face is averted and he looks at the other person from the side.

Be sure not to connect the line of the shoulder with the base of the neck.

The back is perfectly straight, putting a strain on the button and creating folds.

With this curve the line of the stomach is expressed.

Here the folds are brought together to show that the upper body is slightly bent.

Both hands are on the hips in a simply smug pose.

Be careful with details.

Be careful how the fingers are shown. Convey three-dimensionality.

The way the folds are produced at the underarm determines the extension of his arms.

Be careful with details.

Be careful with details.

The legs open out and the knees are distanced in a rather boyish pose for a change.

The neck hangs down at nearly 90 degrees. The slightly visible line connects to the head.

The tuck of the garment is drawn in such a way to make the shoulders appear curved and stooped forward.

The arms are crossed slightly below his chest in an effort to grab hold of himself, giving a truly pitiful atmosphere.

The hipbone sticks out.

With this line, his curved back is emphasized.

The fingers are slightly open. Even the second set of joints is drawn in.

Be careful with details.

The legs seem shut and one leg drags, showing his passive pose.

Anguish

108

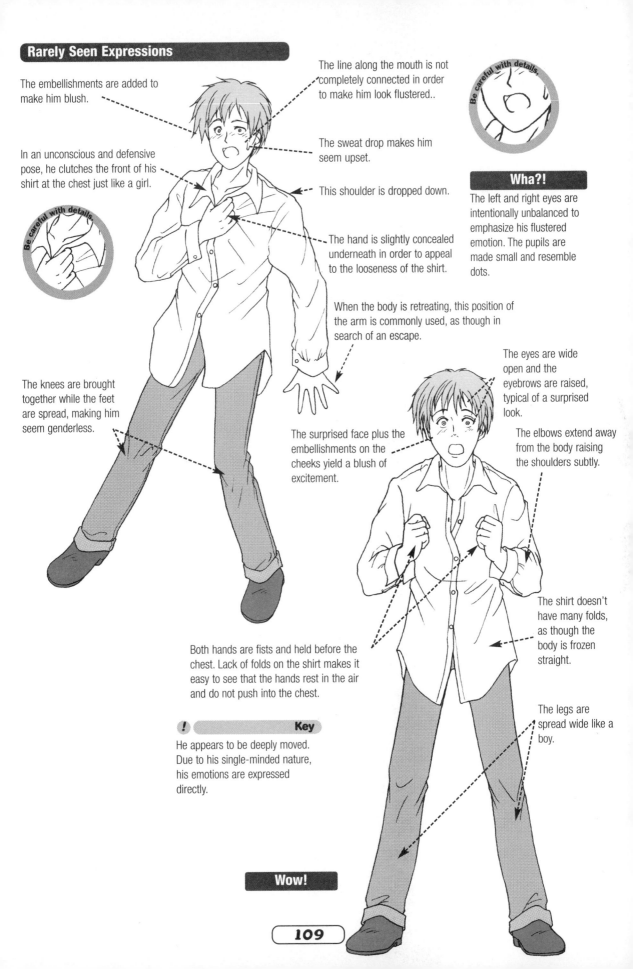

The embellishments are added to make him blush.

The line along the mouth is not completely connected in order to make him look flustered..

Be careful with details.

In an unconscious and defensive pose, he clutches the front of his shirt at the chest just like a girl.

The sweat drop makes him seem upset.

This shoulder is dropped down.

Be careful with details.

Wha?!

The left and right eyes are intentionally unbalanced to emphasize his flustered emotion. The pupils are made small and resemble dots.

The hand is slightly concealed underneath in order to appeal to the looseness of the shirt.

When the body is retreating, this position of the arm is commonly used, as though in search of an escape.

The eyes are wide open and the eyebrows are raised, typical of a surprised look.

The knees are brought together while the feet are spread, making him seem genderless.

The surprised face plus the embellishments on the cheeks yield a blush of excitement.

The elbows extend away from the body raising the shoulders subtly.

The shirt doesn't have many folds, as though the body is frozen straight.

Both hands are fists and held before the chest. Lack of folds on the shirt makes it easy to see that the hands rest in the air and do not push into the chest.

The legs are spread wide like a boy.

! **Key**

He appears to be deeply moved. Due to his single-minded nature, his emotions are expressed directly.

Wow!

Aesthetic Character Type (Young Man)

Expressing Emotions with Gestures

His character has had some trauma that causes him to always to put up a front rather than be himself. If he doesn't strike a pose, he becomes nervous, so he rarely expresses his emotions directly. Striking poses that conceal one part of the body—folding his arms or putting his hands in his pockets—are characteristic. For the most part, he doesn't make extreme poses, such as showing tears, opening his mouth largely in laughter, or raising his fists in rage. Draw him in a stylish manner.

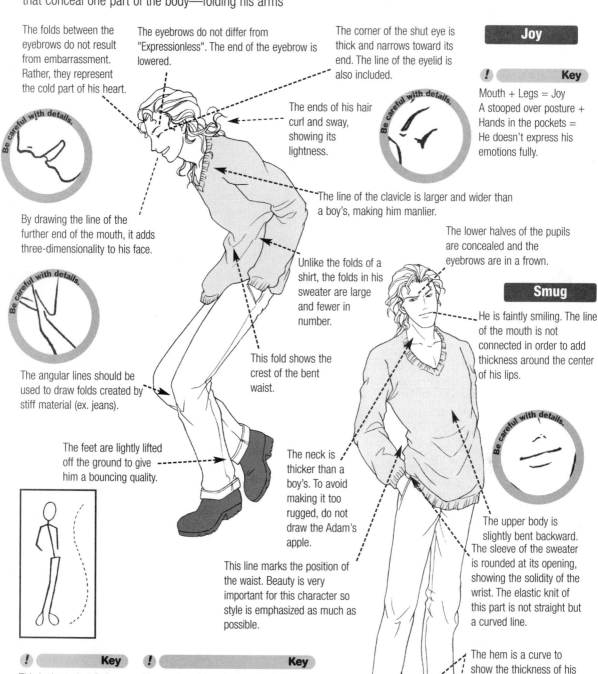

The folds between the eyebrows do not result from embarrassment. Rather, they represent the cold part of his heart.

Be careful with details.

By drawing the line of the further end of the mouth, it adds three-dimensionality to his face.

Be careful with details.

The angular lines should be used to draw folds created by stiff material (ex. jeans).

The feet are lightly lifted off the ground to give him a bouncing quality.

The eyebrows do not differ from "Expressionless". The end of the eyebrow is lowered.

The ends of his hair curl and sway, showing its lightness.

The corner of the shut eye is thick and narrows toward its end. The line of the eyelid is also included.

Be careful with details.

The line of the clavicle is larger and wider than a boy's, making him manlier.

Unlike the folds of a shirt, the folds in his sweater are large and fewer in number.

This fold shows the crest of the bent waist.

The neck is thicker than a boy's. To avoid making it too rugged, do not draw the Adam's apple.

This line marks the position of the waist. Beauty is very important for this character so style is emphasized as much as possible.

Joy

! Key

Mouth + Legs = Joy
A stooped over posture + Hands in the pockets = He doesn't express his emotions fully.

The lower halves of the pupils are concealed and the eyebrows are in a frown.

Smug

He is faintly smiling. The line of the mouth is not connected in order to add thickness around the center of his lips.

Be careful with details.

The upper body is slightly bent backward. The sleeve of the sweater is rounded at its opening, showing the solidity of the wrist. The elastic knit of this part is not straight but a curved line.

The hem is a curve to show the thickness of his shoes. The rolled-up hem shows the quality of the material.

! Key

This is the typical S-Curve pose. This can be easily seen in the outline drawing.

! Key

His mouth and legs indicate his joy. His stooped over posture with the hands in the pockets tells that he conceals his emotions.

The lowered mouth is treated as three lines. The line of the lower lip is clearly drawn in, as though he has taken offense.

The hair doesn't move too much as though his anger is restrained.

Wrinkles form around the end of the eye as he looks down.

The line of the hand and the line of the wrist are not connected.

The arms are folded at the chest and provoke his opponent. This expression also has an element of smugness.

The arms are not rugged and can be grasped in one hand.

Showing the fingers here adds to his arrogance. Be careful with the area of the joints. Only one part is visible so draw it properly to make clear what is being shown.

This fold shows the position of the waist.

The eyebrows are raised and touch the corners of the eyes. The upper halves of the pupils are concealed by the eyelid. There are folds between the eyebrows.

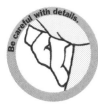

The shoulders are raised so the line of the shoulder begins from the middle of neck.

The right leg bears the weight of the body so the pelvis slants in the same direction and is raised.

These are form-fitting jeans so the folds also follow the form of the body.

The small, vertical lines at both edges of the mouth show that the jaw is shut tight all the way back to the molars.

The feet always point outward.

The folds mark the position of the waist. Placing the folds in a high position gives the impression that his hips are sunken.

Although lowered, the power of the fist is building.

The essential features of this character type:
1. A loosely knit sweater is worn over his bare skin. The V-neck collar gives him a sharper image.
2. He wears slim jeans or leather pants, creating a contrast with the upper body. His tall and slender legs are emphasized.
3. His leather shoes are rubber-soled and meant for casual wear.
4. If he is given accessories, make sure they are simple and not gaudy.

This hand is concealed in part by the body.

The legs are spread wider than the width of the shoulders. With one leg drawn back he is in a stable posture.

The knees are lightly bent as though he is ready to leap into a fight.

An upward fist is more inciting than a downward fist when fighting.

The calf muscles are taught.

Variations of Expressions

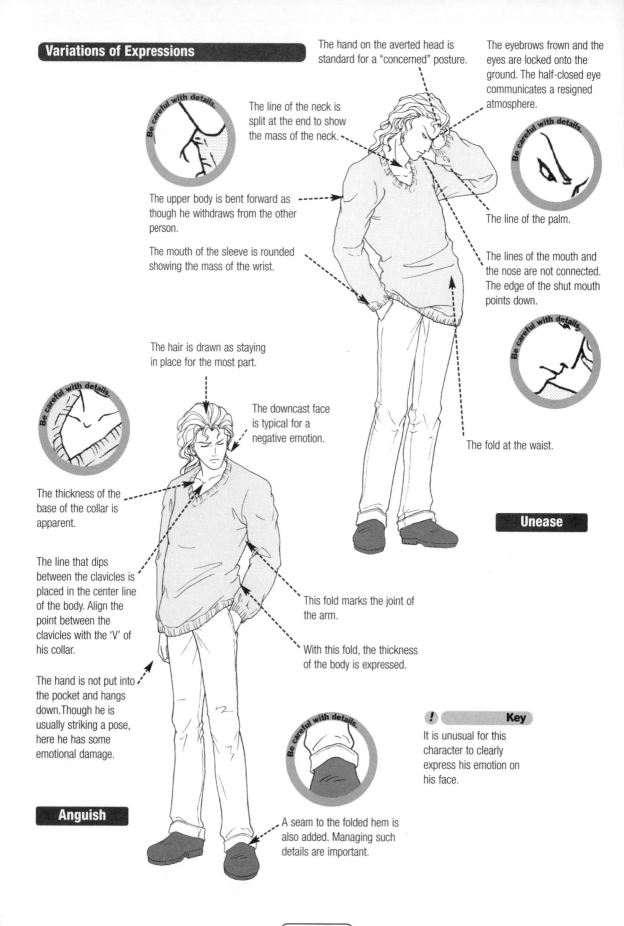

The hand on the averted head is standard for a "concerned" posture.

The eyebrows frown and the eyes are locked onto the ground. The half-closed eye communicates a resigned atmosphere.

Be careful with details.

The line of the neck is split at the end to show the mass of the neck.

The upper body is bent forward as though he withdraws from the other person.

The mouth of the sleeve is rounded showing the mass of the wrist.

Be careful with details.

The line of the palm.

The lines of the mouth and the nose are not connected. The edge of the shut mouth points down.

Be careful with details.

The hair is drawn as staying in place for the most part.

The downcast face is typical for a negative emotion.

The fold at the waist.

Unease

Be careful with details.

The thickness of the base of the collar is apparent.

The line that dips between the clavicles is placed in the center line of the body. Align the point between the clavicles with the 'V' of his collar.

The hand is not put into the pocket and hangs down. Though he is usually striking a pose, here he has some emotional damage.

This fold marks the joint of the arm.

With this fold, the thickness of the body is expressed.

! **Key**

It is unusual for this character to clearly express his emotion on his face.

Anguish

Be careful with details.

A seam to the folded hem is also added. Managing such details are important.

112

Occasionally Seen Expressions

Key

This is an extremely unusual expression. This character is being playful while scorning the other person by placing himself in some lofty, exalted position. At times like this, there is no reasoning with him. In one way, the mood is cold but this is the character's warped sense turned inside-out.

O.K., Come On!

The ends of the eyebrows are unusually lowered while the corners are raised along the forehead, showing the curve of the sockets.

The mouth is opened wide in a laugh but only one edge is raised as though being done deliberately.

Be careful with details.

Bending the elbow with the palm faced up produces natural-looking triangular folds.

The hand is bent back all the way to the wrists, showing his exaggerated expression.

The fold of the palm is represented by the lines at the pinky and the thumb. The line of the wrist and the palm are not connected.

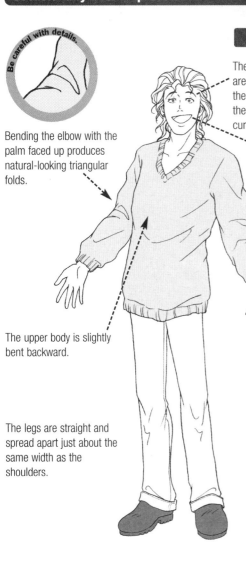

The upper body is slightly bent backward.

The edge of the mouth is raised and the back teeth are clenched on one side. The lower lip is raised on the other side of the clenched teeth.

The eyes are shut tight and there are wrinkles between the eyebrows.

The legs are straight and spread apart just about the same width as the shoulders.

Be careful with details.

The back is rounded as he tries to fight the pain.

He is grasping himself with great strength to endure pain so the bones of his hands are visible. Drawing the knuckles is effective.

He clutches himself in an attempt to endure the pain. The folds on his sweater are drawn radially from the fingers.

Be careful with details.

The hips are bent.

Key

The character always endures his pain without ever revealing it. However, in this case, the level of this pain is so great that he can't even strike a pose.

The legs are open and the knees are bent as though he is trying to steady his footing.

Sharp Pain

Detective Story Character (Girl)

Expressing Emotions with Gestures

She aims to be stylish and chic but her childishness is still visible, making her adorable. She strikes a pose like a Hollywood actress but there is a comical element to this that doubles her charm. Her large gestures reflect her character.

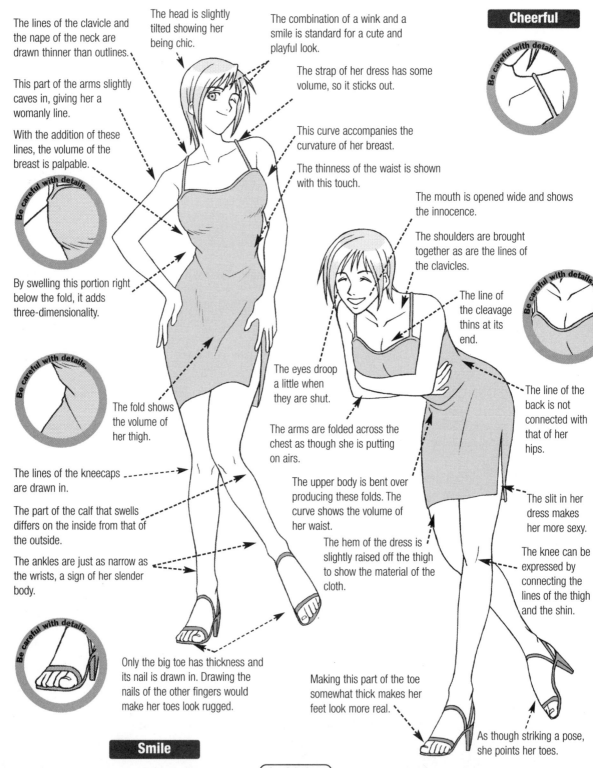

The lines of the clavicle and the nape of the neck are drawn thinner than outlines.

The head is slightly tilted showing her being chic.

The combination of a wink and a smile is standard for a cute and playful look.

Cheerful

This part of the arms slightly caves in, giving her a womanly line.

The strap of her dress has some volume, so it sticks out.

With the addition of these lines, the volume of the breast is palpable.

This curve accompanies the curvature of her breast.

The thinness of the waist is shown with this touch.

The mouth is opened wide and shows the innocence.

Be careful with details.

By swelling this portion right below the fold, it adds three-dimensionality.

The shoulders are brought together as are the lines of the clavicles.

The line of the cleavage thins at its end.

Be careful with details.

The eyes droop a little when they are shut.

The line of the back is not connected with that of her hips.

The fold shows the volume of her thigh.

The arms are folded across the chest as though she is putting on airs.

The lines of the kneecaps are drawn in.

The upper body is bent over producing these folds. The curve shows the volume of her waist.

The slit in her dress makes her more sexy.

The part of the calf that swells differs on the inside from that of the outside.

The hem of the dress is slightly raised off the thigh to show the material of the cloth.

The knee can be expressed by connecting the lines of the thigh and the shin.

The ankles are just as narrow as the wrists, a sign of her slender body.

Be careful with details.

Only the big toe has thickness and its nail is drawn in. Drawing the nails of the other fingers would make her toes look rugged.

Making this part of the toe somewhat thick makes her feet look more real.

As though striking a pose, she points her toes.

Smile

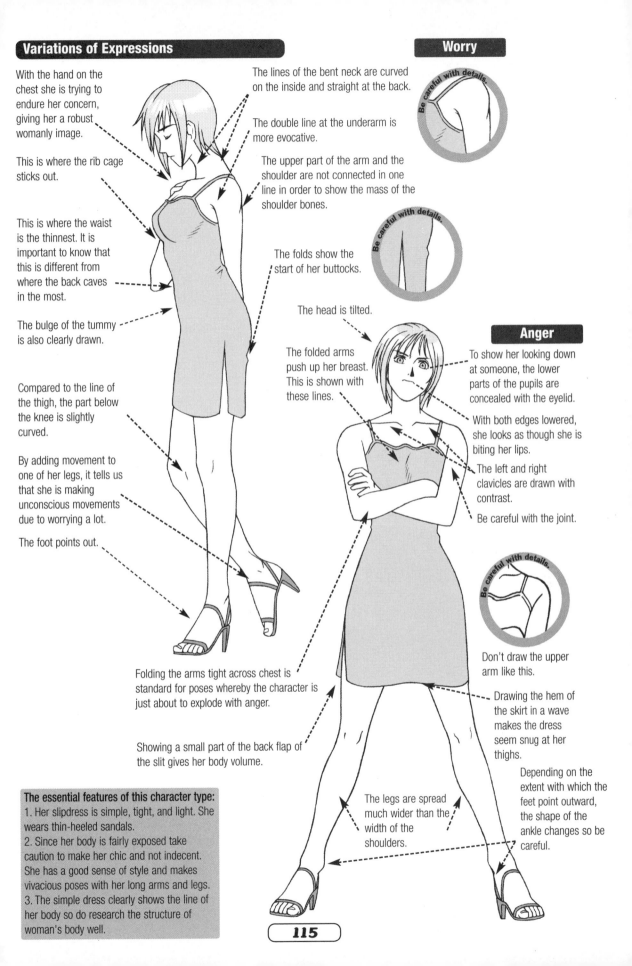

Variations of Expressions

With the hand on the chest she is trying to endure her concern, giving her a robust womanly image.

This is where the rib cage sticks out.

This is where the waist is the thinnest. It is important to know that this is different from where the back caves in the most.

The bulge of the tummy is also clearly drawn.

Compared to the line of the thigh, the part below the knee is slightly curved.

By adding movement to one of her legs, it tells us that she is making unconscious movements due to worrying a lot.

The foot points out.

The lines of the bent neck are curved on the inside and straight at the back.

The double line at the underarm is more evocative.

The upper part of the arm and the shoulder are not connected in one line in order to show the mass of the shoulder bones.

The folds show the start of her buttocks.

The head is tilted.

The folded arms push up her breast. This is shown with these lines.

Folding the arms tight across chest is standard for poses whereby the character is just about to explode with anger.

Showing a small part of the back flap of the slit gives her body volume.

Worry

Be careful with details.

Be careful with details.

Anger

To show her looking down at someone, the lower parts of the pupils are concealed with the eyelid.

With both edges lowered, she looks as though she is biting her lips.

The left and right clavicles are drawn with contrast.

Be careful with the joint.

Be careful with details.

Don't draw the upper arm like this.

Drawing the hem of the skirt in a wave makes the dress seem snug at her thighs.

Depending on the extent with which the feet point outward, the shape of the ankle changes so be careful.

The legs are spread much wider than the width of the shoulders.

The essential features of this character type:
1. Her slipdress is simple, tight, and light. She wears thin-heeled sandals.
2. Since her body is fairly exposed take caution to make her chic and not indecent. She has a good sense of style and makes vivacious poses with her long arms and legs.
3. The simple dress clearly shows the line of her body so do research the structure of woman's body well.

Smug

Looking sideways at the other person communicates her frankness and innocence.

This is the outline of her profile from the nose to the chin. Be sure it is drawn with volume.

The bulge of the shoulder is drawn clearly.

This line is important to show her underarm.

The flesh not covered by the dress is also given an embellishment to show the mass of her bosom.

The line of the chest extends until here.

With hand on hip and the back straightened, she wants to make herself look adult.

Draw in the lines of the kneecap.

Be careful with details.

This fold expresses her concern or displeasure.

The pupil seems to float in the center of the eye as though she is gazing steadily.

The mouth is opened to swallow her breath.

The upper body is bent back, as though she will leap away from the object of her fright.

The shoulders are raised slightly. The raised arms bend and float out. She has just seen something frightening and her body is stiff like a rock.

Even her fingers seem stiff as they flare out.

The curve of the hem matches the bulge of her thighs.

Because the hips are drawn and the upper body is bent greatly, the back of the dress is visible.

The legs are spread a little wider than the width of the shoulders, giving her an air of confidence.

Terror

The knees are bent with weakness. Be careful to make the area directly under the knee sink in when bent.

The tops of her feet are almost vertical and the heels are off the ground.

The ankle juts out here and is not drawn with a straight line from the calf. Draw the bone clearly sticking out.

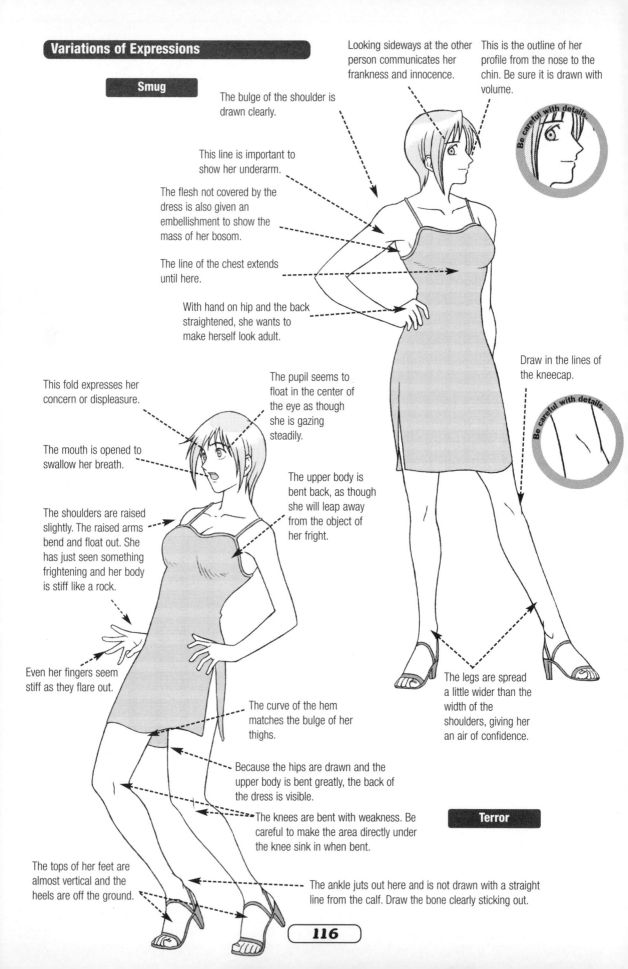

116

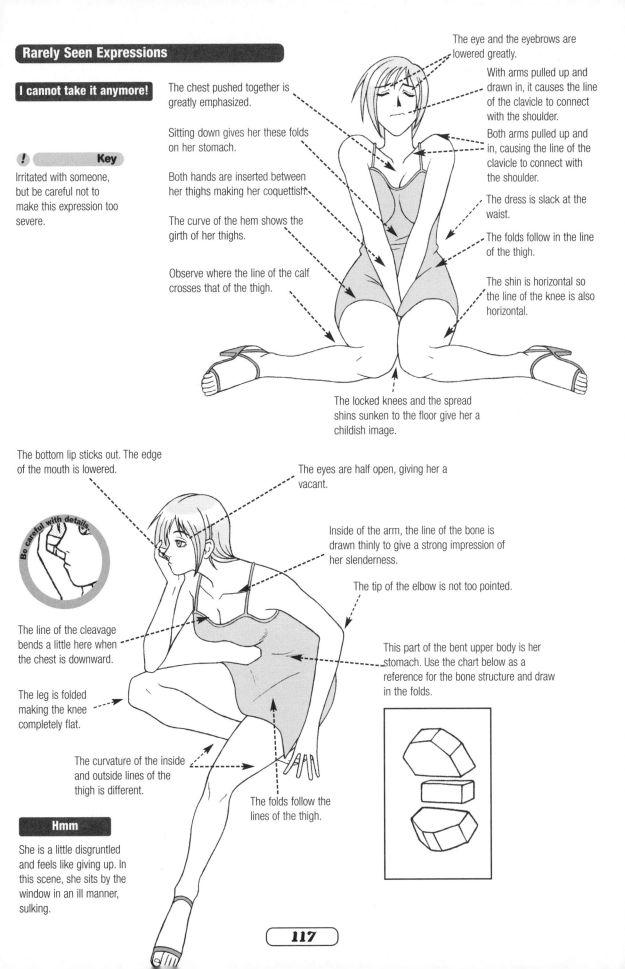

Rarely Seen Expressions

I cannot take it anymore!

! Key

Irritated with someone, but be careful not to make this expression too severe.

The eye and the eyebrows are lowered greatly.

With arms pulled up and drawn in, it causes the line of the clavicle to connect with the shoulder.

Both arms pulled up and in, causing the line of the clavicle to connect with the shoulder.

The dress is slack at the waist.

The folds follow in the line of the thigh.

The shin is horizontal so the line of the knee is also horizontal.

The chest pushed together is greatly emphasized.

Sitting down gives her these folds on her stomach.

Both hands are inserted between her thighs making her coquettish.

The curve of the hem shows the girth of her thighs.

Observe where the line of the calf crosses that of the thigh.

The locked knees and the spread shins sunken to the floor give her a childish image.

The bottom lip sticks out. The edge of the mouth is lowered.

The eyes are half open, giving her a vacant.

Inside of the arm, the line of the bone is drawn thinly to give a strong impression of her slenderness.

The tip of the elbow is not too pointed.

Be careful with details

The line of the cleavage bends a little here when the chest is downward.

The leg is folded making the knee completely flat.

The curvature of the inside and outside lines of the thigh is different.

This part of the bent upper body is her stomach. Use the chart below as a reference for the bone structure and draw in the folds.

The folds follow the lines of the thigh.

Hmm

She is a little disgruntled and feels like giving up. In this scene, she sits by the window in an ill manner, sulking.

Detective Story Character (Young Man)

Expressing Emotions with Gestures

He puts on a poker face, doesn't want to express his emotions much, and his actions when expressing emotion are not heavy handed. As a result, small movements of the hand or face are important points for communicating this character's inner self. Imagine him as one of the detectives of Hollywood "Noir" films.

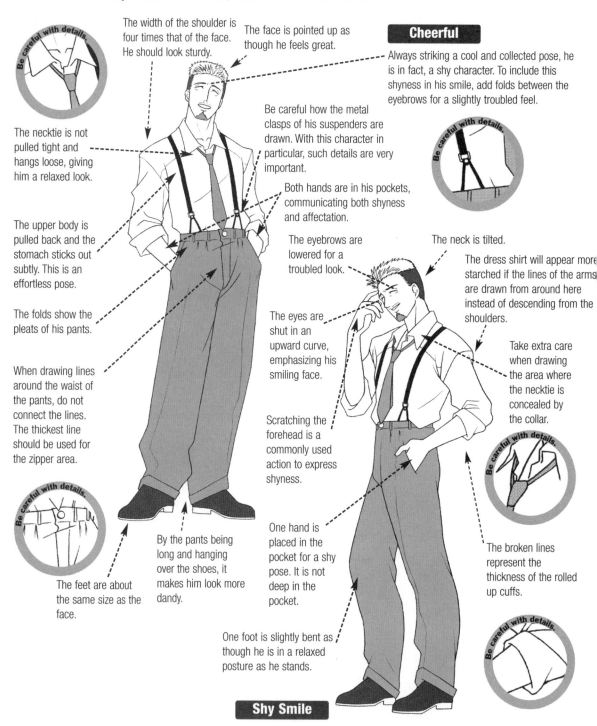

Be careful with details.

The width of the shoulder is four times that of the face. He should look sturdy.

The face is pointed up as though he feels great.

The necktie is not pulled tight and hangs loose, giving him a relaxed look.

Be careful how the metal clasps of his suspenders are drawn. With this character in particular, such details are very important.

The upper body is pulled back and the stomach sticks out subtly. This is an effortless pose.

The folds show the pleats of his pants.

When drawing lines around the waist of the pants, do not connect the lines. The thickest line should be used for the zipper area.

Be careful with details.

The feet are about the same size as the face.

By the pants being long and hanging over the shoes, it makes him look more dandy.

Cheerful

Always striking a cool and collected pose, he is in fact, a shy character. To include this shyness in his smile, add folds between the eyebrows for a slightly troubled feel.

Be careful with details.

Both hands are in his pockets, communicating both shyness and affection.

The eyebrows are lowered for a troubled look.

The eyes are shut in an upward curve, emphasizing his smiling face.

Scratching the forehead is a commonly used action to express shyness.

One hand is placed in the pocket for a shy pose. It is not deep in the pocket.

One foot is slightly bent as though he is in a relaxed posture as he stands.

The neck is tilted.

The dress shirt will appear more starched if the lines of the arms are drawn from around here instead of descending from the shoulders.

Take extra care when drawing the area where the necktie is concealed by the collar.

Be careful with details.

The broken lines represent the thickness of the rolled up cuffs.

Be careful with details.

Shy Smile

Variations of Expressions

The folds between the eyebrows are drawn together.

The width of this curve becomes the width of his broad shoulder.

The eyes are half closed, giving the impression he is looking into the distance.

Sentimental

The short cigarette is held near the base of the fingers. It expresses his brute manliness.

He has his own style and customs and he doesn't compromise his values for the sake of another. Putting his hands in his pockets is his habit. Make sure to include it in any pose where he is not aware of himself.

The opposite is true for women. The cigarette is held between the tips of the fingers, giving her a slender image.

This pleat is at the front of the leg. Unless it extends in the direction of the tip of the toe, it will look like a confused illustration.

When only the edge of the mouth is slightly opened, he seems to be biting his lip.

The feet point outward as though nothing is on his mind. This character can never have feet pointed inward.

The necktie sways in the direction of the upper body. A large sway in the tie makes him seem very angered.

The line of the waist matches the curvature of his body. This illustration is seen slightly from a lowered angle so the line of the waist is an upward curve.

This line of the zipper becomes the center line from the stomach. Be careful of its direction.

This line is the top of the leg.

From this point, the outline is the line of the shin. The leg is raised in a kick so the pantleg is pressed against the shin.

The essential features of this character type:

1. The collar of his shirt is left open and the shirt is a little stiff.
2. The necktie is very slack and there are occasions where it is used to express emotion so a tie tack is not used.
3. Suspenders
4. Pleated and loose pants (no belt). They have been pressed and have a crease.
5. The fold and the hem give him a classic touch.
6. The tough shoes seem made-to-order.

These are the standard items for a crime detective. Use movie videos as a reference.

The body of this character is twisted as above. Without being aware of this bone structure when drawing, the folds and the drawing will look unnatural.

He looks as though he is kicking a trashcan or an empty soda can. Here, the ankle can be seen as an exception.

Be careful with the soles of the shoes. The shadow is drawn to show the hard leather soles.

Anger

Anguish

Lightly pushing back his sunglasses expresses his attempt to bear his anguish. He uses his index and middle fingers to push them back while the other fingers are lightly aligned.

Wearing sunglasses communicates the reluctance to have his emotions seen by anyone.

The eyebrows are brought together and the face is vaguely averted.

This shoulder is level.

His shoulder drops just a little because his hand is in his pocket.

Be careful with details.

One hand is in the pocket as always. When viewed from the front, only one part of the arm is exposed for a rugged look.

The place where the arm is most bulged differs for the interior and exterior. This is due to his male musculature.

The legs come down straight. Their movement is controlled, enacting a calm atmosphere.

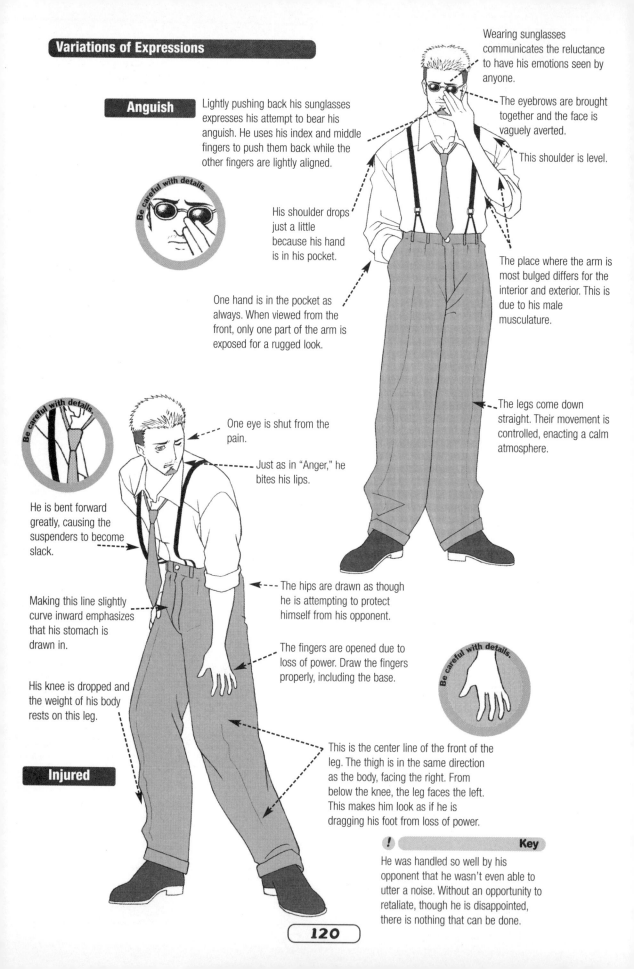

One eye is shut from the pain.

Just as in "Anger," he bites his lips.

Be careful with details.

He is bent forward greatly, causing the suspenders to become slack.

Making this line slightly curve inward emphasizes that his stomach is drawn in.

His knee is dropped and the weight of his body rests on this leg.

The hips are drawn as though he is attempting to protect himself from his opponent.

The fingers are opened due to loss of power. Draw the fingers properly, including the base.

Be careful with details.

Injured

This is the center line of the front of the leg. The thigh is in the same direction as the body, facing the right. From below the knee, the leg faces the left. This makes him look as if he is dragging his foot from loss of power.

! Key

He was handled so well by his opponent that he wasn't even able to utter a noise. Without an opportunity to retaliate, though he is disappointed, there is nothing that can be done.

Rarely Seen Expressions

The left and right eyebrow curve in exactly opposite directions, giving the impression that he has suddenly taken a grouchy attitude.

The pupil is deformed. Making it small adds a comical element.

The cigarette is slightly bent, giving it a worn out look. And since it points upwards, his lower lip seems to jut out.

The edge of the mouth is lowered.

The fingers are bent back.

Adding a line here gives a sense of the volume of the hand.

I give up!

Key

This is a straight pose but the weight of the body subtly rests on the left leg. Apart from commemorative photographs, people generally don't stand with their weight evenly distributed over both legs. Making the weight slightly shifted to one side makes the illustration look real.

Both hands are raised in a "I Give Up!" pose.

The length from shoulder to elbow and from elbow to wrist is about the same.

The hand is opened and raised in a typical pose of greeting someone. Be careful how the fingers overlap.

With his drooping eyes, it brings out a flippant element in his smile.

Adding the folds here shows his lowered neck.

These pants are extra long, causing these sagging folds.

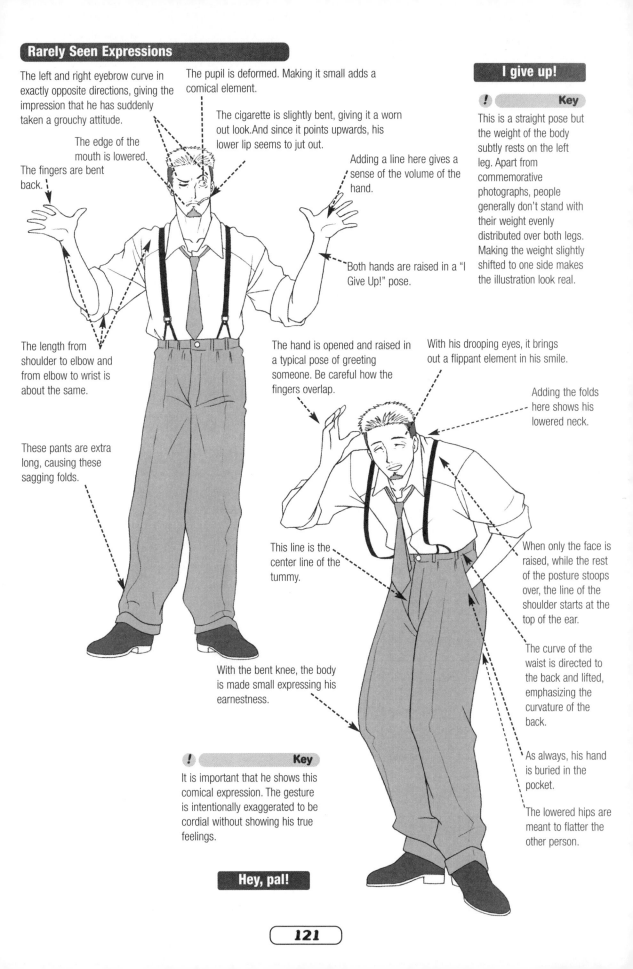

This line is the center line of the tummy.

When only the face is raised, while the rest of the posture stoops over, the line of the shoulder starts at the top of the ear.

The curve of the waist is directed to the back and lifted, emphasizing the curvature of the back.

With the bent knee, the body is made small expressing his earnestness.

As always, his hand is buried in the pocket.

Key

It is important that he shows this comical expression. The gesture is intentionally exaggerated to be cordial without showing his true feelings.

The lowered hips are meant to flatter the other person.

Hey, pal!

121

Student Character Type (Girl)

Expressing Emotions with Gestures

She is lively and active so her expression emotion is large. She has distinct gestures: When she laughs she holds on to her stomach and when she wails, her knees drop to the ground.She is very girlish and has a strong romantic side so don't draw her disorderly when making her boyish. Also, when she has an embarrassed emotion or when she is dreaming, she is exceptionally cute.

The eyebrows are raised and the ends of the eyebrows are lightly lowered.

The smiling eyes are cast up. Both the upper and lower eyelids curve up while covering the top and bottom parts of the pupils.

The mouth is opened sideways and the width of the lower lip is long. This is an ambiguous smile.

The cheeks blush heavily.

The navel is here. The entire body is twisted to the right so be careful with its position and draw in folds. The shape of the body can be seen in the outline drawing.

As the left leg is raised, this side of the skirt moves. Be careful how the pleats ruffle.

As she keeps her skirt down, parts of her fingers are concealed by the pleats.

The mouth connects to the chin and is opened large. This communicates her frank and open character.

The line at the tip of her breast is briefly cut off in order to bring out the softness.

The hands are not made into fists. They seem to be grasping at something. The curvatures of the knuckles are slighter than when she is making fists.

Be careful of the width between the visible parts of the legs. If this width is made too narrow, it will make the pelvis look unnatural.

One leg is turned in and raised a little. It is a little awkward and quite girlish.

The reaction to push down her stomach causes this part of the skirt to move. It is not a rigid pose and is one frame of a movement.

Shy Smile

 Key

This pose best expresses the girlish spirit of this character. When she changes to her summer clothing, imagine asking shyly, "Isn't my skirt too short?" In this way, imagine this character's speech and draw her full of life.

Smile

Even when the legs are spread, the knees point inward, evoking her girlishness.

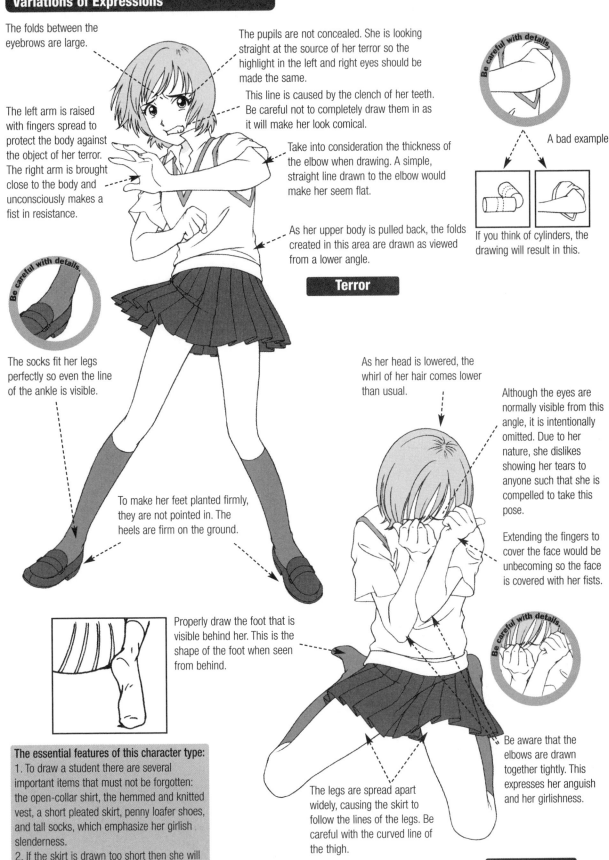

The folds between the eyebrows are large.

The left arm is raised with fingers spread to protect the body against the object of her terror. The right arm is brought close to the body and unconsciously makes a fist in resistance.

The pupils are not concealed. She is looking straight at the source of her terror so the highlight in the left and right eyes should be made the same.

This line is caused by the clench of her teeth. Be careful not to completely draw them in as it will make her look comical.

Take into consideration the thickness of the elbow when drawing. A simple, straight line drawn to the elbow would make her seem flat.

As her upper body is pulled back, the folds created in this area are drawn as viewed from a lower angle.

Be careful with details

A bad example

If you think of cylinders, the drawing will result in this.

Terror

Be careful with details

The socks fit her legs perfectly so even the line of the ankle is visible.

To make her feet planted firmly, they are not pointed in. The heels are firm on the ground.

Properly draw the foot that is visible behind her. This is the shape of the foot when seen from behind.

As her head is lowered, the whirl of her hair comes lower than usual.

Although the eyes are normally visible from this angle, it is intentionally omitted. Due to her nature, she dislikes showing her tears to anyone such that she is compelled to take this pose.

Extending the fingers to cover the face would be unbecoming so the face is covered with her fists.

Be careful with details

Be aware that the elbows are drawn together tightly. This expresses her anguish and her girlishness.

The legs are spread apart widely, causing the skirt to follow the lines of the legs. Be careful with the curved line of the thigh.

The essential features of this character type:
1. To draw a student there are several important items that must not be forgotten: the open-collar shirt, the hemmed and knitted vest, a short pleated skirt, penny loafer shoes, and tall socks, which emphasize her girlish slenderness.
2. If the skirt is drawn too short then she will seem to have no buttocks.

Anguish

Variations of Expressions

Anger

With the shoulders raised, their width is narrowed.

Both the eyes and the eyebrows are slightly arched.

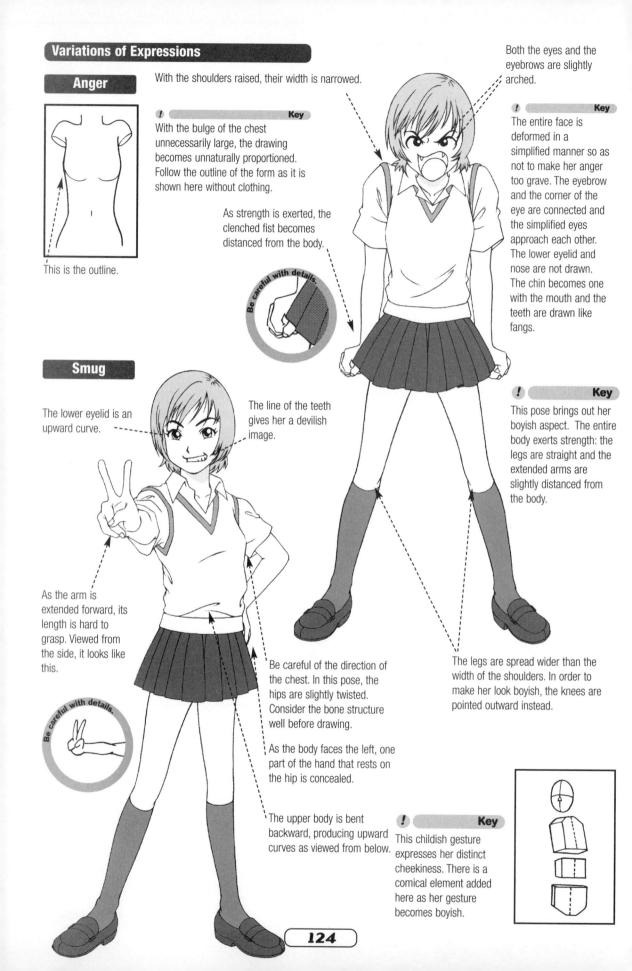

This is the outline.

! Key

With the bulge of the chest unnecessarily large, the drawing becomes unnaturally proportioned. Follow the outline of the form as it is shown here without clothing.

As strength is exerted, the clenched fist becomes distanced from the body.

Be careful with details.

! Key

The entire face is deformed in a simplified manner so as not to make her anger too grave. The eyebrow and the corner of the eye are connected and the simplified eyes approach each other. The lower eyelid and nose are not drawn. The chin becomes one with the mouth and the teeth are drawn like fangs.

! Key

This pose brings out her boyish aspect. The entire body exerts strength: the legs are straight and the extended arms are slightly distanced from the body.

Smug

The lower eyelid is an upward curve.

The line of the teeth gives her a devilish image.

As the arm is extended forward, its length is hard to grasp. Viewed from the side, it looks like this.

Be careful with details.

Be careful of the direction of the chest. In this pose, the hips are slightly twisted. Consider the bone structure well before drawing.

As the body faces the left, one part of the hand that rests on the hip is concealed.

The upper body is bent backward, producing upward curves as viewed from below.

The legs are spread wider than the width of the shoulders. In order to make her look boyish, the knees are pointed outward instead.

! Key

This childish gesture expresses her distinct cheekiness. There is a comical element added here as her gesture becomes boyish.

The eyes are large, spaced apart, and slightly lowered in position to evoke her childishness. The mouth is closed as it is raised.

Her neck is tilted a little and the chin is drawn, a typical girlish pose.

The curve of the skirt's drape shows the volume of the thighs. Making it completely straight would remove the sense of volume of the legs.

The fisted hands allow her boyishness to stand out. Also, it shows that she is concerned with her skirt and is keeping it in place.

The knees are touching and turned inward. As with all girls, she takes care not to make her undergarment visible.

With this small interval filled in black the interior of the skirt can be expressed and the line of the leg can be clearly seen.

Key

This expression is a bold affectation made while she is speaking with her friend but with much little effect. For this character, this is a rather artificial expression as though she is asserting her opinion in a last-ditch effort.

Key

The knees are spread, opening the legs. With the thighs slightly slanted and facing forward, this pose is difficult to draw. Draw them with a set of cylinders in mind.

Do you love me?

! Key

This character in fact has a romantic side found in all girls. This gesture shows the frankness of her youth as she wholeheartedly fixes her gaze. Her face expresses her innocence and is drawn with an overall soft image in mind.

Be careful with details.

Be careful with details.

Whatever!

The face has been simplified and caricaturized. The area of the eyelids is made large to an extreme and the eyes are firmly shut. The mouth is open and drawn warped.

The palms are out turned in an exaggerated manner creating a humorous atmosphere. Be careful with the fingers that go back.

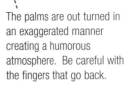
Be careful with details.

The skirt falls at once in the space between the spread knees. The length of the skirt is such that the undergarment is not visible.

Student Character (Boy)

Expressing Emotions with Gestures

This is a typical high school student. Making this character the same as the reader allows for a greater appeal to the reader's emotions. The emotional expression of this character is gentle such that he doesn't have bad intentions and he is drawn as an overall positive character.

The eyebrows are brought together and the upper and lower parts of the pupils are concealed by the eyelids. The line of the eyelashes points downward and giving him drooping eyes. He is staring at the ground and has a sunken feeling.

The back is rounded.

The mouth is slightly open as though he is sighing.

Only the elbows rest on the legs while the arms fall between the legs.

The grasp of the fingers is not fixed as though they have lost their strength.

! Key

This is an extremely serious face. Things are not going well with the girl that he likes (and she means everything in the world to him) and he has fallen into utter discouragement.

The stomach has lost all its strength. In this seated pose with the defeated and sunken shoulders, the illustration would look unnatural if only the hips were curved. Make sure his back is rounded while his stomach is curved as well.

The eyebrows are raised and the eyes are shut in upward curves. The eyelid also points upward to emphasize his joy.

To show he is concealing his emotions out of shyness, the mouth is open but the teeth are shut. This also expresses his childishness.

The embellishments are made large but not too much.

The line of the wrist and the hand are not connected. The bones of the wrist are expressed by the slight tuck.

Discouragement

To mask the level of his uplifted feeling, he strikes a small pose, which inadvertently is quite revealing of his emotions. Take note of how his fingers rest on the hips but do not point sideways but downwards instead.

If the legs are spread apart during his shy smile, the illustration will appear too comical. So instead, close them with the feet pointed outward. This pose cannot be drawn without some awareness, communicating this character's stance of "Don't forget I am always cool," which occasionally becomes a gag.

Be careful with details.

! Key

He is ecstatic at having been complimented by a girl, making this the opposite expression of "Discouragement." Without concealing his soaring emotions in the least, he expresses himself openly and freely.

Joy

The eyebrows are turned in a scowl and his line of sight is fixed on the other person. He is seen from below and his line of sight points up further.

Terror

The vertical line that connects the upper and lower lips is a almost straight line. Though he is seen from below, the lower teeth are also drawn to express the large extent to which the mouth is open.

The heel is raised to become nearly perpendicular to the raised right leg. Such an exaggerated pose is usually very rare but when drawn to this extent of caricature, it serves to evoke the atmosphere.

In addition to "Terror", there also are elements of "Surprise" and "Shock" which add more drama to the action.

The tear-shaped mouth expresses his clenched teeth.

The tears do not run to his chin but toward the ground instead. However, be careful not to make them fall straight down otherwise the curvature of the face will be lost. Keep a sphere in mind when drawing.

His head is tilted back to its limit, trying to hold back his tears from streaming down. But don't forget that humans cannot tilt their heads back to a 90-degree angle. Study how to draw this pose in various cases.

The sorrowful feeling can be conveyed by positioning him to be seen from behind. Having his back completely turned to the viewer won't effectively communicate his emotion while facing forward would diminish his sorrow. The upper body is bent back so there are folds at his spine. Also, his hands as well as a part of his arm are concealed.

To emphasize the exertion of strength in his hands, the outline of the palm is clearly drawn and the hand is spread fairly wide.

The shirt is blown open to show he is leaping.

His thighs are slightly slanted and face forward while the part of the leg below the knee points down toward the ground. Deciding where the outline begins from the knee down is crucial. Have in mind a set of cylinders when drawing.

The fisted hands show that the arms are exerting strength and not just hanging loosely.

Adding the line of the elbow gives a sense of the bone.

Anguish

Since he is revealing his true emotions here, this scene carries no comical undertone at all. There is no excessive drama and his straight posture expresses the large extent of his emotion.

The essential features of this character type:
1. His open-necked shirt, which matches that of the girl, as well as his shoes, are part of his uniform.
2. The shirt has come loose on its own so the buttons are not done and his undershirt is drawn in. Adding a breast pocket makes his clothing all the more like a uniform.
3. The pants are black just like uniform pants. They are not very long nor attractive.

Variation of Expressions

This is a typical rolling-up-the-sleeves pose. Even though he is not used to fighting, he buckles down and prepares himself for a fight, communicating the extent of his feelings for a girl.

His overall pose is comical so the folds between the eyebrows are brought together to the point of touching and the pupils have become simple circles. The lower line of the lower eyelid emphasizes the excited nature of his anger.

The jagged line of the teeth.

Be careful with details.

The bone of the elbow. It is drawn greatly deformed.

The lengths of the arms look different because the left arm is turned more inward than the right.

The hands are drawn larger than in "Expressionless".

One side is raised high.

Anger

The upper body is bent back so there are no folds at the chest.

The edges of the mouth are raised and one side is made slightly larger. The lines of the lower teeth are standard for a smug expression.

Smug

The hands are at the hips. Different from "Joy" the fingers are shown as though he is striking a pose and putting on airs.

The feet are greatly turned outward, communicating his boldness.

! Key

Through his exaggerated pose of spreading his legs nearly twice the width of the shoulders, he puts on the appearance of making himself look larger. To show the left and right legs as the same length, the skeleton of the entire body is twisted in this manner

! Key

The weight of the body is set off slight to the right leg. The slight S-Curve pose eases the rigidity of his upright stance.

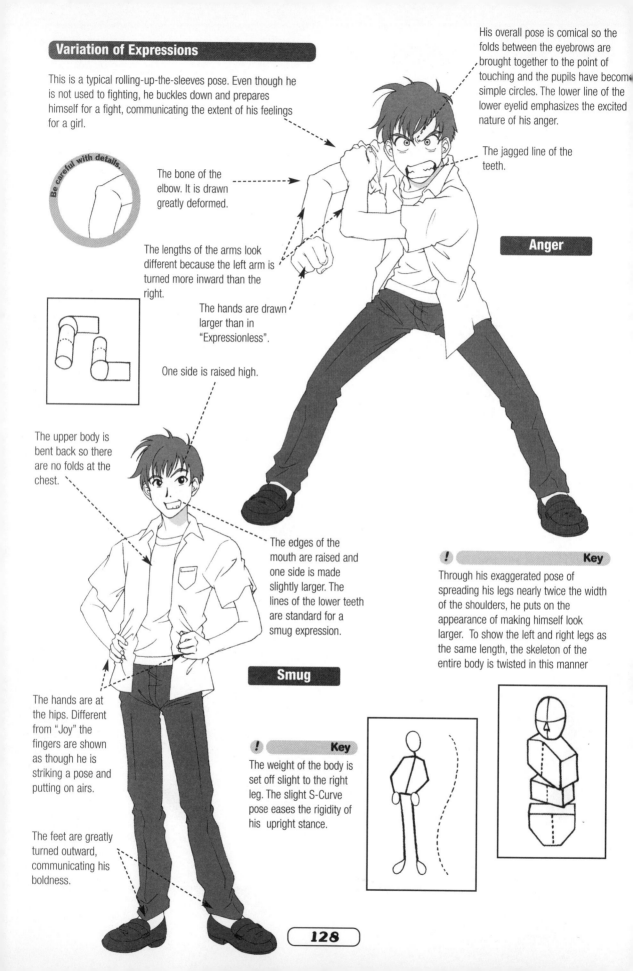

The mouth is a trapezoid shape. It is open to the point of touching the outline of the face, adding a humorous element.

To show his repugnance, there are folds between the eyebrows and the eyebrows themselves are brought into the forehead. The lines of the upper and lower eyelids are connected and the eyes have become simple circles, drawn as small dots.

The lines are treated separately to show the bulge of the muscle.

! Key

This is the expression of surprise when having accidentally seen something unpleasant. It has no element of "Terror".

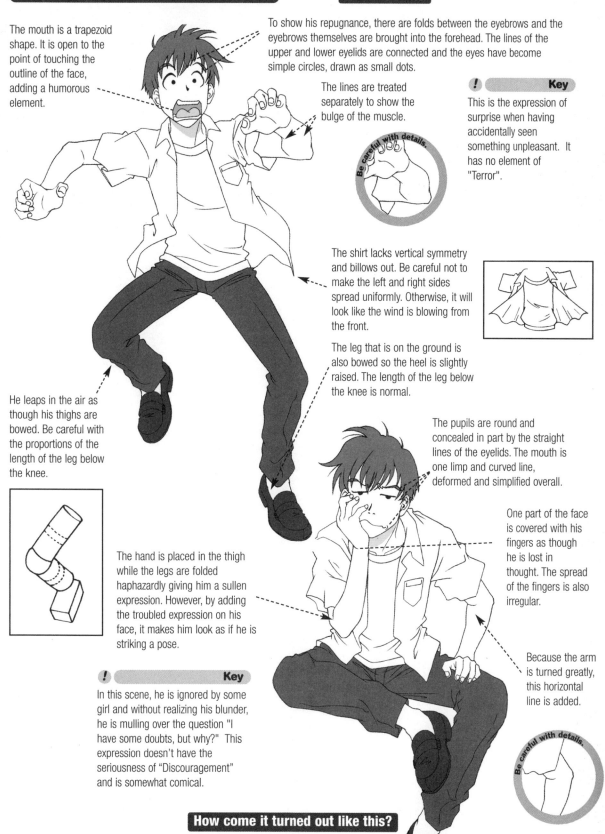

The shirt lacks vertical symmetry and billows out. Be careful not to make the left and right sides spread uniformly. Otherwise, it will look like the wind is blowing from the front.

The leg that is on the ground is also bowed so the heel is slightly raised. The length of the leg below the knee is normal.

He leaps in the air as though his thighs are bowed. Be careful with the proportions of the length of the leg below the knee.

The pupils are round and concealed in part by the straight lines of the eyelids. The mouth is one limp and curved line, deformed and simplified overall.

One part of the face is covered with his fingers as though he is lost in thought. The spread of the fingers is also irregular.

The hand is placed in the thigh while the legs are folded haphazardly giving him a sullen expression. However, by adding the troubled expression on his face, it makes him look as if he is striking a pose.

Because the arm is turned greatly, this horizontal line is added.

! Key

In this scene, he is ignored by some girl and without realizing his blunder, he is mulling over the question "I have some doubts, but why?" This expression doesn't have the seriousness of "Discouragement" and is somewhat comical.

How come it turned out like this?

Advice from Young Illustrators

Tadahiro Kitamura

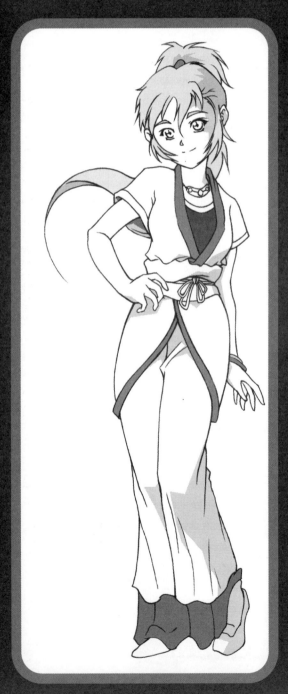

Tadahiro Kitamura
D.O.B. August 20th, 1976
Place of Birth: Oita Prefecture
Graduate of a technical college, he is currently working for a game software company making backgrounds for 3-D games and computer games.

What should you do to draw well?

I don't have enough experience to be able to answer that question for myself with confidence but it is important to think when drawing. Always bear in mind your desire to improve.

It is often said but it is true, you need to train your eye to observe. While waiting for the train at the station, if you take a look around you there are various expressions and figures. Amongst them, you will notice individual styles. If you sharpen this skill, you will be able to grasp the textures of dirt, concrete, cracks, rust, and more which are all important in drawing details. But, this is easier said than done. Even for me, I have to make a conscious effort to observe things. Otherwise, it slips my attention. The important thing is not to get too caught up with information itself but to improve your skill based on the information you obtained. Taking this book also means you have obtained one bit of information.

Finally, all that is left to do is to make use of that information and continue drawing.

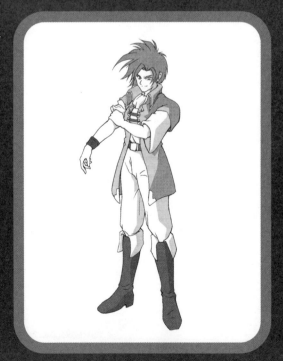

Chapter 3
Directing Different Scenes

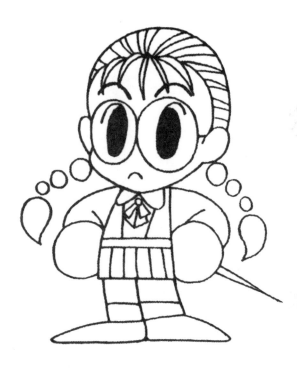

Chapter 3

What is Directing?

The necessary elements of the work: the character set-up, story, and scene. Once all these are established, you can finally begin producing your work.

But before this, let's find out about "Directing." Even if you draw the scene just as you intended, it lacks charm. Directing is placing the characters in the most effective manner within the world (the space) you have created. It is not difficult to do. It is the same as taking pictures with a camera. When you come across a grand landscape don't you take a

picture to remember it? Also, you take close-up shots of your boyfriend or girlfriend, right? Directing is no different. Even when drawing the scene, it is good to think "What can I do to further emphasize the emotion and the story?" Should I make it only a landscape, or a close-up of the character, or totally change the camera position and its angle? You get lost and start over from scratch. This is directing. It is the most interesting part of all.

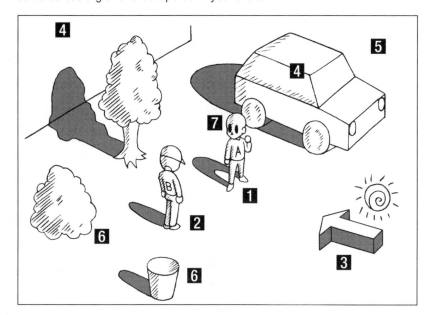

First, you have to decide the camera position—what part of the scene will get included in the frame? To do this, first establish the following elements of the situation:

1. **Where will the character stand?**
2. **If there is another person, his position.**
3. **The lighting angle.**
4. **The position and size of the buildings in the scene and their distance from the characters.**
5. **The overall size.**
6. **The position of small items.**
7. **The character's emotion and drama.**

Once all the elements have been established, decide the area that will fall within the frame. Here, the frame includes A and B, as seen from behind B's back. With a camera, it automatically only shoots what is in the frame, but with illustrations, what falls in the frame must consciously be decided. The area outside the frame must also be taken into consideration. Otherwise, the viewer will become confused.

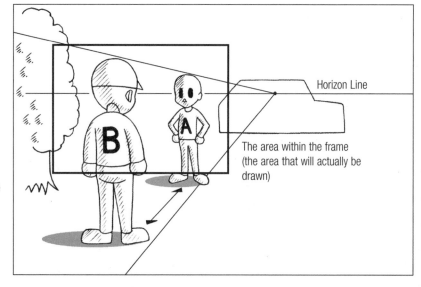

Horizon Line

The area within the frame (the area that will actually be drawn)

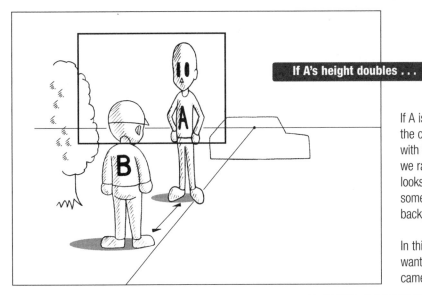

If A is twice the height of B, both of the characters won't fit into the frame with the previous camera position. So we raise the camera angle a little. A looks down at B and A looks somewhat strong, while the background becomes only the sky.

In this manner, depending on what you want to put into the picture, the camera position will change..

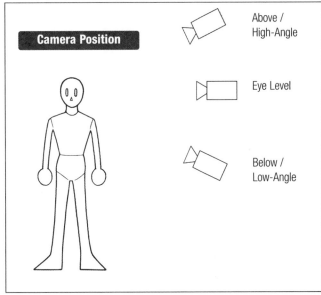

Camera Position

Above / High-Angle

Eye Level

Below / Low-Angle

When unintended, the camera's height is equivalent to the drawer's eye, which is equivalent to the character's eye level.

Please remember the following:
When the camera is faced up, this means that you are composing the drawing whereby you are looking up at the character.

Relative to eye level,
Looking up from below: Below / Low Angle
Looking down from above: Above / High Angle

Camera Frame

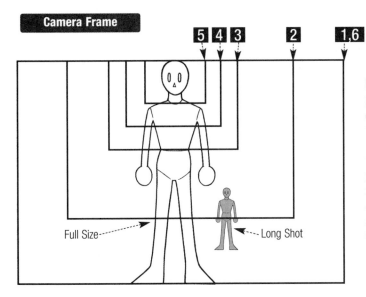

5 4 3 2 1,6

Full Size

Long Shot

Next, let's explain some terms used among professionals in Japan for describing the size of characters. After each it is common to add "Size Shot".

1. **Full (full body)**
2. **Knee (from the knee up)**
3. **Waist (from the waist up)**
4. **Bust (from the chest up)**
5. **Up (close-up of the face)**
6. **Long (from a distance)**

Usually, Close-up Shots are used to show expressions while Long-Size Shots are used to explain conditions of the scene..

The characters operate within the world of the established story. Apart from the protagonist, various other characters are introduced each with its own habits, personalities, expressions, and actions. If all the characters that were introduced had the same reactions, the work becomes boring, wouldn't it? To create a scene, think about how the characters will interact and what emotions will be brought about. Also, think about an effective camera angle and size of the shot. Once you crop the frame, you will have an illustration. Keep in mind the following fundamentals:

A. Emotionally affect the viewer.
B. Make the scene easy to follow.
C. Make the illustration easy to see.

Please look at the illustration below. Let's make an objective scene where A and B are talking. In this case, cameras 1 and 2 become the line of sight of each character, respectively. The third party's line of sight is cameras 3 or 4.

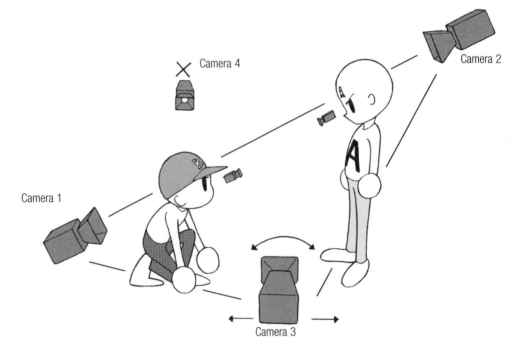

1. Using cameras 3 and 4.

2. Using only camera 3.

In number 1, they don't look as though they are having a conversation, do they? Using only camera 3 is more effective. If you are weak with drawing leftward faces and can only draw rightward faces then you won't be able to do effective directing. This is the start of "Visual Grammar."

Scene 1: Action & Fighting

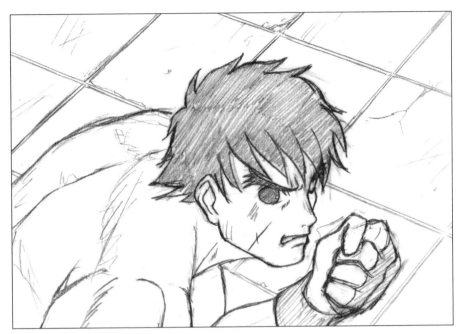

A Fight Scene in the Street

- He has gotten a blow from his enemy but the war is not over. He glares at his opponent searching for his opportunity to retaliate.

- Both pain and his fighting spirit are mixed.
- The angle here is close to the enemy who delivered the blow. From this, the viewer can follow his line of sight and feel the force of the protagonist's strong will.

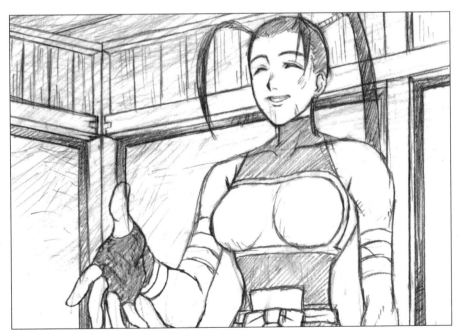

A Scene Inside an Old Dojo

- The battle has concluded, and one of the players offers a handshake: "It was a good match."
- All is calm as she smiles.

- The angle is from below. Looking up at her communicates that she is in a superior position. From this it can be understood that she was the winner.

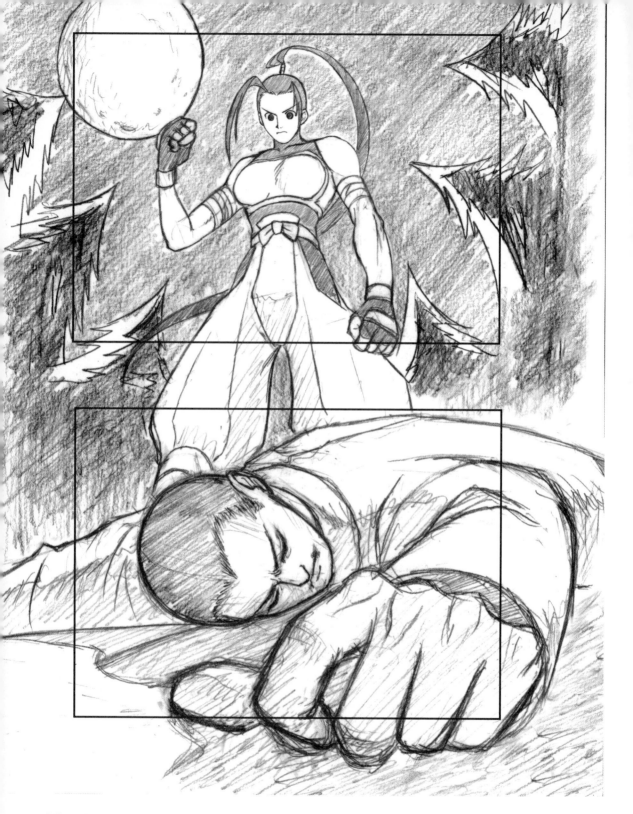

A Duel Deep in the Forest Under a Full Moon

• She fights with all her strength with this coward. He had set a trap for her and laid waiting. She made a glorious victory.

• The battle has just ended and her breathing has not returned to normal yet.

• The view of the camera changes as it is gradually raised from the side of the fallen person. In the backdrop there is a brilliant, full moon. She stands victorious. The angle from below may have been made with a wide-angle lens and fish-eye lens. The camera is tilted as it rests next to the enemy who has just been toppled. The tree tops are deformed with a fish-eye lens effect, expressing the power of the battle and its tension.

Scene 2: A day in the life of a detective

A Conversation in the Detective's Office
- The girl whose promise is broken rebukes the detective.
- She is fuming while he tries to calm her down:
 "Tell me what is going on immediately!"
 "Okay, okay, I'll tell you."

- To explain the scene with just this one illustration, it is made from the side. If you want to further emphasize the emotion of either character, it would be best follow with a close-up shot.

A Visitor Enters the Same Detective's Office
- All of a sudden there is someone at the door. The gift brought by the visitor astonishes both of them.
- Their faces are frozen in shock:
 "Woah, what is it?"

- They both focus on one point. In the next scene, the camera will pan sideways to show the source of their surprise.

A Crowded Street

- For now, work is over.
- He is not exactly satisfied with what he has found out so far in his investigation.

- The angle is slightly from below showing the surrounding buildings and streetlights which help to explain the circumstances.

Nighttime at the Office

- The detective returns to his office after finishing some business. Unexpectedly, the girl holding a bouquet of flowers greets him.
- She has a mixed shy and buoyant smile: "Hi!"

- The reader's line of sight and the detective are the same. This is directed to give the reader a sense of what was said by her. Drawing the blinds, the picture frame, the desk, and other small items in the background explains that this is a man's office.

Scene 3: Aesthetic & Young

Inside a High School Bathroom
(Closing-In Scene)
- An upper classman corners him, forcing him up against the wall.
- Trapped, he expresses his fear: "Stop it, please. I hate this kind of joking."

- The face of the upper classman is intentionally not shown. His back takes up one-third of the picture. His shadow falls on the young boy, expressing pressure. With the gaudy accessory, the character's gender is clear.

Inside the Young Man's Bachelor Pad
(Provocation Scene)
- He is fed up with the boy who has been following him, and to tease him he strips off his clothing and jumps on the bed.
- A composed and relaxed smile. We imagine he is looking at the boy who was compelled to visit him: "What's the matter? Don't stand all the way over there. Come here."
- As he is lying down on the bed, he is shot from a lower angle. Had this been shot straight on, it would have lost its sense of enticement.

The School Gymnasium (Interior Scene)
- The cheerful young man embraces the utterly confused boy. Everyone is amazed.
- He looks embarrassed and surprised, not knowing what to say.
- To include their surroundings, the camera is pulled back a little. By making the ceiling visible, the expanse of the place is explained.

Scene 4: School Life of a Girlfriend and Boyfriend

Class at the End of the Day, Sunset

- After lunchtime, the girl had a quarrel with the boy.
- She still doesn't realize her feelings for him. She is disappointed that they had an argument. The face looks off to the side, not looking at anything in particular but off into the distance: "Oh, what am I doing?"

- The camera is set just slightly off of front to emphasize this is a classroom by showing the students sitting behind her. With this the window also gets into the picture, which is effective for showing the streaming sun and her distracted gaze.

There is No One Around—School Corridor during Summer Vacation

- As the girl who came to school alone is just about to leave, the protagonist appears.
- Smiles all over. "Yo!"

- Without saying a word, he came just to pick her up, emphasizing the purity and seriousness of his emotion. To make the camera (the reader) the same as the girl's line of sight, the camera is slightly low and he is seen from below.

Going to School (Bickering Scene)

- Although their day-to-day conversation is natural and up-tempo, when it comes to the topic of love, it becomes very awkward. Her relentless questioning makes him upset.
- She gives him a mean look from the side, disgruntled and puckering her mouth. He becomes flustered and angry: "Who was that girl you were with yesterday at the mall?" "Were you spying on me?"

- Making the camera a close-up shot will make it like a conversation between three people as the viewer becomes the third character. On the other hand, a long shot would make the scene too objective and weak. The most suitable framing for this scene would be from the waist up as if their conversation is being overheard by a third person. Placing the characters at both ends of the frame works best.

In the Classroom After School (Duo Scene)

- Embarrassed, she reluctantly hands over the good-luck charm she bought on a class trip. Only when the two of them are alone does she have the courage to give it to him. As this was very sudden, his body has yet to face her.
- To conceal her embarrassment, she faces down while hardly making any movements. His face shows his surprise while his posture remains relaxed.

- The sunset in the background casts shadows to the characters which make their expressions difficult to see. This is effective for conveying their complicated thoughts in an ambiguous way. Moreover, the camera is pulled back to the point where it is once again difficult to see their expression. It will work just as fine even if the camera is further distanced from them.

Scene 5: Giant Robot Battle Squad Member

Inside the Giant Robot Cockpit (Mental Blow)
- The boy has just received the news that his instructor who taught him how to operate a giant robot has died. The boy is shocked and remains frozen.
- The face cannot be seen. The hand stays on the lever just as though his action was suspended since he received the shocking news:"Dead?"

- He is seen from a very high angle, emphasizing his depression without even showing his face. Drawing in the front and side devices gives the feeling of the tight space of the cockpit, its oppressiveness, and gives a strong impression of protagonist's state of mind. After this scene it is effective to draw the character in a close-up shot.

Mid-Battle, Attacked During Training (Attack Scene)
- Here he meets an enemy with fast moves. Though the protagonist is able to match blows with the enemy, a momentary loss of sight allows his enemy to get behind him.
- The protagonist turns in his attack. The eyes are wide open and the mouth is open in scream mode. Adding streaming effects emphasizes the speed of his actions.
"I'm not gonna let you . . .!"

- This is a very fast movement which wouldn't last. The face is viewed in a close-up, expressing power. Inserting the entire body would make expressing speed difficult.

Control Tower

- The female staff is enraged as the male protagonist ignores her specific order and takes the matter into his own hands.
- The mouth is deformed and a small comical element is added. She is so angered that she has ripped the microphone out of the panel.

- To contrast her from the other girls in the control room, the shot size is between a Full and a Long with the girl placed in the center. The symmetry of the scene gives an atmosphere of a mechanical control room and at the same time strongly communicates her presence. The dramatic angle from below emphasizes her hostility.

Inside the Giant Robot Cockpit (Practice Scene)

- She is sitting in the pilot's seat to practice operating the giant robot. Doing what she loves to do the most, she is overflowing with joy. However, she isn't familiar with all the new gadgets and installments such that she makes a lot of mistakes.
- Not realizing that she has made a mistake or how, she sits with a blank stare on her face:

"What just happened?"

- To make her expression and the interior of the cockpit understandable, she is viewed from straight on. Apply perspective effects to the monitors on the left and right to add three-dimensionality.

Scene 6: Cat Girl and Dog Boy

Inside the Cave of the Dog Boy's Clan

- This is the decisive battle. This is the moment when he unleashes his hidden weapon at last.
- The eyes are wide open and gaze steadily. The mouth is open, screaming. To emphasize his hidden strength, both hands are open and his fingers become sift with exertion:

- The sharp, low-angle shot gives a sense of intensity. Drawing the ancient looking pillars in the background gives the impression of a shrine. In this scene, the glowing body of the hidden weapon that he manipulates is the most important object and is placed in the center of the drawing. The Waist Size Shot gives him the perfect size.

The Lobby of a Small Inn (A Hushed Talk)

- Here is the Cat Girl together with the Dog Boy who will spend the night at the inn. It is important for the protagonist to conceal his true identity to avoid being recognized by his enemy.
- A comical element is added to their expressions. The boy clenches his teeth as he makes a threat; he is explaining the conditions of the situation to her (she has been helpless):

"Are you listening? I am supposed to be your older brother. But for today only . . ."
"Okay, I got it!"

- The two are face to face in an extreme close-up as though the viewer is going to get involved in their hushed talk. It is effective to have the viewer enter the emotions of these protagonists. Drawing the waitress explains the location.

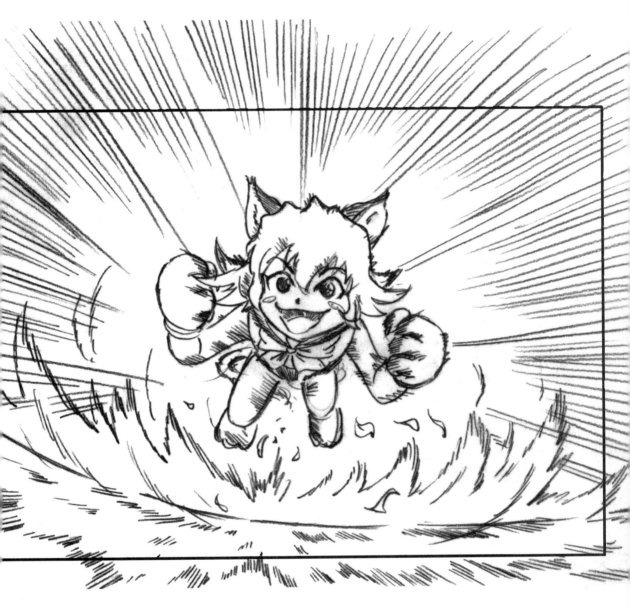

Outdoor Battle

- The Cat Girl is on the attack. With great power, she comes running almost as if flying.
- Dauntlessly smiling. The ears stand up straight as though she is full of might:
 "Leave it to me!"
 "Here I come!"
- Although she is at eye level height, due to her great speed, she is completely tilted forward and her body is seen from head to toe in a sharp perspective. Adding the streaming effect to the illustration emphasizes her power and speed. There is a cloud of dust kicked up behind her, which would be clouds of spray if this scene was over water. Also, making the ground slanted expresses power rather than instability.

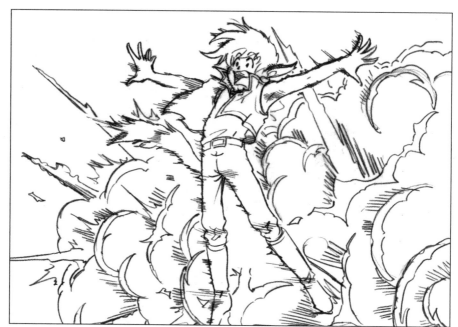

Outdoor Battle (1)
- The protagonist is thrown by the blast of his enemy's attack.
- The blast pushes him from the back. Both arms and legs are spread wide from its force.

- The entire illustration is taken up by the blast. The navel is made the center and the rest of his body bends radially outward. His tail and hair are also blown in the direction of the blast.

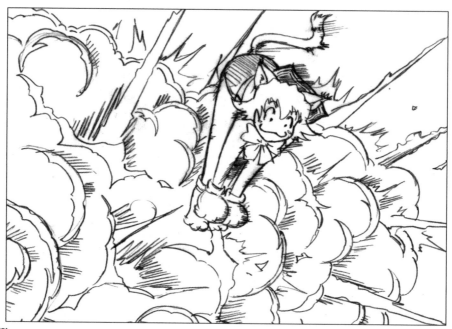

Outdoor Battle (2)
- After having gone through several attacks, she is making her escape now.
- Given the comical nature of the character, the face is greatly deformed. This pose is also indicative of a cat, surprised with its back arched.

- Do not make her tail and clothing deformed in a flutter. By drawing her in an opposite composition of the protagonist, it conveys the atmosphere of confusion.

Scene 7: The World of Adventure Fantasies

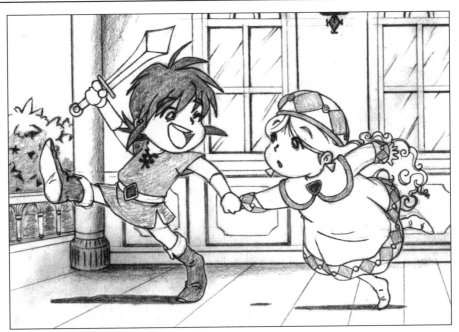

On the Terrace of the Castle (Taking Off)

- The princess and a common boy. The boy has got some important information out of the princess and he is asking her to guide his way. He wants to take off right away and he is pulling the princess along with him.
- One of his eyes is closed to express a light smile. His hand and leg are raised in a profoundly energetic pose. The princess is surprised. Getting pulled like so, she falls forward:
"O.K., let's go there right now?"
"You mean now? At this moment?"
- There are elements of a picture-story show. The picture is made with shots from the side. The characters are full-sized. Since their bodies are proportionately smaller than their heads, large movements of the arms and legs enact a comical expression.

The Princess's Room (Conversation)

- The haste-driven boy is discussing something with the princess
- Fallen to the floor, his knees rest on the ground and his mouth is opened wide:
"You know, our destination is all the way on the other side of the sea."
"So, we can't get there without a boat?"
"That's what I have been saying all along!"
- To explain the boy's emotion and the situation, the scene is seen from above. Both of them are visible as well as the interior of the room. In order to show his sunken feeling, his full body is shown. The princess lifts both hands in the air as though she is trying her best to explain something.

Coming to His Senses

- Separated entirely from his mother when he was small, his emotions explode when he finds out the whereabouts of his mother as well as the secret of his birth..
- Large teardrops well up uncontrollably as his mouth is opened large. The shoulders are raised as he lets out a shout.

"My mother. My mother. . . ."

- To evoke his heightened emotions, the background or other characters and other extra information are not shown. The entire drawing is occupied by his face...

Encountering a Sprite in the Forest

- A sprite appears in front of the legend-believing, courageous princess.
- Her face bends back a little while she opens her mouth in surprise. Her eyes are wide open even as she laughs.
"Oh my, are you for real?"

"Hello, princess."

- The encounter is centered like in a picture-story show. A Waist Size Shot is used to show the size of small sprite.

Night, Outdoors and After the Battle
* The opponent he has finally overthrown turns out to be just one of the followers. From this point, his new grasp of things allows his resolve to move him to action, preparing him for his long journey.
* With the castle behind the boy, it is explained that the battle had just took place. If the castle were drawn before the boy, it will give

the image that he is about to embark on the battle:
"Wait for me. I swear I will find you!"
"Wait for me. I will promise to find you!"
* To express his strong resolution, the angle is from below and slanted. The slanted earth shot with a wide-angle lens makes the space seem even broader, making the world seem expansive. After this, the camera will move into a higher position, showing only the night sky then moving on to the next scene.

Advice from Young Illustrators

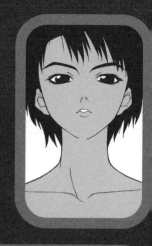

Ryo Kasumi

D.O.B. September 17th, 1976
Place of Birth: Tokyo
Graduate of a technical college. After many turns and twists, he is currently working on character design for an animation project aimed for a millennium release. However, his true aspiration is to become a Manga artist.

I started drawing "pictures" when I was in grade school. After a lot of meandering, midway, I found myself back here due to my love of drawing pictures. In this business, ability is what only matters and your work gets judged without any leniency. Criticism and rejection is not uncommon. At times, I would have violent breakdowns. Seeing the sheer talent of those around you can become a humbling experience. Often times, I became upset of my shortcomings. I remember being very jealous and envious of my friends who got ahead of me. Aside from a few exceptions, in order to make a living in this industry which is completely different from the school environment, you simply must love to draw. Otherwise, although you may eventually get accustomed to it, it will only be at the expense of a fragmented will.

As it is often mentioned in instructional books, there are no shortcuts to improving your drawing. This is the absolute truth. The only way to get there is through hard and continuous work. People often ask, "But, what kind of effort should be made?" For this, I have a little advice. For example, be careful with how you draw the hair of your characters. The tufts of hairs for every person do not have the same width. Some are thick (big) while others are in thin bunches (small). Adding variance of thickness will be a feast for the eyes.

One more thing: the body itself has differences in thin and thick parts. For example, the leg has a soft bulge in the shin while being taut at the ankle. Also, the interior line of the leg and its exterior line are different even though it is the same part. Certainly, there is no symmetry.

Use photographs as references and look over your drawings again. There always is an essential point to master in the course of improving your drawing. So, draw all the details with great care and your skill level will improve. For those of you haven't been paying attention until now, let this be an opportunity for change. For those who have already been drawing with care, draw with even greater care and let it be of use to your work.

Chapter 4
Experience On Paper

In this section, we invited the readers to submit their works. The author selects and corrects the works, which then get reproduced here. This time, from the first pool of applicants, six were selected and their works are reproduced here along with helpful suggestions and corrected examples.
With just the slightest change in a line, the drawings may come to life. Apply the advice given here to your own drawings.

Experience On Paper

Touch Up Example 1

This difficult pose of the girl looking back is drawn very well. It is girlish and cute. Although the 4-to-1 head-body ratio is a strong form, in order to have an overall balance, be careful with the size of each part. Take your time with small details.

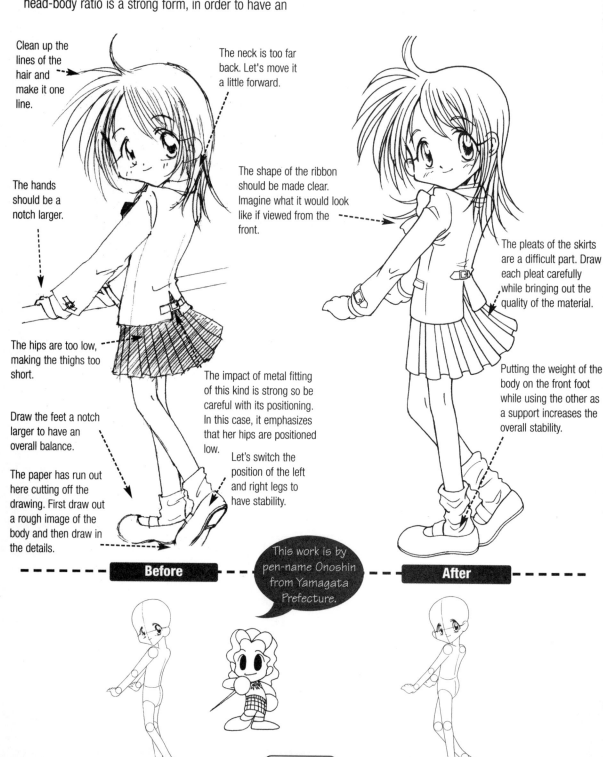

Clean up the lines of the hair and make it one line.

The neck is too far back. Let's move it a little forward.

The hands should be a notch larger.

The shape of the ribbon should be made clear. Imagine what it would look like if viewed from the front.

The hips are too low, making the thighs too short.

The pleats of the skirts are a difficult part. Draw each pleat carefully while bringing out the quality of the material.

Draw the feet a notch larger to have an overall balance.

The impact of metal fitting of this kind is strong so be careful with its positioning. In this case, it emphasizes that her hips are positioned low.

The paper has run out here cutting off the drawing. First draw out a rough image of the body and then draw in the details.

Let's switch the position of the left and right legs to have stability.

Putting the weight of the body on the front foot while using the other as a support increases the overall stability.

Before

This work is by pen-name Onoshin from Yamagata Prefecture.

After

The developed touch with the eyes and nose really shows a lot of practice and is rather cute. The next step would be to try drawing in different poses to get a good grasp of the body. It is important to keep the entire body in mind at all times.

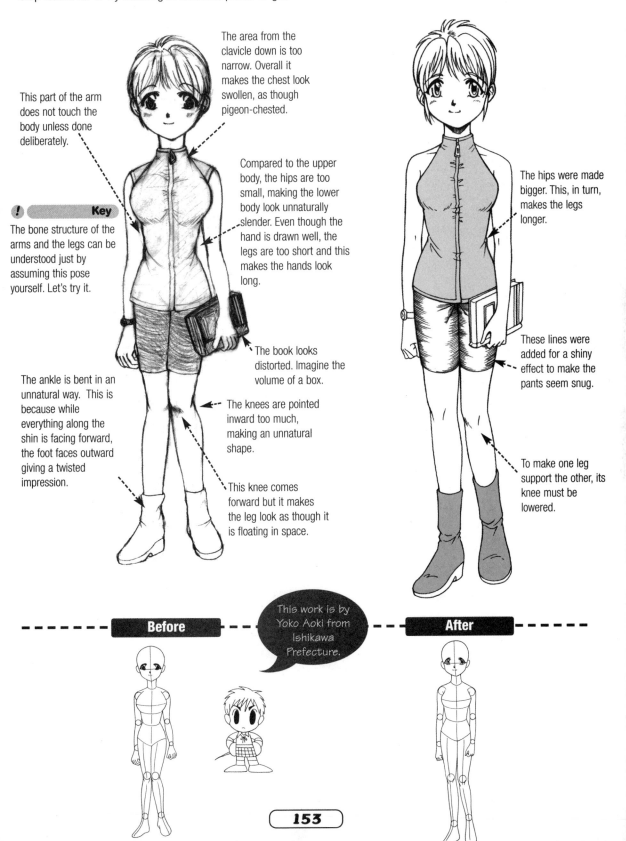

This part of the arm does not touch the body unless done deliberately.

The area from the clavicle down is too narrow. Overall it makes the chest look swollen, as though pigeon-chested.

! Key

The bone structure of the arms and the legs can be understood just by assuming this pose yourself. Let's try it.

Compared to the upper body, the hips are too small, making the lower body look unnaturally slender. Even though the hand is drawn well, the legs are too short and this makes the hands look long.

The hips were made bigger. This, in turn, makes the legs longer.

The ankle is bent in an unnatural way. This is because while everything along the shin is facing forward, the foot faces outward giving a twisted impression.

The book looks distorted. Imagine the volume of a box.

The knees are pointed inward too much, making an unnatural shape.

This knee comes forward but it makes the leg look as though it is floating in space.

These lines were added for a shiny effect to make the pants seem snug.

To make one leg support the other, its knee must be lowered.

Before

This work is by Yoko Aoki from Ishikawa Prefecture.

After

What this character is doing is ambiguous such that it becomes difficult to understand what is intended to be communicated to the viewer. Clearly decide the character's intentions before drawing. If the character is in the middle of doing something (ex. running her hand through her hair), choose a pose that makes her look the best while being easily recognizable.

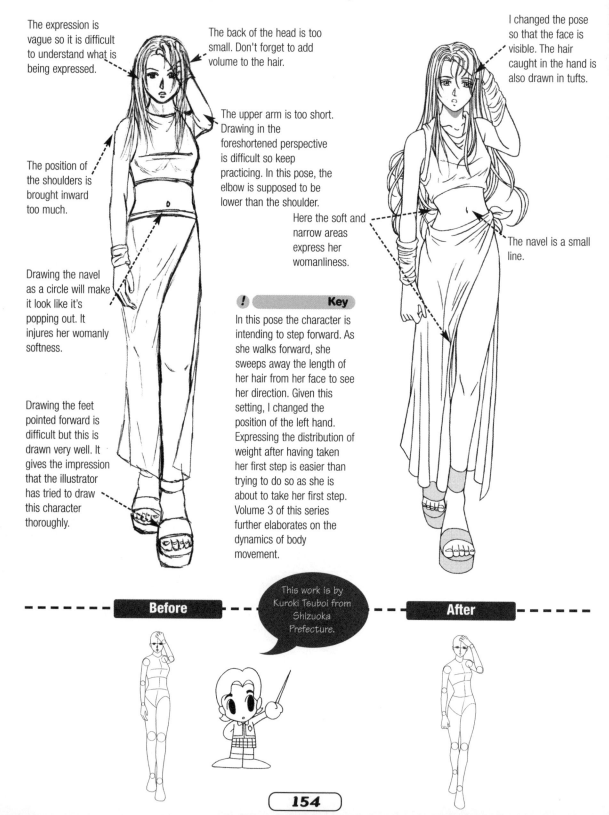

The expression is vague so it is difficult to understand what is being expressed.

The back of the head is too small. Don't forget to add volume to the hair.

The position of the shoulders is brought inward too much.

The upper arm is too short. Drawing in the foreshortened perspective is difficult so keep practicing. In this pose, the elbow is supposed to be lower than the shoulder.

Drawing the navel as a circle will make it look like it's popping out. It injures her womanly softness.

Here the soft and narrow areas express her womanliness.

Drawing the feet pointed forward is difficult but this is drawn very well. It gives the impression that the illustrator has tried to draw this character thoroughly.

I changed the pose so that the face is visible. The hair caught in the hand is also drawn in tufts.

The navel is a small line.

! Key

In this pose the character is intending to step forward. As she walks forward, she sweeps away the length of her hair from her face to see her direction. Given this setting, I changed the position of the left hand. Expressing the distribution of weight after having taken her first step is easier than trying to do so as she is about to take her first step. Volume 3 of this series further elaborates on the dynamics of body movement.

Before

After

This work is by Kuroki Tsuboi from Shizuoka Prefecture.

Since the neck is shifted from the front of the face, the body should not be facing forward so much.

Although the image itself is communicated, the facial outline should be drawn with one solid line.

This is probably meant to express his individuality but the arm is too long. The legs are well separated for balance but the supporting leg is spread unnaturally. Let's make the arm a little shorter.

It is a little short.

With the elbow high, he looks unstable and exerting unnecessary force in his elbow.

As the feet are spread double the width of the shoulders, this will make the character tired. It is unnatural, unstable, and a detraction from the atmosphere.

The strength of this drawing is in the coherence of the designed clothing, the personalized weapon, and the character's peculiar shoulders which ably demonstrate his position in his society.

Distancing the weapon from the silhouette of the body is a good way of showing small items held in the hand.

With set poses, all of the details must be worked out.

! ▬▬▬▬▬▬▬▬▬▬ Key

Matching the direction of the neck, the body has been turned away from the viewer slightly. This makes showing the volume of his body easier. With set poses, a character turned to its side is better than faced completely forward.

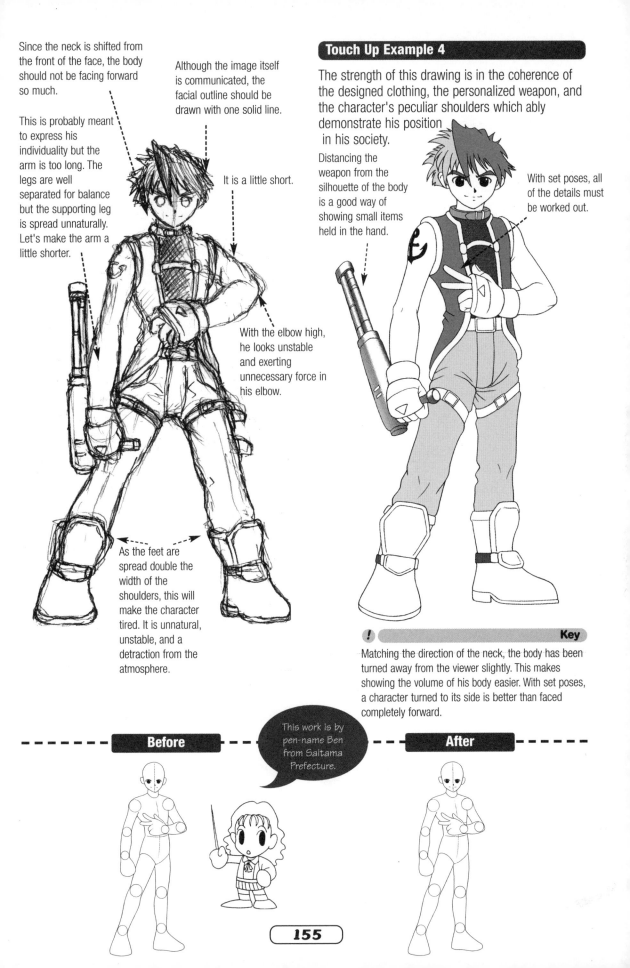

Before

This work is by pen-name Ben from Saitama Prefecture.

After

It looks like this person is accustomed to character design. The hairstyle and the character's various articles perfectly express its individuality. But the drawing skill needs a little work. Be careful with the flow from the upper to the lower body. If you take care of that, all you need to do is to pay attention to details and polish up your technique.

Distancing the arm from the body, the coolness of this character can be expressed with the set pose.

The lines are added to show the flow and softness of the hair.

The hips are turned forward too much with respect to the direction of the neck and the chest. This is a possible pose but, since the direction of the legs is slanted intentionally, something is unnatural.

Make sure the edges are rounded.

Considering the length of the hair, it should also be visible below the fabric.

To show this is made of some inorganic material, let's slightly fix the shape.

The thigh has been turned in too much and makes her backside seem unnaturally small.

Matching the direction of the chest, the pose is slanted and turned to the side. The placement of the legs has been moved very slightly to follow in the direction of the hips thereby adding more stability.

Let's make the folds of the fabric smooth and bring out its velvety quality.

This curve should follow the form of the leg and be rounded appropriately.

Make the design of the left and right sides uniform.

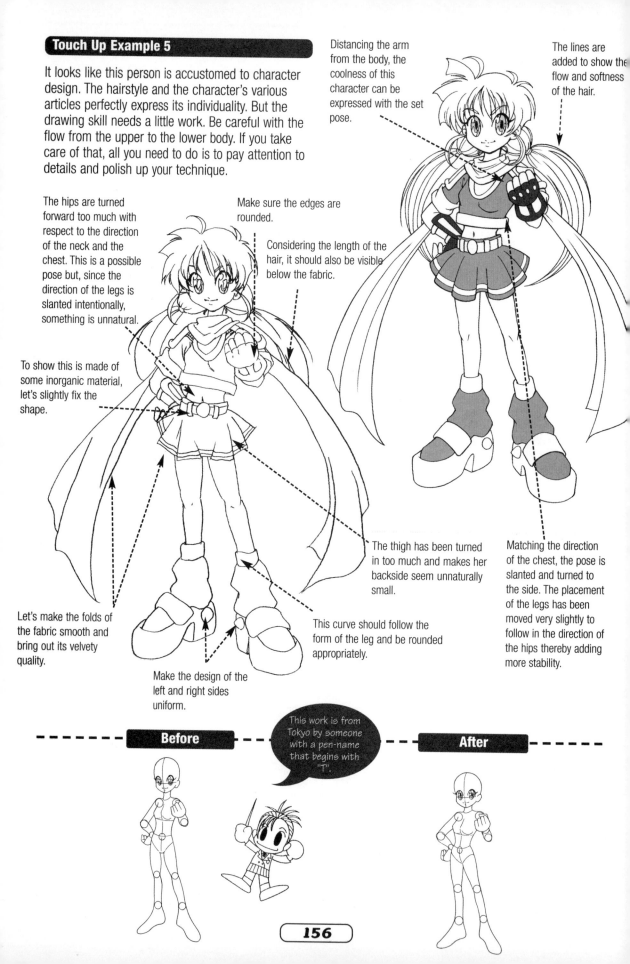

Before

This work is from Tokyo by someone with a pen-name that begins with "T".

After